Destination Art

Destination Art

500 Artworks Worth the Trip

Φ

Destination Art divides the world into seven regions: Australasia, Asia, Europe, Africa, the Middle East, North America, and South America. The featured artworks are grouped geographically. Country maps are interspersed throughout each section, indicating the location of individual artworks. Regions and countries are named at the outer edge of each page and cities at the top. GPS coordinates are provided at the bottom of each page.

KEY TO SYMBOLS
The following symbols indicate:

O Artwork can be viewed anytime.

● Artwork can be viewed during specific hours.

A Artwork can be viewed by appointment only.

For details, the Visitor Information index (p. 544) provides websites and telephone numbers, when available. While every care has been taken to ensure accuracy, hours are subject to change and access may be limited.

PLACE NAME ABBREVIATIONS
The abbreviations listed below are used in the addresses.

AB	Alberta	IN	Indiana	PA	Pennsylvania
ACT	Australian Capital Territory	KY	Kentucky	QC	Quebec
		LA	Louisiana	QLD	Queensland
AK	Alaska	MA	Massachusetts	TAS	Tasmania
AR	Arkansas	MI	Michigan	TX	Texas
AZ	Arizona	MN	Minnesota	UT	Utah
BC	British Columbia	MO	Missouri	VA	Virginia
CA	California	NC	North Carolina	WA	Washington (United States)
CO	Colorado	NH	New Hampshire		Western Australia (Australia)
CT	Connecticut	NJ	New Jersey		
DC	District of Columbia	NM	New Mexico		
		NSW	New South Wales	WI	Wisconsin
FL	Florida	NV	Nevada		
GA	Georgia	NY	New York		
HI	Hawaii	OH	Ohio		
IA	Iowa	ON	Ontario		
IL	Illinois	OR	Oregon		

Why do we travel for art?

In an age when the internet provides instant access to a seemingly infinite bank of images, why should we still make the effort to be in the presence of a particular work in a specific place? Images may convey essential information, but there will always be something unique about experiencing an artwork in person. That firsthand experience owes a debt to not only the physical quality of the work itself but also the environment in which it is installed.

Destination Art is the essential guide to place-specific art: permanently installed works around the globe that are worth the journey to experience in situ. These works are found in the widest variety of locations: from the teeming hearts of great cities to quiet corners of suburbia, from picturesque gardens to remote stretches of coastline. The pages of this book take readers from Naoshima island in Japan to a traffic circle in India, from a mountainside in Iceland to a salt lake in Western Australia—and almost everywhere in between. In total, *Destination Art* includes works from more than sixty countries and over three hundred cities.

The notion of a journey is essential to this volume. The concept of undertaking a journey to view an object in person has deep, and religious, roots. All the major world religions have traditions of pilgrimage, often to places connected to the lives and deaths of holy figures. Many of these destinations housed significant objects—relics or images—that became a focal point for pilgrims at the end of their (often grueling) travels. In the mid-seventeenth century, a new concept of travel emerged with the European Grand Tour. Personal improvement was considered attainable through direct exposure to the culture of the classical world or High Renaissance—and, of course, to the vibrant cultures that surrounded ancient sites, churches, and museums. Tourism and its pleasures are far more accessible today, but the idea persists that going to see art offers its own rewards, which is undoubtedly a part of what motivates people to make the trip.

In this book, the art itself is the destination—in public streets and parks, harbors, train stations, libraries, sacred or political sites, university campuses, forests, deserts, and elsewhere. The works represent a wide variety of mediums, including sculpture, sound and light installations, indoor and outdoor murals, Land Art, fountains, stained glass, tapestries, bus stops, memorials, and even an acoustic ceiling and a playground. In size, they range from the monumental to the subtle and understated.

In the spirit of contemporary pilgrimage and in the name of aesthetic experience, we have curated a list of five hundred artworks, culled from thousands of possible examples. Some of them exist independently, while others are part of sculpture parks, predefined art trails, and other types of sites with multiple permanent artworks. In such cases, we have selected one noteworthy example and hope that our recommendation is the starting point for readers to discover other works nearby.

Like any survey of art, this book presents a diverse record of human creativity, and as a global guide, it offers the excitement of traveling the world from the comfort of your armchair. But our ultimate hope is that *Destination Art* will inspire readers to make a journey for art. We are confident that visiting any of these destinations will offer pleasures and insights that extend well beyond the pages of this book.

AUSTRALASIA

AUSTRALIA

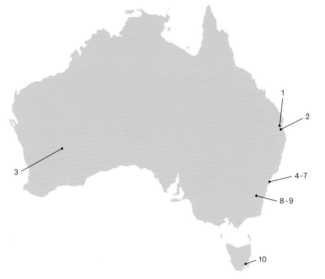

AUSTRALIA

1
2
3
4–7
8–9
10

NEW ZEALAND

11
12
13–14
15

10

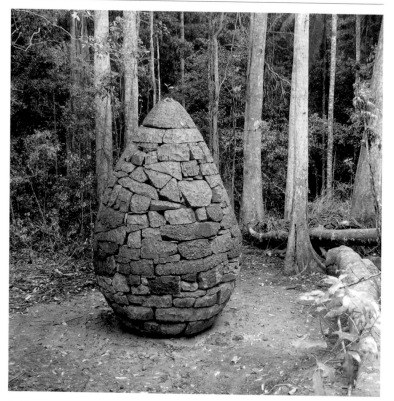

ANDY GOLDSWORTHY, STRANGLER CAIRN, 2011

Conondale National Park, Kenilworth, QLD 4552

AUSTRALASIA — AUSTRALIA

Famed sculptor Goldsworthy, also celebrated for his Land Art, used two of his favorite materials—stone and plants—in creating this piece. Its egglike form is composed of hand-cut granite and metamorphic stone blocks, with a rainforest strangler fig growing from the top of it. As time passes, the fig's roots will grow around, or "strangle," the cairn.

AUSTRALASIA — AUSTRALIA

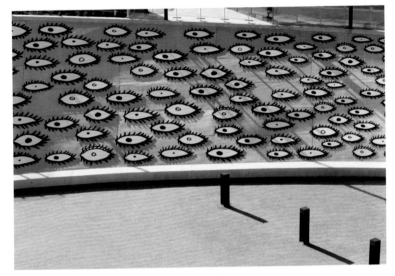

YAYOI KUSAMA, EYES ARE SINGING OUT, 2012 ○

Queen Elizabeth II Courts of Law, 415 George Street, Brisbane,
QLD 4000

Kusama is known for her use of polka dots, but here, eyes are her theme
of choice. Facing Brisbane's Queen Elizabeth II Courts of Law is a block-long
curved concrete wall covered with more than three hundred enameled steel
eyes, symbolizing the courts' acceptance of public scrutiny.

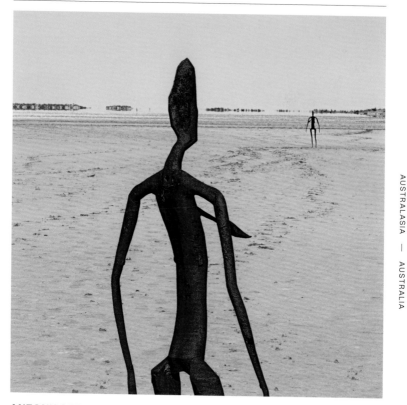

ANTONY GORMLEY, INSIDE AUSTRALIA, 2003

Lake Ballard, near Menzies, WA 6436

AUSTRALASIA — AUSTRALIA

Fifty-one tall, slim statues populate a 2.7-square-mile (7 sq km) area of Lake Ballard, an ephemeral salt lake in a remote region of Western Australia near the small town of Menzies. To create the sculptures, Gormley took digital scans of local residents' bodies, which he abstracted and cast in alloys made from the mineral-rich local soil.

AUSTRALASIA — AUSTRALIA

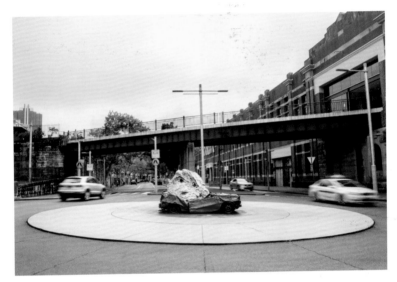

JIMMIE DURHAM, STILL LIFE WITH CAR AND STONE, 2004

Hickson Road at Pottinger Street, Dawes Point, Sydney, NSW 2000

During the 2004 Biennale of Sydney, an audience watched as a 2.2 ton (2 t) stone was dropped on the roof of a 1999 Ford Fiesta. The resulting sculpture now resides in the middle of a Walsh Bay roundabout. The work can be seen as a comment on monumentality and the implacability of nature.

AUSTRALASIA — AUSTRALIA

FRANK STELLA, CONES & PILLARS SERIES, 1985

Grosvenor Place, 225 George Street, The Rocks, Sydney, NSW 2000

Three painted reliefs hang in the foyer of Grosvenor Place, a commercial office tower: *Salto nel mio Sacco!* [Jump into my Sac!], *L'arte di Franceschiello* [Franceschiello's Trade], and *Corpo Senza L'Anima* [Body without Soul]. Stella likens the three paintings to the Italian folktales of Italo Calvino: direct and simple yet containing layers of meaning.

33°51'45.9"S 151°12'25.6"E

AUSTRALASIA — AUSTRALIA

JENNY HOLZER, I STAY (NGAYA NGALAWA), 2014

8 Chifley Square, Sydney, NSW 2000

This LED artwork displays stories, song lyrics, letters, poems, and other texts by aboriginal Australians and Torres Strait Islanders. The title—and its translation in the contemporary Eora language—conveys the idea of locating oneself in a particular place. Holzer's installation recognizes the importance of the narratives of displacement and resilience that are integral to the history of native cultures.

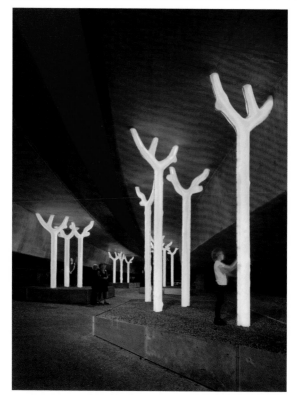

WARREN LANGLEY, ASPIRE, 2010

Bulwara Road between Allen and Fig Streets, Pyrmont, Sydney, NSW 2009

A luminescent forest of polyethylene tree forms lit from within populates a path under an elevated freeway. Langley's sculptures not only transform an otherwise unwelcoming space into a pleasant one but also reference a story of successful organizing: the local community dissuaded the thruway planners from demolishing their homes to make way for the freeway by suggesting an alternate overhead configuration.

33°52'30.7"S 151°11'45.9"E

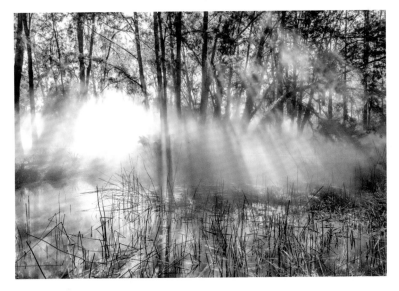

FUJIKO NAKAYA, FOGGY WAKE IN A DESERT: AN ECOSPHERE, 1976

National Gallery of Australia Sculpture Garden, Parkes Place, Parkes, Canberra, ACT 2600

A blanket of mist envelops the marsh pond at a corner of the National Gallery of Australia's sculpture garden, which displays works by Australian and international artists along with native Australian plantings. Nakaya's fog is entirely artificial, generated by forcing water at high pressure through tiny nozzles. The artist, who exhibits her fog sculptures worldwide, developed the technology with an atmospheric physicist.

35°17'58.9"S 149°08'15.5"E

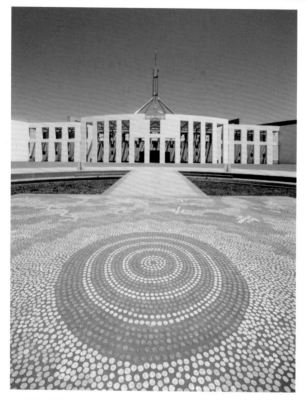

AUSTRALASIA — AUSTRALIA

MICHAEL NELSON TJAKAMARRA, FORECOURT MOSAIC, 1986–87

Parliament House, Parliament Drive, Canberra, ACT 2600

The soil-colored mosaic in the forecourt of Canberra's Parliament House pays homage to aboriginal Australian cosmology. Tjakamarra, a contemporary exponent of traditional Warlpiri sand painting, created an abstract depiction of a ceremonial meeting between ancestral marsupials. Composed of ninety thousand individual hand-cut pieces of granite, the illustration is as technically intricate as it is layered in mythic meaning.

WIM DELVOYE, CLOACA PROFESSIONAL, 2010

Museum of Old and New Art, 655 Main Road, Berriedale,
Hobart, TAS 7011

Looking like something out of a scientist's laboratory, Delvoye's *Cloaca Professional* turns food into excrement. Essentially a digestive system, the machine was developed after years of consultation with gastroenterologists and plumbing experts. This version was specially constructed for the quirky Museum of Old and New Art, where it is displayed alongside antiquities and modern art from the David Walsh collection.

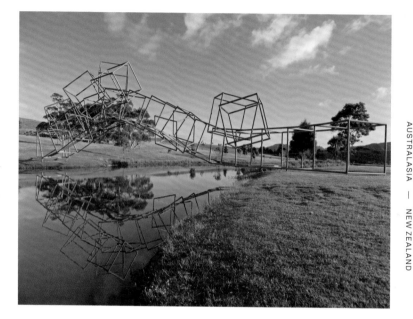

MARIJKE DE GOEY, THE MERMAID, 1999

A

Gibbs Farm, 2421 Kaipara Coast Highway, Makarau,
Kaipara Harbour 0984

De Goey's distinctive blue sculpture, made from twenty-two steel cubes,
stretches across an artificial lake in the expansive landscape of a remarkable
sculpture park. Gibbs Farm is home to New Zealand's largest collection of
permanent outdoor artworks and features monumental installations by artists,
including Richard Serra, Len Lye, and Anish Kapoor.

AUSTRALASIA — NEW ZEALAND

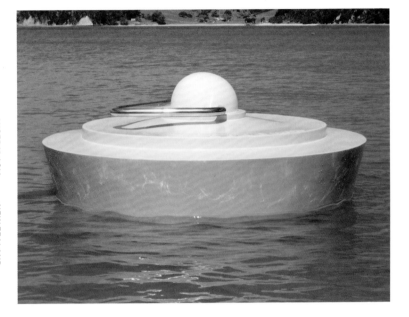

JULIA ORAM, BUNG, 2007

A

Connells Bay Sculpture Park, 142 Cowes Bay Road, Waiheke Island 1971

A giant bath plug floats in the open sea off the coast of New Zealand's Waiheke Island. Part of the Connells Bay Sculpture Park collection, Oram's humorous work prompts viewers to consider the serious subject of water conservation on an island reliant on tank water. It is one of more than thirty site-specific artworks by prominent New Zealand artists on view at the park.

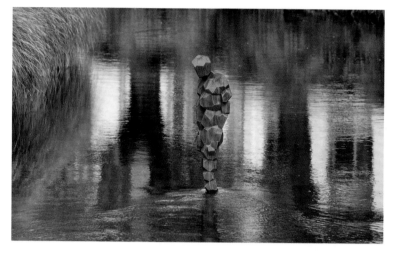

AUSTRALASIA — NEW ZEALAND

ANTONY GORMLEY, STAY, 2014

⬤

Avon River near the Gloucester Street Bridge, Christchurch 8011

Gormley created this cast-iron piece a few years after a severe earthquake struck Christchurch, in 2011. *Stay* consists of two identical downward-gazing figures, which share an air of inner reflection, perhaps like that of the city's community during rebuilding. One figure is in the Avon River, and the other is in the northern quadrangle of the city's Arts Centre.

43°31'48.8"S 172°38'01.6"E

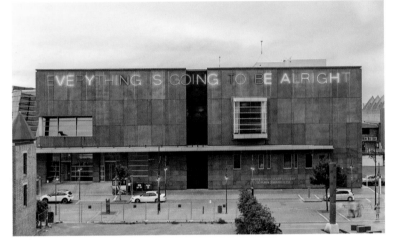

MARTIN CREED, WORK NO. 2314, 2015

Christchurch Art Gallery, Worcester Boulevard and Montreal Street,
Christchurch 8013

This neon piece by Creed has particular poignancy in Christchurch following
the devastation of the 2011 earthquake. The statement offers comfort and
reassurance, not least on account of its scale. Yet some have reflected on
the phrase as a platitude, suggesting it can also be read as "a reality check
on the glibness of public messages of aspiration."

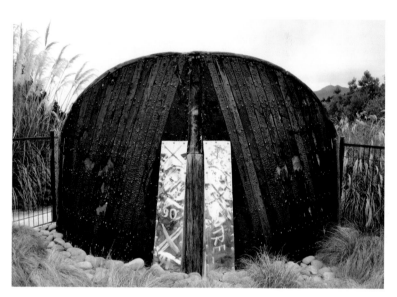

RALPH HOTERE, BLACK PHOENIX II, 1991

⬤

Hotere Garden Oputae, Flagstaff Lookout, Constitution Street,
Port Chalmers, Dunedin 9023

This sculpture was created from the stern of a burned-out boat. It sat outside
Hotere's Port Chalmers studio until the building was demolished in 1993. It now
resides at a nearby sculpture garden designed by the New Zealand artist.
Hotere donated four works to the site, which also includes sculptures by New
Zealand artists Chris Booth, Shona Rapira-Davies, and Russell Moses.

45°48'57.0"S 170°37'36.2"E

SOUTH ASIA

INDIA

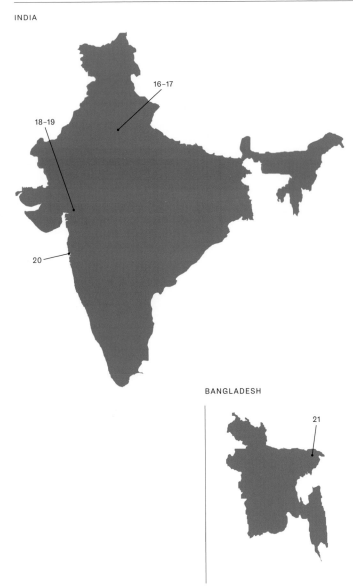

ASIA

BANGLADESH

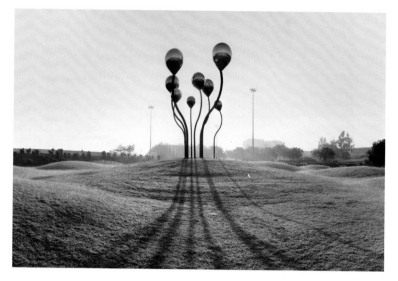

ASIA — INDIA

VIBHOR SOGANI, SPROUTS, 2008

○

Roundabout near All India Institute of Medical Sciences,
Sri Aurobindo Marg, New Delhi, Delhi 110023

Undulating steel bulbs, towering at 40 feet (12.2 m) in height, germinate in
clusters over a 6-acre (24,281 sq m) parkland traversed by a highway. Sogani
gave industrial materials the innocent appearance of plant life, signaling
the unstoppable force of growth, both in the biological and economic sense.
This monument of the New Delhi cityscape commemorates the nation's
unrelenting progress.

28°34'11.4"N 77°12'29.3"E

ASIA — INDIA

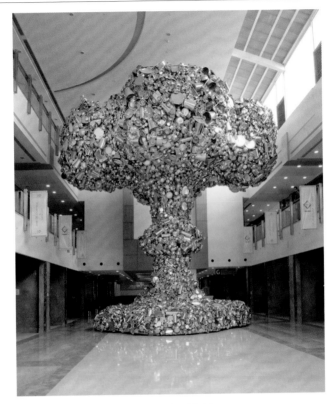

SUBODH GUPTA, LINE OF CONTROL, 2008

DLF South Court Mall, Saket District Centre, District Centre, Sector 6, Pushp Vihar, New Delhi, Delhi 110017

This colossal mushroom cloud weighs 26 tons (23.6 t) and is formed by over one thousand shiny cooking utensils. Located in a New Delhi shopping mall adjacent to the Kiran Nadar Museum of Art, Gupta's sculpture symbolizes the threat that nuclear weapons pose to daily life around the globe—a notion that is enhanced by the work's title, which refers to a military-enforced boundary within a disputed territory.

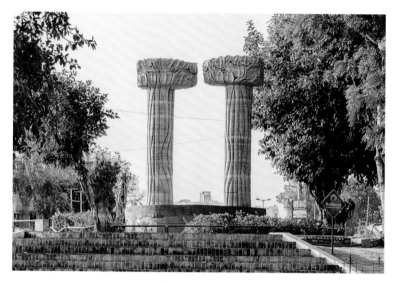

ASIA — INDIA

NAGJI PATEL, BANYAN TREE, 1992 ⬤

Chhani Jakat Naka Cir, Chhani Jakatnaka, Vadodara, Gujarat 391740

This imposing sculpture celebrates the banyan, the tree after which Vadodara is named (the plant is known locally as *vad*). Patel depicted two banyans with bees, birds, and monkeys, and he referenced traditional Indian architecture in his use of sandstone. In 2015 the sculpture was controversially relocated after its original site was redeveloped. Today it speaks to the city's heritage in the face of rapacious development.

22°20'41.3"N 73°10'33.5"E

ASIA — INDIA

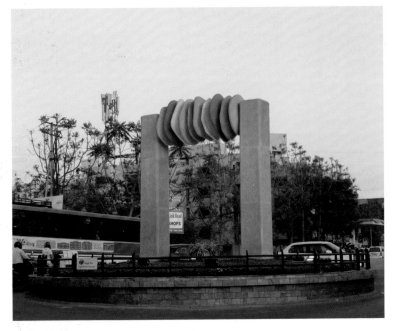

NAGJI PATEL, ABACUS, 2004

Sama-Savli Road, New Sama, Vadodara, Gujarat 391740

A simple counting device is made monumental in this 20-ton (18.1 t) sculpture. Towering over drivers entering and leaving the city, the large stone structure is made of two 14.8-foot-tall (4.5 m) uprights connected by colored marble discs. Patel chose the form of the abacus to represent the roots from which the revolution in computing and technology arose.

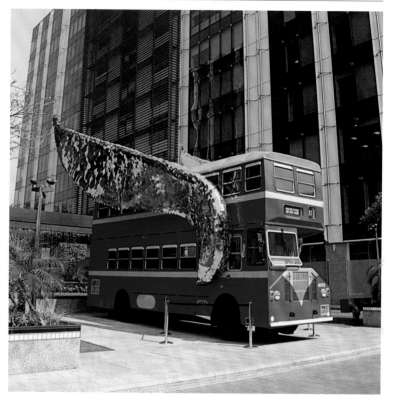

SUDARSHAN SHETTY, THE FLYING BUS, 2011

Maker Maxity, Bandra Kurla Complex, Bandra East, Mumbai,
Maharashtra 400051

Shetty transforms the iconic Mumbai double-decker bus into an artwork
and exhibition space. The 37-foot-long (11.3 m) replica is outfitted with a pair
of 34-foot-long (10.4 m) steel wings. The heroic-looking vehicle offers
a visual metaphor for the preservation and transformation of the indomitable
Indian city, where motorized double-decker buses have been operating since
the 1930s.

ASIA — BANGLADESH

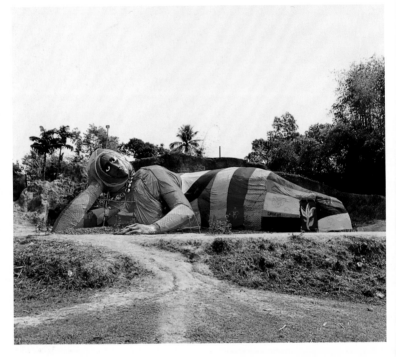

**PAWEŁ ALTHAMER, ROKEYA, A SCULPTURAL CONGRESS—
PAWEŁ ALTHAMER AND THE NEIGHBOURS, 2017**

A

Srihatta—Samdani Art Centre and Sculpture Park, Sylhet

This enormous reclining woman, constructed of woven palm leaves over
a bamboo frame, was the first sculpture commissioned for the Samdani Art
Centre and Sculpture Park. Althamer worked with drug rehabilitation
patients to realize this colorful piece, naming it after the Bengali pioneer
of women's education, Begum Rokeya. Future works for the park will also
involve the community in their creation.

SOUTHEAST ASIA

PHILIPPINES

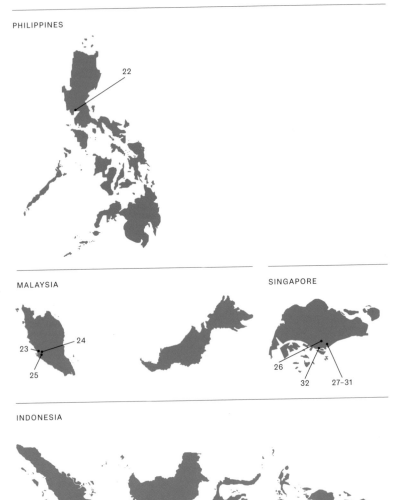

MALAYSIA

SINGAPORE

INDONESIA

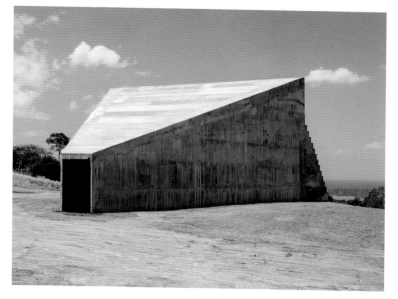

ASIA — PHILIPINES

NOT VITAL, CHAPEL, 2016

Bagac, Bataan, Philippines

The isolated farm area where Vital's minimalist structure is located is near the starting point of the Bataan Death March of 1942, during which many Filipino and American POW soldiers died. Despite this history and references to Christianity, the chapel is neither memorial nor church but part of a series of surrealist buildings by Vital meant for spiritual contemplation by all faiths.

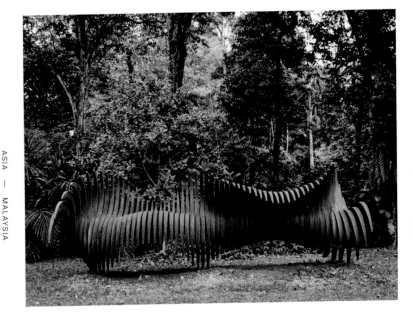

ABDUL MULTHALIB MUSA, SIXTY TURNS, 2009 **A**

Rimbun Dahan, Km. 27 Jalan Kuang, 48050 Kuang, Selangor

An architect by training, Multhalib Musa is known for creating sculptures informed by abstraction, geometry, design, and the mathematics of nature, in which a dynamic composition often counterbalances the density of the material. This piece was commissioned on the occasion of Rimbun Dahan co-founder Angela Hijjas's sixtieth birthday (hence the title) and reflects the artist's interest in a state between reality and imagination.

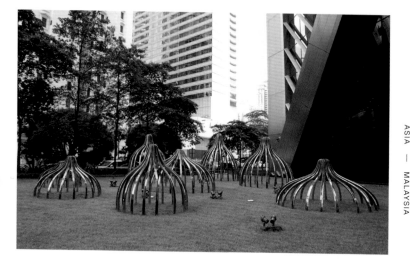

ASIA — MALAYSIA

PINAREE SANPITAK, BREAST STUPA TOPIARY, 2013

Ilham Tower, No. 8, Jalan Binjai, 50450 Kuala Lumpur

Both sensual and spiritual, Sanpitak's art focuses on female identity through a recurring breast motif that also echoes the shapes of a Buddhist stupa (shrine) and a monk's offering bowl. Sanpitak originally intended her sculptures to be displayed indoors, but she began exhibiting them outside to incorporate natural elements such as grass, flowers, and scents in the work.

ASIA — MALAYSIA

ABDUL MULTHALIB MUSA, ASCENSION, 2017 ⬤

Persiaran Sunsuria and Jalan Sunsuria, Sunsuria City,
Sepang, Selangor

The cascading, undulating forms and clean lines of this towering white
sculpture were generated using computer-aided design. The methods of
architecture are central to Multhalib Musa's work, which explores the complex
relationship between art and the built environment. Resembling a futuristic
pavilion, *Ascension* provides a landmark for this modern township.

KUMARI NAHAPPAN, NUTMEG AND MACE, 2009

ION Orchard Mall, 2 Orchard Turn, Singapore

During the nineteenth century, orchards and nutmeg plantations occupied the area where Singapore's busiest shopping district sits today. Once a highly valuable spice, the nutmeg seed—and the bright-red membrane that surrounds it, known as mace—was celebrated as the only tropical fruit with two flavors. Nahappan's bronze sculpture marks the nutmeg's history and its status as a traditional symbol of prosperity.

ASIA — SINGAPORE

ROY LICHTENSTEIN, SINGAPORE BRUSHSTROKE A–F, 1996 ⬤

Roy Lichtenstein Sculpture Plaza, Millenia Walk, 9 Raffles Boulevard, Singapore

The brushstroke is a recurring subject in Lichtenstein's work, in both paintings and sculptures—a reference to an elemental component of art and to the gestural strokes of abstract expressionist painting. The aluminum sculptures of *Singapore Brushtroke A–F* allude to Chinese calligraphy and interpretations of natural landscapes in reference to the history of the island nation of Singapore.

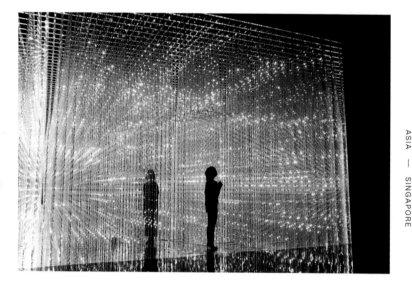

TEAMLAB, CRYSTAL UNIVERSE, FUTURE WORLD: WHERE ART MEETS SCIENCE, 2016

ArtScience Museum, 6 Bayfront Avenue, Singapore

Interdisciplinary art collective teamLab's immersive installation offers a magical universe that interweaves art, science, and technology. Visitors are encouraged to interact with fifteen digital environments, including *Crystal Universe*, that address teamLab's goals of exploring new relationships between humans and nature, and between oneself and the world. The environments perpetually transform as visitors engage with them.

ASIA — SINGAPORE

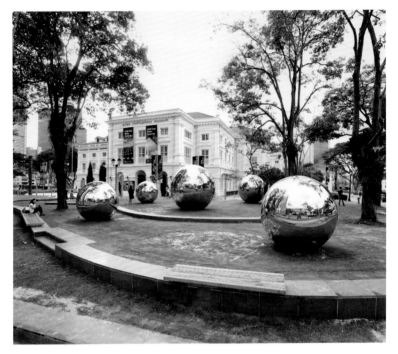

BAET YEOK KUAN, 24 HOURS IN SINGAPORE, 2015 ⭘

Asian Civilizations Museum, 1 Empress Place, Singapore

The five large stainless steel spheres of *24 Hours in Singapore* are audio
time capsules of Singapore. Visitors can listen to the sounds of traffic and
conversations recorded in 2015 at local wet markets and coffee shops
as a tribute to the rich heritage of daily life. This memorial is the country's
first long-term sound sculpture.

ASIA — SINGAPORE

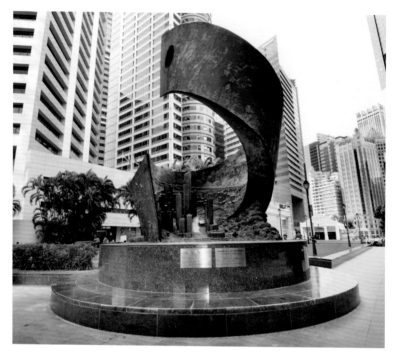

YUYU YANG, PROGRESS AND ADVANCEMENT, 1988

1 Raffles Place, Singapore

Combining both abstraction and realism, Yang presents the history of Singapore in this sculpture. Situated in the city-state's financial hub, the central spiraling form features a running narrative set in deep sculptural relief. The story chronicles the country's transition from a maritime trading hub into one of the world's most prosperous economies.

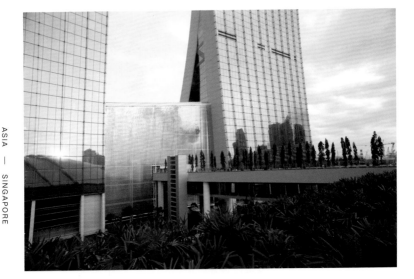

NED KAHN, WIND ARBOR, 2011

Marina Bay Sands Hotel, 10 Bayfront Avenue, Singapore

Kahn's installation on the facade of this hotel does double duty as artwork and environmentally conscious architectural element. Covering 4 vertical acres (16,187 sq m) around the lobby, it serves as a shade, filtering sunlight and heat. When wind moves across the surface, the nearly half a million individual components begin to undulate, reflecting light and adding levity to the building's surface.

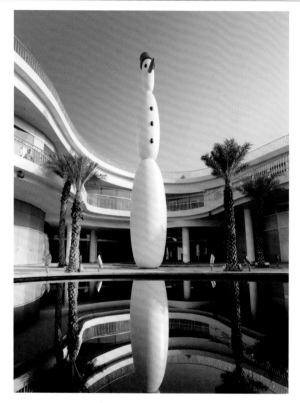

INGES IDEE, SNOWMAN / SNOWFLAKE, 2006

VivoCity, 1 HarbourFront Walk, Singapore

This elongated snowman towers over shoppers at the VivoCity mall in Singapore. An enlarged cluster of crystalline snowflakes sits on the roof nearby, another unfamiliar sight in this tropical climate, which has never had a snowfall. Such witty incongruities are typical of this German artist collective, which has been designing quirky public sculptures since the early 1990s.

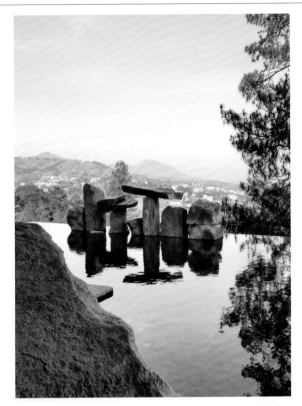

SUNARYO, WOT BATU, 2015

Wot Batu, Jl. Bukit Pakar Timur No. 98, Bandung

Inspired by the surrounding mountains, Wot Batu is the vision of Indonesian artist and sculptor Sunaryo. Within the space, carefully arranged stone sculptures of varying sizes integrate elements of earth, wind, fire, and water against sweeping views of Bandung. Some stones include incisions and inlays, which were intended as a twenty-first-century legacy for future generations to discover.

6°51'34.9"S 107°38'09.5"E

CHINA, SOUTH KOREA, JAPAN

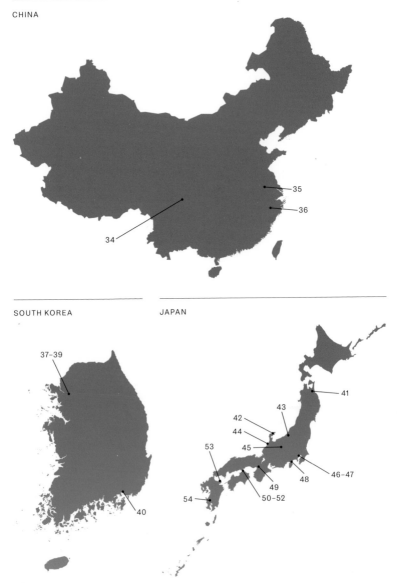

CHINA

ASIA

35

36

34

SOUTH KOREA

37–39

40

JAPAN

41

42

43

44

45

53

46–47

48

49

54

50–52

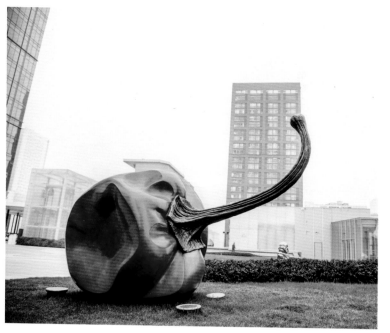

ASIA — CHINA

KUMARI NAHAPPAN, MALA, 2014

Chengdu International Finance Square, No. 1, Section 3, Hongxing Road, Jinjiang, Chengdu, Sichuan

Nahappan transforms a fiery local chili pepper into a monumental tribute to the food of China's Sichuan province. Located in the capital city of Chengdu, a 2011 UNESCO city of gastronomy, *Mala* uses bold color and monumental scale to signify the importance of local cuisine in shaping cultural identity.

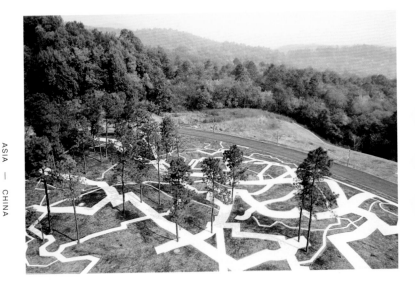

XU ZHEN, MOVEMENT FIELD, 2013 ●

Sifang Art Museum, No. 9 Zhenqi Road, Pukou District, Nanjing,
Jiangsu

The Steven Holl-designed Sifang Art Museum is located within Sifang
Parkland, a complex featuring commissioned works by artists and architects.
The museum hosts Xu's labyrinthine garden, whose entangled paths invite
viewers to embark on a revision of memories, uncertainties, and infinite
spiritual quests while paying homage to the beautifully preserved forest area.

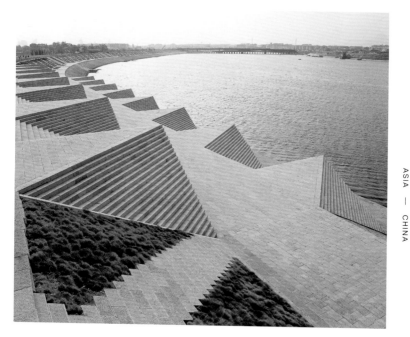

ASIA — CHINA

AI WEIWEI, YIWU RIVERBANK, 2003

Aiqing Road near Dayanhe Street, Jindong District, Jinhua, Zhejiang

Ai's striking granite structures have transformed a stretch of riverbank on the Yiwu River. The stark, angular architecture incorporates sloping terraces, promenades, and parks that offer spaces for contemplation while also providing stabilizing and flood protection to the local area. Nearby, the Ai Qing Cultural Park includes the artist's memorial to his father, the renowned Chinese poet Ai Qing.

29°06'05.7"N 119°41'48.3"E

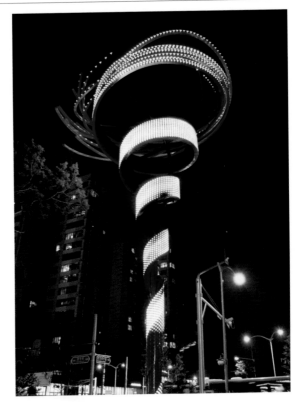

RON ARAD, VORTEXT, 2011

D-Cube City, Sindorim-dong, 692, Guro-gu, Seoul

A spiraling, ribbonlike form unfurls from a red steel column, fraying into thinner, swirling strands. The 55.8-foot-high (17 m) structure is animated by thousands of multicolored LEDs, which display a range of images and texts, from poetry to horoscopes. Arad, wanting to challenge the static nature of public art, designed the sculpture as an evolving carrier of content.

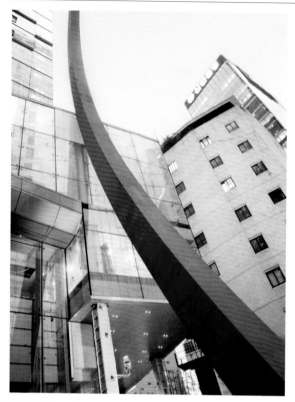

BERNAR VENET, 37.5° ARC, 2010

Ferrum Tower, Eulji-ro 5-gil, 19, Suha-dong, Jung-gu, Seoul

This 124.7-foot-tall (38 m) metal arc leans effortlessly against the gleaming headquarters of Dongkuk Steel. Made from Cor-Ten steel, the sculpture displays the familiar orange-brown patina associated with this versatile metal. The piece is typical of Venet's dynamic works, which explore the physical properties of steel and the relationship between artist and material.

ASIA — SOUTH KOREA

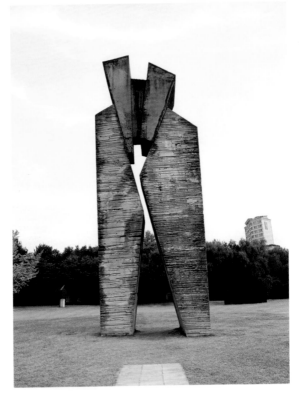

JOSEP M. SUBIRACHS, THE PILLARS OF HEAVEN, 1987

Olympic Park, Olympic-ro, 424, Songpa-gu, Seoul

This sculpture is one of two works Subirachs created for an outdoor sculpture exhibition held during the 1988 Summer Olympics in Seoul. Now incorporated into a grassland park at the Seoul Olympic Museum of Art, the work's brute concrete pillars evoke opposing yet complementary forces. The triangular iron piece straddling them is both a literal and a symbolic unifying element.

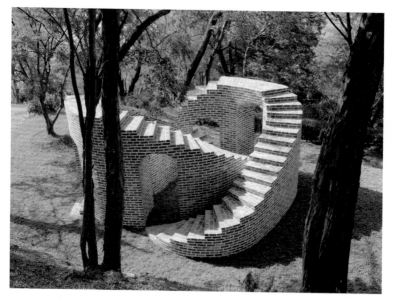

ASIA — SOUTH KOREA

MICHEL DE BROIN, INTERLACE, 2012

Masan Dotseom Marine Park, Dotseom Island, Masanhappo-gu, Changwon

Created for the 2012 sculpture biennial in Changwon, a location known in South Korea for its strong sculptural tradition, these two intertwined brick staircases exemplify de Broin's talent for transforming architectural features into seemingly movable, flexible objects. The spiraling stairs suggest constant movement, but the final destination is unclear—giving the work an existential overtone.

ASIA — JAPAN

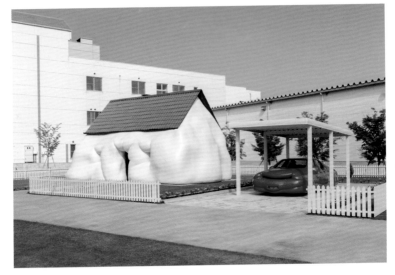

ERWIN WURM, FAT HOUSE, 2003

Art Square, Towada Art Center, 10-9 Nishi-Nibancho, Towada,
Aomori 034-0082

The walls of this suburban house are swollen and bulging like fatty flesh.
Intended as a criticism of consumer culture, Wurm's sculpture is displayed
alongside his *Fat Car* (2003) at the Towada Art Center in northern Japan.
The gallery maintains a permanent collection of commissioned artworks
by more than thirty artists, including Yoko Ono, Yayoi Kusama, Ron Mueck,
and Paul Morrison.

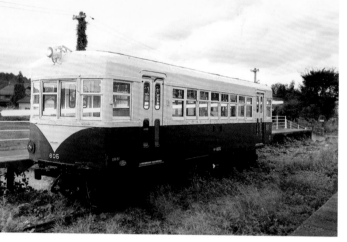

ASIA — JAPAN

ADEL ABDESSEMED, MA-MO-NAKU, 2017 ⬤

Former Ukai station, U-19 Hōryūmachi Ukai, Suzu-shi, Ishikawa
927-1222

The defunct Noto Line is the site of various art installations, including
Abdessemed's decommissioned train car at Ukai station. Unveiled during
the Oku-Noto Triennale, it features a protruding neon cylinder that illuminates
the car's interior at night. A train-crossing bell chimes at regular intervals.
The title originates from the word *mamonaku* (shortly), used to announce the
arrival of trains.

JAMES TURRELL, HOUSE OF LIGHT, 2000

2891 Uenokō, Tōkamachi, Niigata 948-0122

Modeled after a traditional Japanese-style house, this building is filled with Turrell's mesmerizing light installations. The centerpiece is an aperture in the bedroom ceiling, which frames the evening sky like a monochrome painting. The building, which can be rented as a guesthouse, is located in the Echigo-Tsumari Art Field, where more than 150 artworks are on display.

ASIA — JAPAN

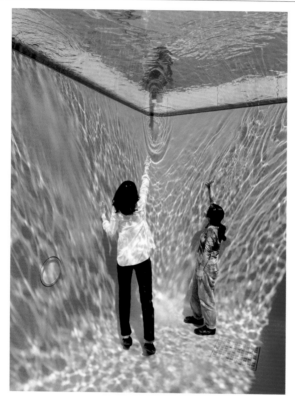

LEANDRO ERLICH, SWIMMING POOL, 1999/2004

21st Century Museum of Contemporary Art, 1-2-1 Hirosaka,
Kanazawa, Ishikawa 920-8509

Viewers looking into this pool may be shocked to see people walking beneath
its shimmering surface. Since the water is only 4 inches (10.2 cm) deep,
held between two glass sheets, the subterranean interior can easily be
explored without getting wet. Erlich's illusory pool belongs to a collection
of site-specific installations at the museum, by artists including Olafur
Eliasson, Pipilotti Rist, and Michael Lin.

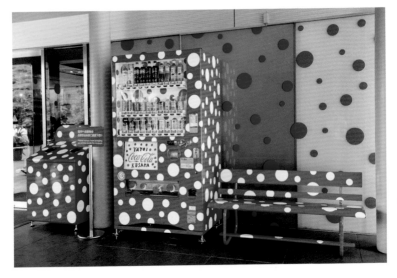

YAYOI KUSAMA, DOTS OBSESSION, 2012

Matsumoto City Museum of Art, 4-2-22 Chuo, Matsumoto,
Nagano 390-0811

This multipart piece is the result of a collaboration between Kusama and
the Coca-Cola Company. A functioning vending machine, a recycling bin,
and a bench decorated in the artist's trademark white polka dots on
a red background welcome visitors to the Matsumoto City Museum of Art.
Part practical object, part artwork, the piece invites interaction and fuses
art and functionality.

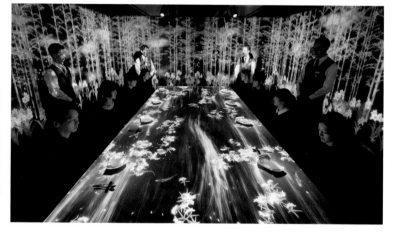

ASIA — JAPAN

TEAMLAB, WORLDS UNLEASHED AND THEN CONNECTING, 2015 ●

MoonFlower Sagaya Ginza, Puzzle Ginza, 6th Floor, 2-5-19 Ginza, Chuo, Tokyo 104-0061

teamLab's immersive digital installation enhances the sensory experience of a meal at the restaurant Sagaya Ginza. Projections of natural landscapes, triggered by the dish being served, unfold around the room. The worlds unleashed from the dishes on the table influence one another, react to the actions of guests, and combine to create one single, continuous world that is constantly changing from moment to moment, with no two moments the same.

ASIA — JAPAN

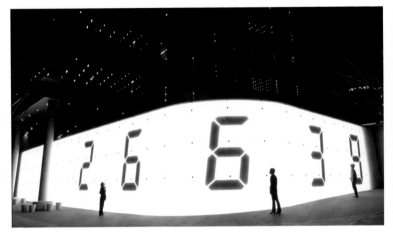

TATSUO MIYAJIMA, COUNTER VOID, 2003

TV Asahi Building, 6-9-1 Roppongi, Minato, Tokyo 106-8001

This austere light installation comprises six digital counters marking time at different speeds. The countdown runs from 9 to 1—Miyajima does not use a zero since it contradicts his emphasis on the dynamic energy and permanence of human life. The piece was commissioned for TV Asahi's headquarters in Tokyo's Roppongi Hills complex, where works by more than twenty international artists and designers are on public display.

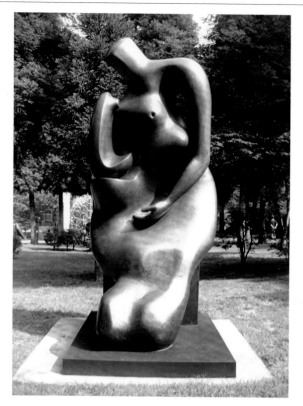

HENRY MOORE, MOTHER AND CHILD: BLOCK SEAT, 1983–84

Hakone Open-Air Museum, 1121 Ninotaira, Hakone-machi,
Ashigarashimo-gun, Kanagawa 250-0407

Eleven works by Moore are displayed at the Hakone Open-Air Museum,
including this large mother-and-child bronze. The artist revisited this
subject many times, considering it a universal theme with endless sculptural
possibilities. More than one hundred sculptures by international artists can
be found at this huge sculpture park, including a large Picasso collection.

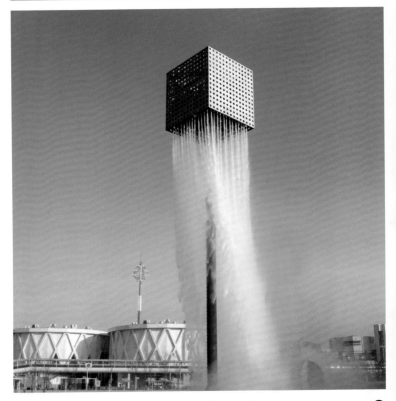

ISAMU NOGUCHI, EXPO '70 FOUNTAINS, 1970

Expo '70 Commemorative Park, Suita, Osaka 565-0826

ASIA — JAPAN

The 1970 World Expo in Osaka was a vibrant celebration of fantastical architecture. Noguchi's nine fountains, which include a floating cube and two intersecting disks spraying water, integrate sound and light into their liquid theater. They are sited on three artificial lakes created by the architect Kenzo Tange in the main festival venue (now Expo '70 Commemorative Park).

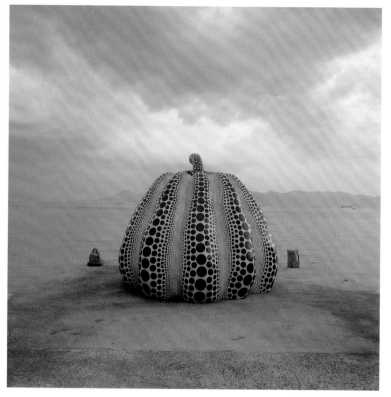

ASIA — JAPAN

YAYOI KUSAMA, PUMPKIN, 1994

Benesse Art Site Naoshima, Benesse House Museum Outdoor Works,
Gotanji, Naoshima, Kagawa 761-3110

Kusama's yellow gourd on a pier on Naoshima island welcomes visitors
to Benesse Art Site Naoshima, an art and architecture destination. Among
the many art sites to enjoy are the Chichu Art Museum—where Claude
Monet's *Water Lilies* and installations by James Turrell and Walter De Maria
are on view—and the Benesse House, both designed by Tadao Ando.

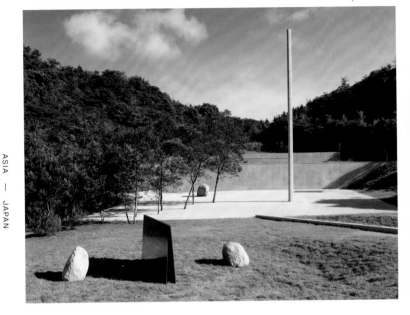

LEE UFAN MUSEUM, 2010

Benesse Art Site Naoshima, Lee Ufan Museum, 1390 Azakuraura, Naoshima, Kagawa 761-3110

Ufan collaborated with architect Tadao Ando to create this museum dedicated to his art. Set in a valley surrounded by hills, the semiunderground building houses examples of his paintings and sculptures from the 1970s to the present. The tranquil museum, where art and architecture are in complete harmony, provides a meditative environment to enjoy the Korean artist's influential works.

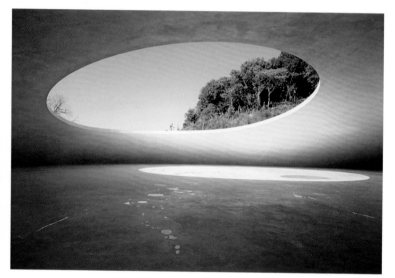

ASIA — JAPAN

REI NAITO, MATRIX, 2010 ●

Benesse Art Site Naoshima, Teshima Art Museum, 607 Karato,
Teshima, Tonosho-cho, Shozu-gun, Kagawa 761-4662

Naito's *Matrix* is the sole artwork in the Teshima Art Museum, which was
specifically designed to house it. Resulting from a six-year collaboration with
architect Ryue Nishizawa, the building resembles the shape of a water droplet.
Water seeping up from the ground dances across the space and forms small
pools on the concrete floor, as winds and sounds from outside blow through
the structure's openings.

34°29'22.4"N 134°05'28.0"E

TATSUO MIYAJIMA, HUNDRED LIFE HOUSES, 2014

1140-4 Joubutsu, Kunisaki-machi, Kunisaki-shi, Oita 873-0535

This installation originated as a site-specific project for the 2014 Kunisaki Art Festival, held in a mountainous peninsula revered for its syncretic traditions of Shinto and Buddhism. Miyajima invited various collaborators to design small concrete shelters to house LED counters, a stark symbol of life in the artist's work since 1988. Participants set the speed of the counters, resulting in variance from one to another.

33°35'12.8"N 131°36'57.0"E

PHILLIP KING, SUN ROOTS, 1999

Kirishima Open-Air Museum, 6340-220 Koba, Yūsui, Aira,
Kagoshima 899-6201

Located amid woodlands at the foot of a mountain, Kirishima Open-Air
Museum hosts more than twenty permanent artworks by Yayoi Kusama,
Tsubaki Noboru, Antony Gormley, and others. The national flag of Japan
is evoked by King's striking red sculpture, the abstract forms of which
are inspired by the Shinto sun goddess Amaterasu.

31°56'19.6"N 130°46'45.2"E

NORWAY, SWEDEN, FINLAND, DENMARK, ICELAND

NORWAY

SWEDEN

FINLAND

DENMARK

ICELAND

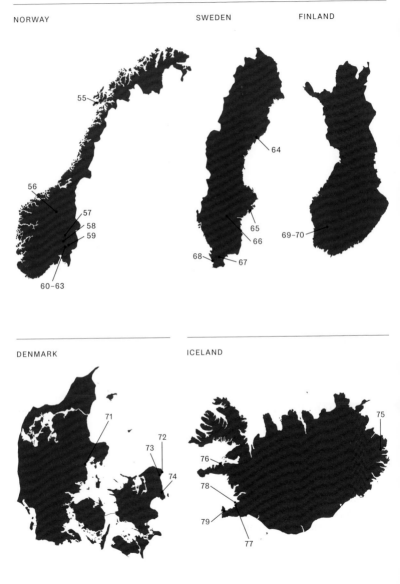

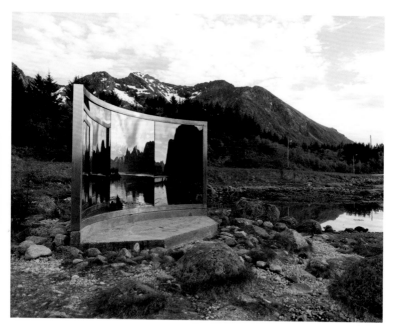

DAN GRAHAM, UNTITLED, 1996

Kleppstad, Vågan, Nordland

A stunning fjord is reflected and distorted by Graham's large, curved sculpture. Installed at the water's edge, its glass is simultaneously translucent and reflective, allowing viewers to see the landscape both in front of and behind it. Alluding to Romantic paintings of the 1800s, the sculpture heightens viewers' experiences of the spectacular Norwegian landscape, offering a sublime visual experience.

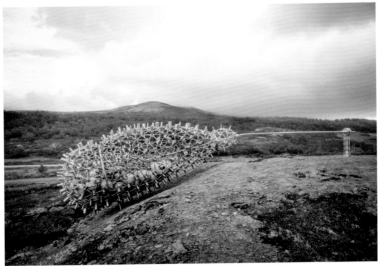

PER INGE BJØRLO, MENTAL GENE BANK, 2016 ⬤

Hjerkinn, Dovre, Oppland

The mind is a frequent subject of Bjørlo's artworks. This stainless steel
sculpture, which features spheres inside an exterior mesh of tubes, is
a representation of mental space: everyone has thoughts that they keep to
themselves. The piece was created as part of the Skulpturstopp project,
which invites artists to select sites in eastern Norway to display their works.

EUROPE — NORWAY

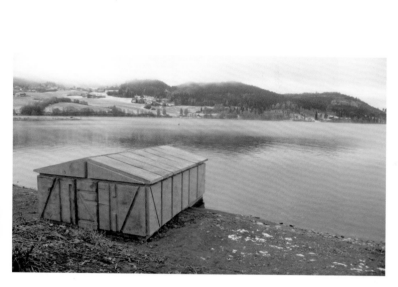

RACHEL WHITEREAD, THE GRAN BOATHOUSE, 2010 ○

Røykenvik, Gran, Oppland

On the edge of this remote fjord stands what appears to be a wooden cabin. Closer inspection reveals that it is made entirely from concrete; furthermore, it is inside out. To create this sculpture, Whiteread cast the interior space of an old 1960s boathouse. Many such structures once resided here, and this peaceful work preserves the site's history.

60°25'48.9"N 10°28'14.8"E

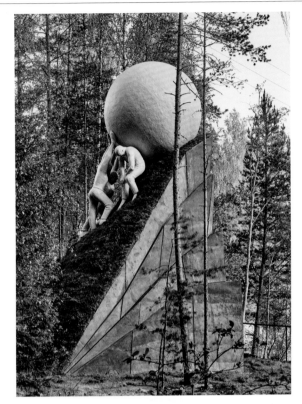

ILYA AND EMILIA KABAKOV, THE BALL, 2017

Kistefos-Museet, Samsmoveien 41, 3520 Jevnaker

Sisyphus of Greek mythology was condemned to push a giant rock up a hill for eternity. The Kabakovs reimagined the ancient tale by depicting the protagonist with helpers, emphasizing the value of collective effort over solitary struggle. The artwork is installed at Kistefos-Museet, Scandinavia's largest sculpture park.

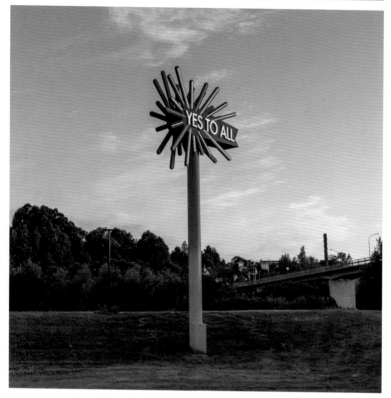

EUROPE — NORWAY

SYLVIE FLEURY, YES TO ALL, 2016

Dampsagveien, near Lillestrøm station, 2004 Lillestrøm

Lines of colored neon radiate from the center of this commercial-looking sign, whose bright white letters display the text "Yes to All." Deliberately ambiguous, Fleury's message invites multiple interpretations. But the phrase might be familiar to computer users since it is regularly displayed by the Windows operating system. Taken out of context, the words become subject to new meanings.

JIM DINE, THE ABDUCTION, 2006

Peer Gynt Sculpture Park, near Peter Møllers vei and Lørenveien,
0585 Oslo

This work by Dine is one of the sculpture park's twenty pieces, by various artists, that all illustrate moments from *Peer Gynt* (1867), a play by the Norwegian dramatist Henrik Ibsen in which a lazy, boastful young man abducts a bride from her wedding. Dine used an ape and Barbie as stand-ins for characters from the play.

EUROPE — NORWAY

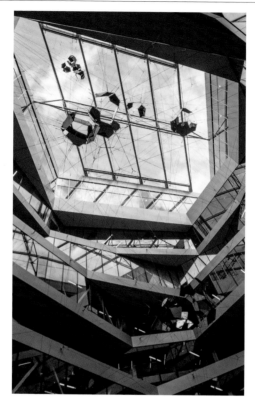

TOMÁS SARACENO, SUNDIAL FOR SPATIAL ECHOES, 2015

Stranden 1, Aker Brygge, 0250 Oslo

Clusters of interconnected polyhedra hang from the roof of this cavernous indoor courtyard. Appearing like droplets of rain clinging to a spider's web, the mirrored forms reflect the surrounding architecture as well as the people far below. Saraceno's installation is intended as a proposal for what he calls *Cloud Cities*, utopian aerial communities that offer alternative, sustainable models of living.

EUROPE — NORWAY

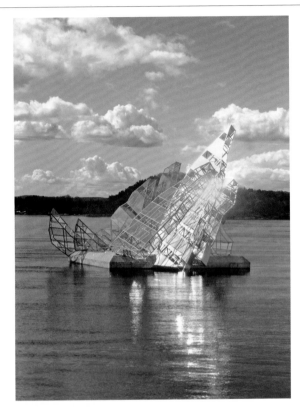

MONICA BONVICINI, SHE LIES, 2010

Oslofjord, near Norwegian Opera and Ballet, Bjørvika, Oslo

Bonvicini's floating stainless steel and glass sculpture turns on its axis according to the tide, and the sunlight reflects off the mirrored surface, suggesting a state of perpetual change. A 3-D representation of Caspar David Friedrich's *Das Eismeer* [The Sea of Ice] (1823–24), a shipwreck, Bonvicini's sculpture, created for Oslo, presents the pile of ice as a symbol of power.

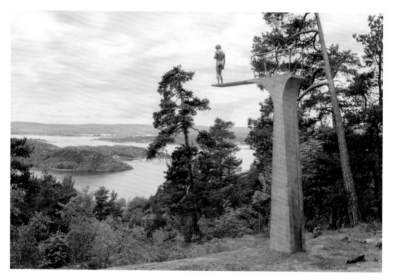

EUROPE — NORWAY

ELMGREEN & DRAGSET, DILEMMA, 2017

Ekebergparken, Kongsveien 23, 0193 Oslo

An apprehensive boy stands at the edge of a towering diving board. This Scandinavian artist duo describes the sculpture as a metaphor for adolescence and entering the world of adult responsibilities. The site-specific work belongs to the ever-growing collection at Ekebergparken, where contemporary and modern artworks are displayed within the stunning wooded landscape.

59°53'54.4"N 10°45'35.1"E

EUROPE — SWEDEN

MIROSLAW BALKA, CONCRETE AND LEAVES, 1996 ⬤

Umedalens Skulpturpark, Umedalen, 903 64 Umeå

Typical of Balka's works, this piece draws from autobiographical details: the shape of one of the concrete structures is based on his body's dimensions, and the shape of the other is based the floor plan of his childhood home. Prominent artists, including Antony Gormley, Cristina Iglesias, and Louise Bourgeois, have contributed to the forty-four-piece permanent collection of this sculpture park.

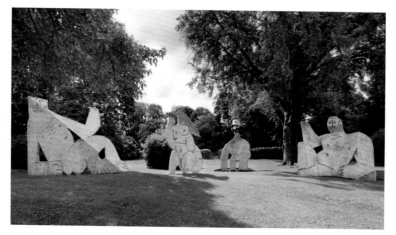

PABLO PICASSO, DEJEUNER SUR L'HERBE [LUNCHEON ON THE GRASS], 1962

Moderna Museet, Skeppsholmen, 111 49 Stockholm

This tableau of concrete sculptures in the sculpture garden of Moderna Museet reinterprets Édouard Manet's famous painting *Le déjeuner sur l'herbe* (1863), in which the men are clothed and the women are naked. In Picasso's work, all the figures are nude. The light, sketchy style contrasts with the weight and durability of the concrete slabs.

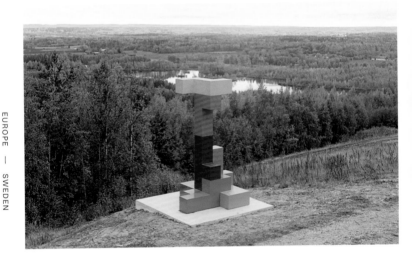

JACOB DAHLGREN, TETRIS, 2017

Konst på Hög, Kvarntorpshögen, 692 92 Kumla

From Konst på Hög, a sculpture park atop a hill, visitors can see art and
enjoy sweeping views of the landscape below. About thirty works are on
display, including the painted steel sculpture *Tetris*, by Dahlgren, a Swedish
artist who is known for his use of vibrant colors. The piece appears as
a 3-D interpretation of the famed video game.

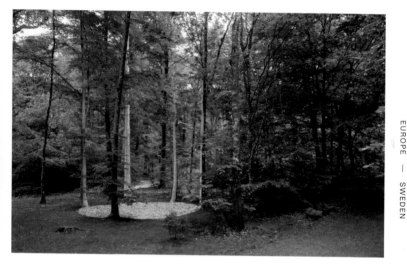

EUROPE — SWEDEN

MALIN HOLMBERG, I WILL STOP LOVING YOU, 2010 ●

Wanås Konst, Hässleholmsvägen, Wanås, 289 90 Knislinge

A circle of trees and the ground between them are painted yellow. Influenced by the brutal history of the surrounding woods—according to legend, seventeenth-century rebel fighters were once put to death there—Holmberg created a peaceful meeting place. It is one of over seventy permanent works at the sculpture park Wanås Konst, situated in the woods and grounds of Wanås Castle.

56°11'14.4"N 14°02'55.1"E

EUROPE — SWEDEN

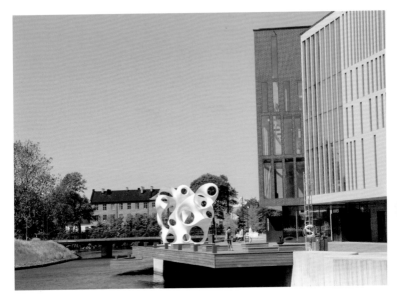

EVA HILD, RUBATO, 2015

Malmö Live, Dag Hammarskjölds Torg 4, Malmö

The swirling forms of this large white sculpture, located outside Malmö
Live Concert Hall, create a sense of movement frozen in time. The organic
curves and flowing lines are derived from the delicate ceramic sculptures
for which Hild is best known. Made with painted aluminum, the striking
waterside structure appears fragile. Its undulating shapes and spaces blur the
distinctions between interior and exterior spaces.

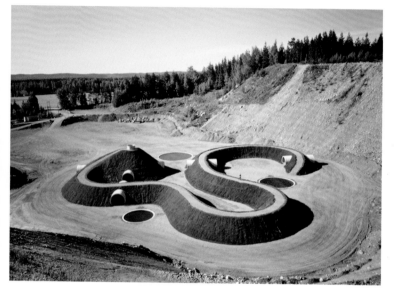

EUROPE — FINLAND

NANCY HOLT, UP AND UNDER, 1987–98

Sasintie 555, 39150 Pinsiö

O

This 630-foot-long (192 m) work of Land Art consists of aboveground tunnels located on the site of a former quarry. Holt designed the project to be seen and experienced by visitors from every possible vantage point—with reflection pools, viewing mounds, and entryways and holes for exploring the winding tunnels.

61°34'28.5"N 23°26'05.8"E 85

EUROPE — FINLAND

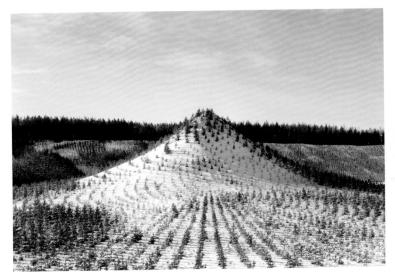

AGNES DENES, TREE MOUNTAIN—A LIVING TIME CAPSULE— 11,000 TREES, 11,000 PEOPLE, 400 YEARS, 1992-96

Pinsiönkankaantie 10, 39150 Pinsiö

This work comprises a massive man-made mountain measuring almost 125 feet (38 m) high. Eleven thousand trees were planted individually by eleven thousand people from all over the world and arranged on the mountain in an elliptical pattern directed by Denes. The trees will benefit future generations and offer a living example of the effects of time on a work of art.

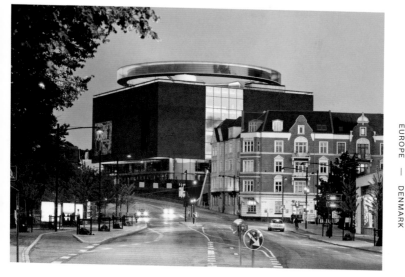

OLAFUR ELIASSON, YOUR RAINBOW PANORAMA, 2011

ARoS Aarhus Art Museum, Aros Allé 2, 8000 Aarhus

Crowning the ARoS Aarhus Art Museum building, this rainbow-colored walkway blurs the distinction between architecture and artwork. Mounted 164 feet (50 m) above street level, the large circular structure provides panoramic views of Aarhus, while its tinted glass divides the city, to the viewer inside, into different-colored zones. The chromatic installation is a distinctive landmark, especially at night, when it is illuminated.

56°09'13.9"N 10°11'58.5"E

EUROPE — DENMARK

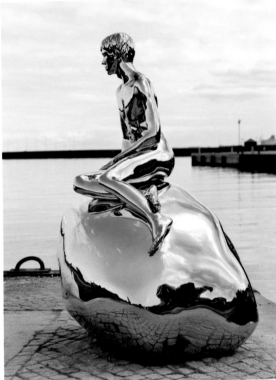

ELMGREEN & DRAGSET, HAN, 2012

Pier near Allegade 2, 3000 Helsingør

This gleaming sculpture perches on the waterfront at Helsingør harbor. The boy's pose recalls Edvard Eriksen's *Little Mermaid* statue in Copenhagen (1913), although unlike that famous bronze, Elmgreen & Dragset's sculpture is made of polished steel. The highly mirrored surface reflects and distorts its surroundings, and an internal hydraulic system briefly shuts the boy's eyes every half hour.

56°02'14.7"N 12°36'56.7"E

MAX ERNST, THE LARGE TORTOISE; THE LARGE ASSISTANT (THE LARGE FROG); THE LARGE GENIUS (THE LARGE ASSISTANT), ALL 1967/76

Louisiana Museum of Modern Art, Gl. Strandvej 13, 3050 Humlebæk

These three sculptures are examples of Ernst's later works and the vast array of influences visible in his art. Here, Ernst combined the Dadaist humor from his early years in Cologne, in the early twentieth century, with the love for craft he learned from Alberto Giacometti in the 1930s and the anthropomorphic totemic figures he saw in the American desert in the 1940s and '50s.

EUROPE — DENMARK

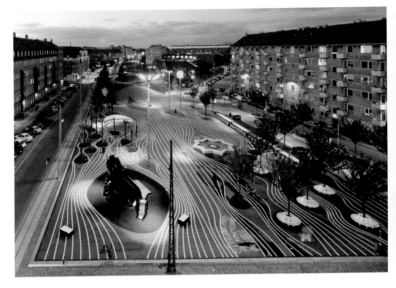

SUPERFLEX, SUPERKILEN, 2011 ○

Superkilen Park, Nørrebroruten between Nørrebrogade
and Tagensvej, Nørrebro, 2200 Copenhagen

Superkilen is a vast urban park project conceived by the Danish experimental
art collective Superflex. Designed according to Superflex's notion of "extreme
participation," the park offers three distinct and purpose-built areas of public
space for Copenhagen residents: a traditional park square, an outdoor venue
for cafés and music, and another area for sports, picnicking, and dog walking.

55°41'57.0"N 12°32'30.8"E

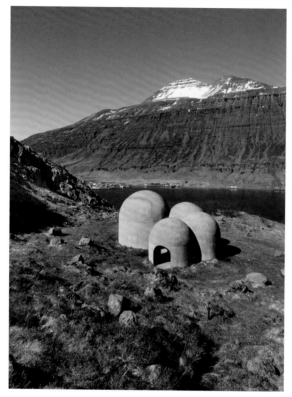

EUROPE — ICELAND

LUKAS KÜHNE, TVISÖNGUR, 2012

Mountainside above the town of Seyðisfjörður

This site-specific sound sculpture features five interconnected concrete
structures within an area of about 323 square feet (30 sq m). Kühne installed
the work on a secluded site in the Icelandic mountainside overlooking a fjord.
Visitors are encouraged to sing and make sounds inside the hollow domes, which
amplify tones within the traditional Icelandic five-tone harmony scale.

65°16'04.1"N 13°58'55.9"W

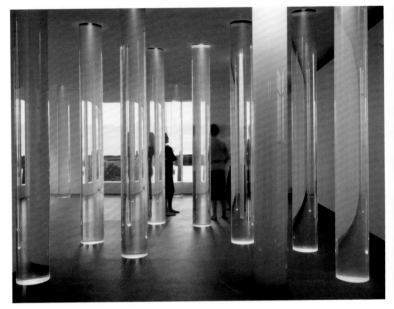

EUROPE — ICELAND

RONI HORN, LIBRARY OF WATER, 2007 ●

Bókhlöðustígur 19, Stykkishólmur

For this installation, Horn transformed a former library building located
on a hill in the coastal town of Stykkishólmur. The artist's unconventional
library features glass displays of water from different glacial sources in
Iceland, archived as if in a library. The space can also be used for community
gatherings and reflection.

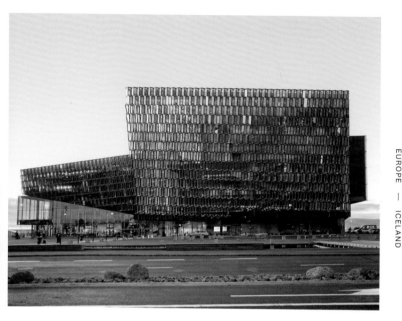

EUROPE — ICELAND

OLAFUR ELIASSON, FACADE FOR HARPA REYKJAVÍK CONCERT HALL AND CONFERENCE CENTRE, 2008–11

Harpa Concert Hall and Conference Centre, Austurbakki 2, Reykjavík

Designed to evoke Iceland's crystalline basalt columns, this building's south facade employs a modular component called a "quasi brick," a polyhedron that is partly irregular, creating a slightly chaotic appearance. The glass in the modules appears to shift color, depending on how light hits it. Eliasson's studio created the design, in collaboration with the architecture firm Henning Larsen.

64°09'00.4"N 21°55'58.4"W

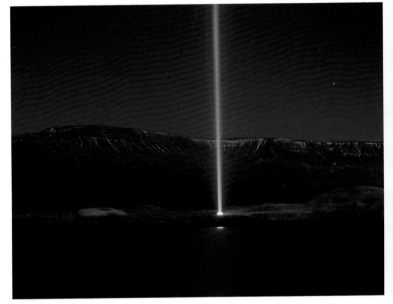

YOKO ONO, IMAGINE PEACE TOWER, 2007

Viðey Island, Kollafjörður Bay, Reykjavík

Imagine Peace Tower is a tribute to John Lennon by Ono, his widow. The stone base of the monument, conceived like a wishing well, is inscribed with the words "imagine peace" in twenty-four languages. The base projects a vertical light beam of searchlights and mirrored prisms that is visible up to 2.5 miles (4 km) in the sky.

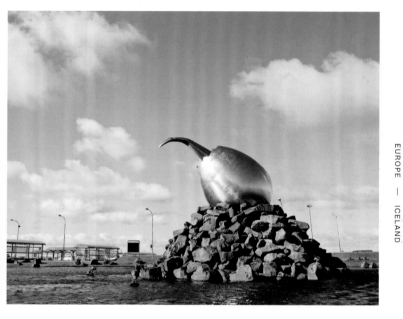

MAGNÚS TÓMASSON, THE JET NEST, 1989-90

Keflavík International Airport, Keflavík

The Jet Nest, one of several public artworks commissioned for the central airport in Reykjavík, represents a steel egg on top of a mound of Icelandic boulders. The sculpture is massive, with the egg itself measuring more than 16 feet (5 m) high and weighing 6.6 tons (6 t). The egg appears to be hatching, revealing an airplane jet wing.

UNITED KINGDOM

SCOTLAND

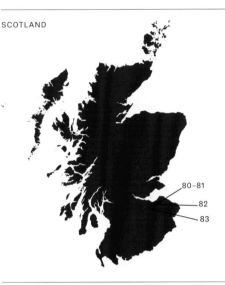

80–81
82
83

ENGLAND

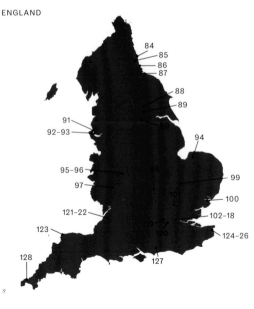

84
85
86
87
88
89
91
92–93
90
94
95–96
97
98
99
101
100
121–22
102–18
123
09
120
124–26
128
127

NORTHERN IRELAND

129

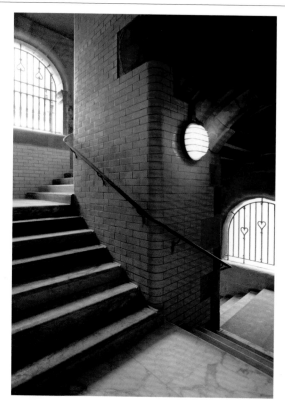

MARTIN CREED, WORK NO. 1059, THE SCOTSMAN STEPS, 2011

Entry at the Scotsman Hotel or Market Street under the North Bridge, Edinburgh EH1 1SB

When invited to create a public artwork on the Scotsman Steps, a well-known enclosed staircase that links Old Town and New Town in Edinburgh, Creed repaved the stairs with 104 kinds of marble. He likened the experience of stepping on the many unique slabs of marble to the diversity experienced when walking through the world.

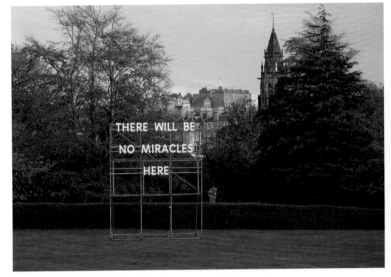

NATHAN COLEY, THERE WILL BE NO MIRACLES HERE, 2006 ●

Scottish National Gallery of Modern Art, 75 Belford Road, Edinburgh
EH4 3DR

Coley is interested in investing public spaces with new meaning. This light
sculpture, which depicts a sentence prohibiting divine intervention, hangs
from a nearly 20-foot-high (6 m) scaffolding. Sited in the landscaped grounds
of the Scottish National Gallery of Modern Art, it is ambiguous whether
here refers to within the museum, the wider city that lies beyond, or anywhere
on Earth.

JIM LAMBIE, A FOREST, 2010

Jupiter Artland, Bonnington House Steadings, Wilkieston, Edinburgh
EH27 8BY

One of over thirty outdoor artworks at Jupiter Artland sculpture park, Lambie's
installation appears to merge art and nature. Mirrors cover a building's
external walls and reflect the surrounding forest, which from a distance make
the walls seem to evaporate into the landscape. The intentional peeling
of the mirror-panels' edges, marked with bright colors not found in nature,
reveals the artifice.

55°54'26.4"N 3°25'20.2"W

EUROPE — SCOTLAND

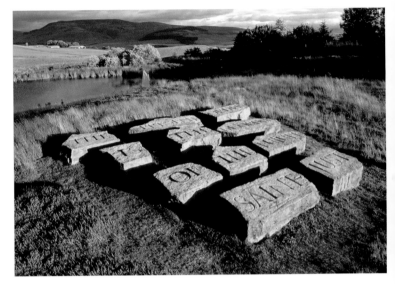

IAN HAMILTON FINLAY, THE PRESENT ORDER, 1983

Stonypath, Dunsyre, South Lanarkshire ML11 8NG

A poet turned artist and self-described avant-gardener, Finlay believed that nature is cultivatable yet indomitable, an understanding that informs his best-known work, *Little Sparta*. The sculpture garden, designed and cultivated in collaboration with his wife, Sue, is home to over 275 of Finlay's works in stone, wood, and metal—"poem-objects," as he described them, that blend into the landscape rather than dominate it.

EUROPE — ENGLAND

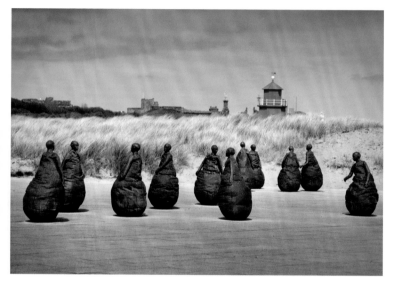

JUAN MUÑOZ, CONVERSATION PIECE, 1999

Littlehaven Beach, South Shields NE33 1LH

Twenty-two enigmatic bronze figures are arranged in small, scattered groups. Although the installation is inspired by eighteenth-century paintings of convivial social gatherings, the relationship between these bulbous figures is ambiguous: their mouths remain sealed, and while some look at one another, others seem detached. Muñoz made many of these conversation tableaus, which address issues of alienation and communication breakdown.

EUROPE — ENGLAND

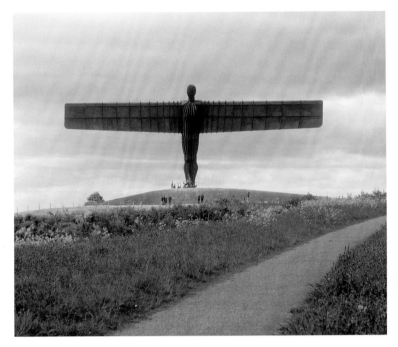

ANTONY GORMLEY, ANGEL OF THE NORTH, 1998 ⬤

Durham Road, Low Eighton, Gateshead NE9 7TY

Gormley's monumental sculpture of an angel stands on a site that was once a coal mine. The angel's wings—measuring 177 feet (54 m) across—are angled slightly forward, to subtly suggest the sense of an embrace. Its face lacks features, in a nod to timelessness and to celebrate the many individuals who once worked on this site.

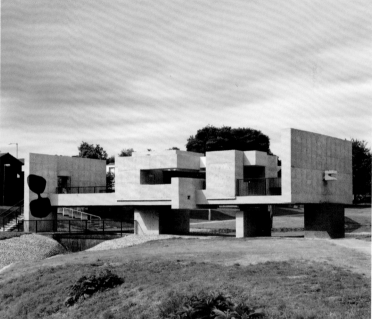

VICTOR PASMORE, APOLLO PAVILION, 1969

⭕

Oakerside Drive, Peterlee, County Durham R8 1LE

This modernist pavilion, named for the Apollo Space Program, is the centerpiece of Peterlee, a small English town founded in 1948. The large concrete planes of the striking structure, which spans a small lake, also provide a walkway for local residents. After languishing in disrepair for many years, the pavilion was eventually restored, and in 2011 it received protected status.

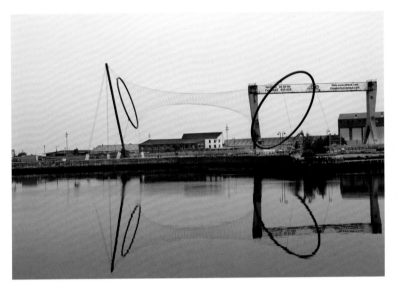

ANISH KAPOOR, TEMENOS, 2010

Middlehaven Dock, between Transporter Bridge and Riverside Stadium, Middlesbrough TS3 6RS

This site at Middlehaven Dock demanded an artwork of sweeping scale. Collaborating with engineer Cecil Balmond, Kapoor created this colossal yet ethereal-looking steel sculpture, which stands about 360 feet (110 m) long and 164 feet (50 m) high. The cable mesh is tensioned, like in a bridge.

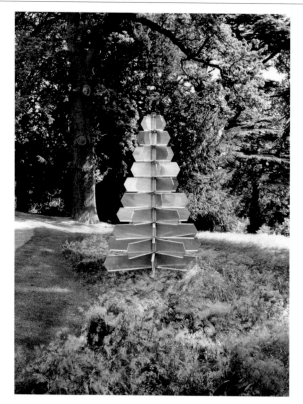

EUROPE — ENGLAND

LEO FITZMAURICE, WHATUSEISASIGNIFWEKNOWTHEWAY, 2005

Harewood House, Harewood, Leeds LS17 9LG

Fitzmaurice's treelike sculptures purport to be signposts, but closer inspection reveals them to be devoid of text. Commissioned especially for Harewood's permanent collection, this work distorts the idea of an everyday object to challenge viewers' assumptions. The blank metal signs point in all directions, suggesting many possible routes through the leafy West Garden, even though the adjacent footpath suggests otherwise.

EUROPE — ENGLAND

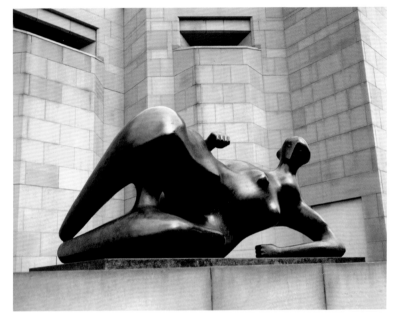

HENRY MOORE, RECLINING WOMAN: ELBOW, 1981 ⭕

Leeds Art Gallery, The Headrow, Leeds LS1 3AA

Rendered in Moore's characteristic style of organic abstraction, the curvaceous body and emotionless face of this provocative lounging woman combine to project stoicism mixed with sensuality. Installed in 1982 by the artist himself outside the Leeds Art Gallery in his native Yorkshire, today it contributes to a citywide art trail stretching from the University of Leeds to the Henry Moore Institute.

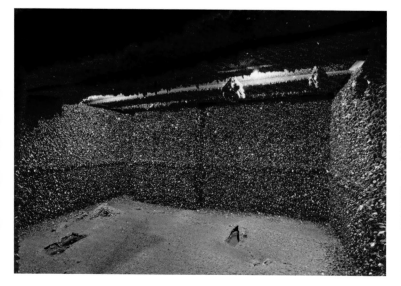

EUROPE — ENGLAND

ROGER HIORNS, SEIZURE, 2008

●

Yorkshire Sculpture Park, West Bretton, Wakefield WF4 4LG

The sharp blue crystals of this installation evoke the contrasting sensations of aggression and attraction, pain and beauty. Hiorns originally created the piece by filling an abandoned council flat in London with copper sulfate. After the building was demolished, the piece found a new home in Yorkshire Sculpture Park, where it is displayed inside a building designed by architect Adam Kahn.

EUROPE — ENGLAND

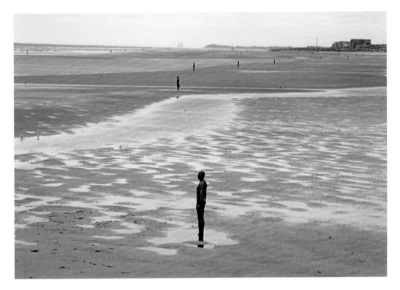

ANTONY GORMLEY, ANOTHER PLACE, 1997

Crosby Beach, Crosby, Merseyside L23 6XW

One hundred life-size, cast-iron figures stand on this beach, stretching almost 0.62 miles (1 km) out to sea. Each sculpture is cast from Gormley's own body. Standing upright and facing the water, the figures hold a variety of postures, from relaxed to tense. The installation, like many of the artist's works, speaks to the individual's place in the world and to humanity's relationship to nature.

53°28'39.9"N 3°02'34.1"W

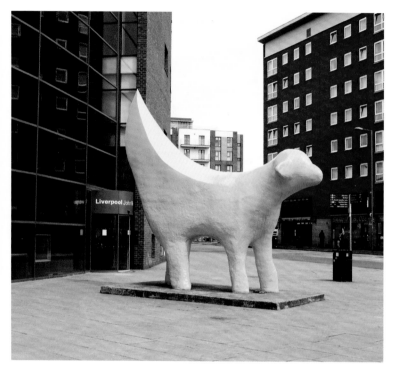

EUROPE — ENGLAND

TARO CHIEZO, SUPER LAMBANANA, 1998 ●

Avril Robarts Library, 79–81 Tithebarn Street, Liverpool L2 2ER

This hybrid creature has the head and body of a lamb, but its tail appears to have been transformed into a banana—a notion reinforced by its vivid yellow color. Chiezo's sculpture combines the formalism of modernist abstraction and the cuteness of a Japanese cartoon character. A well-known icon of the city, it references Liverpool's historic role as a major port for import and export.

BETTY WOODMAN, LIVERPOOL FOUNTAIN, 2016

George's Dock Ventilation Tower, George's Dockway, Liverpool
L3 1DD

This bronze fountain is decorated with imagery inspired by antiquity and modernism. References to Greek, Etruscan, and Egyptian art are intermingled with elements derived from Matisse and Picasso. Woodman's fountain converses with the surrounding architecture, specifically a 1931 Art Deco structure designed by Herbert James Rowse, an architect influenced by the archaeological discoveries in Egypt during the 1920s.

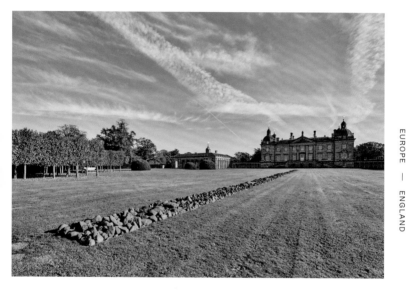

EUROPE — ENGLAND

RICHARD LONG, A LINE IN NORFOLK, 2016

●

Houghton Hall, King's Lynn, Norfolk PE31 6UE

Long's striking band of rust-colored stones stretches down the middle of a manicured lawn at Houghton Hall. Created entirely by hand, the 275.6-foot-long (84 m) sculpture uses a type of sandstone seen in local historic buildings. Houghton Sculpture Garden boasts a growing collection of contemporary works by artists including Anya Gallaccio, Zhan Wang, Rachel Whiteread, and Phillip King.

52°49'35.3"N 0°39'29.3"E

MARTIN CREED, WORK NO. 409, 2005

Ikon Gallery, 1 Oozells Square, Brindleyplace, Birmingham B1 2HS

At Birmingham's Ikon Gallery, Creed transformed an ordinary elevator ride into a sonic experience. As the elevator car ascends or descends, a chromatic scale playing through speakers does as well. The scale is articulated through the word *ooh*, sung by male and female voices. Another edition of the piece is permanently installed in London's Southbank Centre.

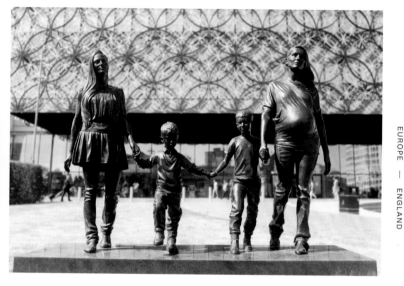

GILLIAN WEARING, A REAL BIRMINGHAM FAMILIY, 2014

Centenary Square, Broad Street, Birmingham B1 2DR

This group of bronze figures depicting two sisters and their children celebrates the modern family. The sisters, both single mothers, were chosen by competition to challenge notions of what constitutes family in the twenty-first century. Wearing, whose work deals with identity and social issues, was struck by the women's strong friendship and commitment to each another.

CLARE WOODS, RACK ALLEY, 2012

The Hive, Sawmill Walk, The Butts, Worcester WR1 3PD

The dark, organic-looking bands of color running vertically and horizontally across this painting echo the architectural lines of the building where it is installed. Woods designed this abstract work specifically for the library's atrium, finding inspiration in Worcester's history and architecture. Local influences are fused with her long-standing interest in landscape painting and the strangeness of organic and geological forms.

52°11'37.6"N 2°13'35.0"W

EUROPE — ENGLAND

LILIANE LIJN, LIGHT PYRAMID, 2012

Campbell Park, Milton Keynes MK9 3FZ

At night, this 19.7-foot-high (6 m) pyramidal sculpture becomes an illuminated beacon, shining from Campbell Park's highest point. The perforated surface of the five steel triangles arranged in a circle allows bright light to radiate out from inside. The sculpture, Lijn's second for Milton Keynes, is one of the city's many contemporary artworks by artists, including Michael Craig-Martin, Elisabeth Frink, and Bill Woodrow.

52°02'50.5"N 0°44'37.5"W

CLAIRE BARCLAY, GLOWING PROMISE, 2007 ⊙

Jesus College, Cambridge CB5 8BL

Viewers must look up to see this enigmatic sculpture, installed high on a wall in an obscure part of Cambridge's campus. Protruding forms evoke the skyline of this collegiate city, referencing its remarkable legacy. Originally commissioned for Jesus College's biennial outdoor art exhibition, Barclay's work joined a growing collection of work exhibited at the college by artists, including Antony Gormley, Eduardo Paolozzi, and Cornelia Parker.

52°12'32.4"N 0°07'24.3"E

EUROPE — ENGLAND

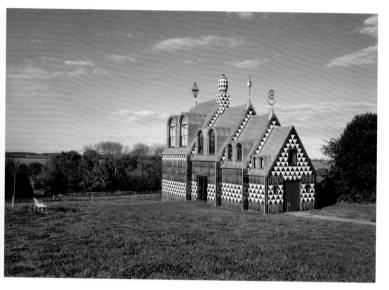

GRAYSON PERRY AND FAT ARCHITECTURE FOR LIVING ARCHITECTURE, A HOUSE FOR ESSEX, 2015

A

Black Boy Lane, Manningtree, Essex CO11 2TP

Evoking a wayside chapel, this eccentric green-and-white tile-clad house was designed by Perry and FAT Architecture as a celebration of the artist's home county, Essex. Inside the building are sculptures and tapestries telling the tragic story of Julie Cope, a fictional everywoman of Essex. Blending art and architecture, the two-bedroom property, which sleeps four, can be rented for holidays and short breaks.

51°56'28.7"N 1°10'23.7"E

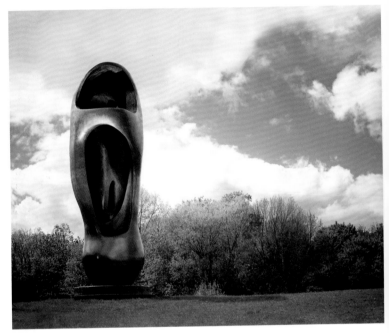

HENRY MOORE, LARGE UPRIGHT INTERNAL/EXTERNAL FORM, 1953–54

Henry Moore Studios & Gardens, Dane Tree House, Perry Green, Hertfordshire SG10 6EE

Open every summer, the more than 70 acres (0.27 sq km) of gardens and countryside at the Henry Moore Studios & Gardens provide an opportunity to experience the artist's work in the setting in which it was created. In addition to the artworks on display, the site includes Moore's studios, his home of more than forty years, and a visitor center.

EUROPE — ENGLAND

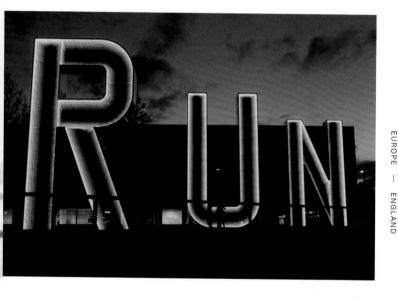

MONICA BONVICINI, RUN, 2012

Copper Box Arena, Queen Elizabeth Olympic Park, Waterden Road,
London E9 5JT

Bonvicini's 30-foot-tall (9.1 m) *Run* is a mirror to the surrounding environment
during the day, and at night it projects an illuminated glow, thanks to LED
lights installed inside the giant letters. Created as part of the 2012 Olympics
Art in the Park program, the sculpture alludes to not only an Olympic event
but a common park activity.

EUROPE — ENGLAND

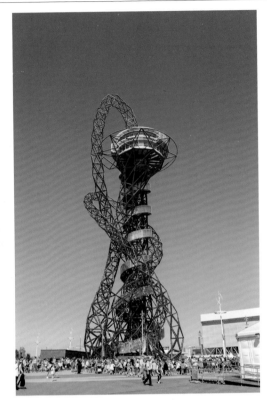

ANISH KAPOOR, ORBIT, 2012

Queen Elizabeth Olympic Park, 3 Thornton Street, Stratford,
London E20 2AD

This structure does triple duty, offering art, panoramic views, and a slide
for thrill seekers. The looping steel-lattice sculpture is reportedly the tallest
in the United Kingdom, at 376 feet (114.5 m) high. It was commissioned for
the London 2012 Olympic Games and was made in collaboration with Cecil
Balmond. Later, a tunnel slide by Carsten Höller was added.

JEM FINER, LONGPLAYER, 2000–3000

Trinity Buoy Wharf, 64 Orchard Place, London E14 0JY

London can seem frenetic, but this sound installation invites visitors
to slow down and ponder the nature of time. Featuring 234 Tibetan singing
bowls, *Longplayer* is a musical composition that lasts a thousand years.
Visitors to Trinity Buoy Wharf's lighthouse can hear the algorithmically
generated piece at a listening post and see bowls that are used in occasional
live performances.

51°30'28.6"N 0°00'30.4"E

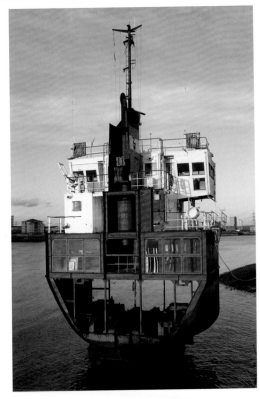

RICHARD WILSON, SLICE OF REALITY, 2000

Thames Path, Meridian Gardens, Greenwich Peninsula,
London SE10 0PH

Wilson often employs theatrical interventions to subvert conceptions of
architectural space, as he does here with a sand dredger turned sculpture
anchored to the foreshore of the Thames in London. The vessel's body
was reduced to 15 percent of its original length. Absent its prow and stern,
the unshielded structure is exposed to the weather and tide.

51°30'14.9"N 0°00'00.8"W

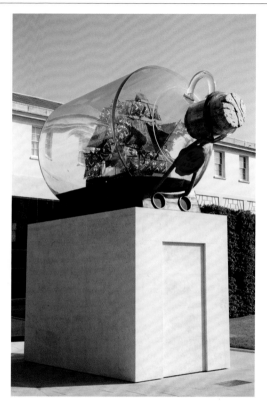

EUROPE — ENGLAND

YINKA SHONIBARE, NELSON'S SHIP IN A BOTTLE, 2010

National Maritime Museum, Greenwich, London SE10 9NF

A trademark of Shonibare's art is his use of Dutch Wax fabric, a material typically associated with African clothing and identity. In this scale replica of a navy ship employed in Britain's victory at the Battle of Trafalgar, commissioned for the Fourth Plinth in Trafalgar Square, Shonibare substituted traditional white sails with the patterned fabric—a choice that evokes the complexity of Britain's history of colonialism, trade, and multiculturalism.

RACHEL WHITEREAD, TREE OF LIFE, 2012

Whitechapel Gallery, 77–82 Whitechapel High Street, London E1 7QX

Shimmering clusters of gold-plated leaves sprout from the facade of Whitechapel Gallery. Whiteread's installation is inspired by the Arts and Crafts–era Tree of Life motif on the building's towers and by the urban weeds growing on neighboring buildings. A frieze was planned to adorn the facade at the building's opening, in 1901, but not until Whiteread's commission was this hope fulfilled.

51°30'57.5"N 0°04'12.8"W

EUROPE — ENGLAND

RICHARD SERRA, FULCRUM, 1987 ⬤

Broadgate Circle, outside Liverpool Street station, London EC2M 2QS

Serra had only a small ground area allotted for this piece, so he utilized vertical space as well. Inside the 55-foot-high (16.8 m) sculpture, the sky is dramatically framed by five sheets of Cor-Ten steel. The piece is part of the Broadgate Art Trail, a roughly forty-five-minute walk that also leads to pieces by George Segal, Lincoln Seligman, Danny Lane, and others.

EUROPE — ENGLAND

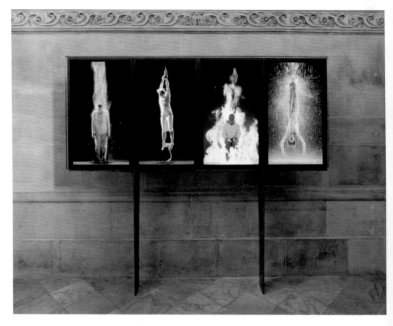

BILL VIOLA, MARTYRS (EARTH, AIR, FIRE, WATER), 2014

St. Paul's Cathedral, St. Paul's Churchyard, London EC4M 8AD

This silent video illustrates four people enduring pain and hardship as they are beset by the four elements. Viola's piece pays tribute to human values, like fortitude and the spirit of sacrifice, while also referencing the passive role observers play when viewing the horrors visible daily in the media— the original meaning of the word *martyr* in ancient Greek is "witness."

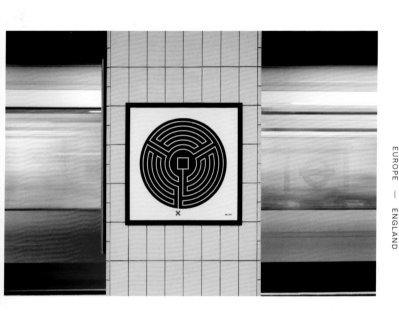

EUROPE — ENGLAND

MARK WALLINGER, LABYRINTH # 98/270 MANSION HOUSE, 2013

⭘

Mansion House station, 38 Cannon Street, London EC4N 6JD

Created to commemorate the London Underground's 150th anniversary, this multipart artwork offers travelers images of labyrinths as places for spiritual journeys. A unique labyrinth design is displayed at each of the Tube's 270 stations, the circular form of the labyrinths echoing that of the Tube's roundel logo. Wallinger used vitreous enamel, the same material employed in signs throughout the Tube.

EUROPE — ENGLAND

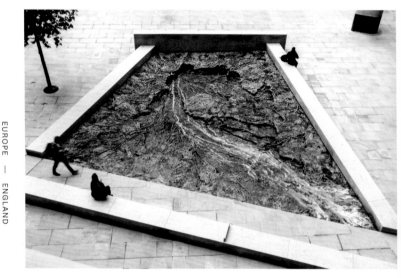

CRISTINA IGLESIAS, FORGOTTEN STREAMS, 2017

Bloomberg London, 3 Queen Victoria Street, London EC4N 4TQ

An ancient river appears to have been uncovered in this cast bronze water feature. Water trickles and flows across three marshy-looking areas that suggest the subterranean rivers of London, lost tributaries of the Thames that were covered over by city developers. Iglesias's installation in this public plaza specifically references the Walbrook river that once flowed near this site.

EUROPE — ENGLAND

FIONA BANNER, FULL STOP OPTICAL AND FULL STOP COURIER, 2003

More London Riverside, London SE1 2RE

Scattered around the riverfront plaza near City Hall, these glistening bronze sculptures appear like abstract forms. Stemming from Banner's preoccupation with text, they are in fact 3-D representations of full stops, or periods. Each of the five oversize forms is styled after a different typeface. Coated with the same paint as London's black taxis, their reflective surfaces mirror the surrounding architecture.

EUROPE — ENGLAND

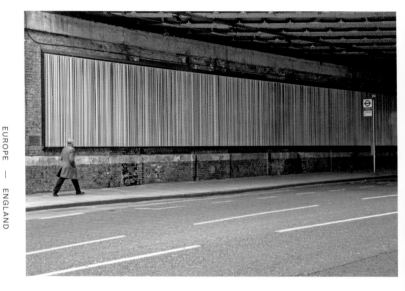

IAN DAVENPORT, POURED LINES: SOUTHWARK STREET, 2006 ○

Southwark and Burrell Streets, London SE1

This 158-foot-long (48 m) painting is installed beneath a railway bridge near Tate Modern. The vibrant mural, which contains more than three hundred colors, is made from hundreds of vertical lines. Using his signature technique, Davenport carefully poured liquid-enamel paint along a series of tilted flat panels. Like all his works, the final composition was determined by the action of gravity.

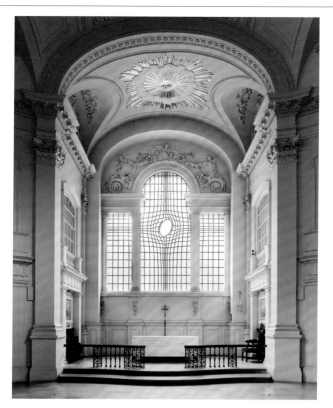

EUROPE — ENGLAND

**SHIRAZEH HOUSHIARY AND PIP HORNE, EAST WINDOW
AND ALTAR, 2011**

St. Martin-in-the-Fields, Trafalgar Square, London WC2N 4JJ

Installed above an altar, this striking window fuses contemporary art with
ecclesiastical architecture in a historic London church. A warped framework
holds handmade glass etched with delicate patterns while a central ellipse
forms a focal point, allowing light to stream into the chancel. Houshiary's
windows took the place of stained glass that was shattered by bombs during
World War II.

EUROPE — ENGLAND

RICHARD WILSON, SQUARE THE BLOCK, 2009

London School of Economics and Political Science, New Academic
Building, Kingsway and Sardinia Street, London WC2A 3LJ

Wilson's five-story intervention disrupts the southwest corner of this
London School of Economics building. While the upper portions introduce a
subtle distortion to the existing facade, the lower section projects outward,
appearing crumpled up like a piece of paper. As with all of the artist's
architecturally inspired works, the piece surprises viewers with incongruity,
humor, and a sense of disturbance.

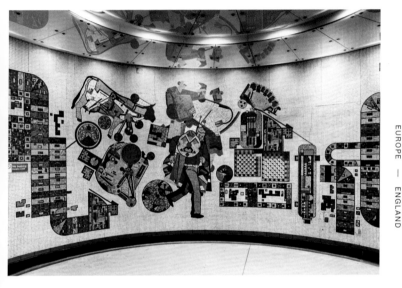

EDUARDO PAOLOZZI, UNTITLED, 1984

Tottenham Court Road station, Oxford Street, London W1D 2DD

Paolozzi's multicolored glass mosaics cover over 10,000 square feet (950 sq m) on platforms and interconnecting spaces at the Tottenham Court Road London Underground station. The energetic compositions feature abstract and representational elements intended to capture the vitality of modern urban life. The mosaics were recently restored during the station's renovation, and several sections moved to the Edinburgh School of Art.

51°30'58.2"N 0°07'49.1"W

IAN HAMILTON FINLAY, FIRST MEMORIAL TO DIANA, PRINCESS OF WALES, 1998

Serpentine Gallery, Kensington Gardens, London W2 3XA

The Serpentine Gallery commissioned Finlay to create a multipart piece as part of a major renovation of the gallery and its grounds. This inscription near the gallery's entrance, eight benches, and a tree plaque are etched with poetry and bits of interesting information, such as the types of trees found in Kensington Gardens. Finlay added Princess Diana's name to the center of the circle as a memorial following her death.

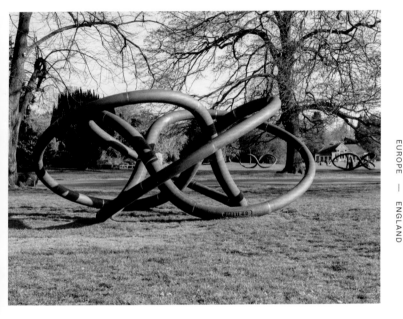

CONRAD SHAWCROSS, THREE PERPETUAL CHORDS, 2014 ●

Dulwich Park, London SE21 7ET

After a Barbara Hepworth sculpture was stolen from Dulwich Park, Shawcross designed this series of three artworks as replacements, using inexpensive cast iron to make theft unlikely. The airy forms pay subtle homage to Hepworth's use of holes in her work. The intriguing shapes, which visually represent musical intervals (the octave, fifth, and fourth), entice park goers to stroll between them.

**LANGLANDS & BELL, MOVING WORLD (NIGHT & DAY)—
(NORTH SCULPTURE), 2008**

London Heathrow Airport, Terminal 5, Interchange Plaza, London
TW6 2GA

Radiant arcs of blue neon greet passengers at London's Heathrow Airport.
Installed on large glass walls at opposite ends of Terminal 5's interchange
plaza, these flashing texts spell out airport codes from around the world.
Granite plinths at the base of each wall invite visitors to sit and absorb the
constantly shifting patterns of light before continuing with their journeys.

EUROPE — ENGLAND

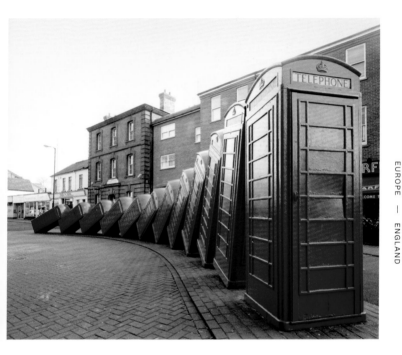

DAVID MACH, OUT OF ORDER, 1989

Old London Road, Kingston upon Thames, Surrey KT2 6QF

In this installation by Mach, twelve phone boxes appear to have fallen like a row of dominoes. The work is typical of Mach's signature style, in which he employs large quantities of ordinary items to create new forms and meanings. The materials he has used in other artworks have included teddy bears, tires, coat hangers, magazines, and matchsticks galore.

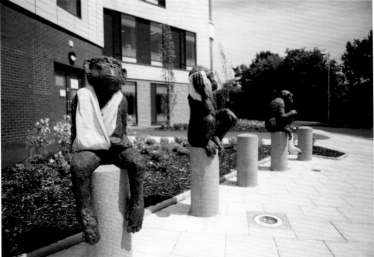

LAURA FORD, PATIENT PATIENTS, 2014

Southmead Hospital, Southmead Road, Westbury-on-Trym,
Bristol BS10 5NB

Three injured monkeys nurse their wounds near the entrance to Southmead
Hospital's emergency room. The life-size bronzes belong to a series of animal
sculptures by Ford installed in different zones of the hospital campus. Other
fantastical figures include a bear with a sore back, a lion with a bandaged paw,
and an elephant with a bruised trunk.

51°29'52.4"N 2°35'37.8"W

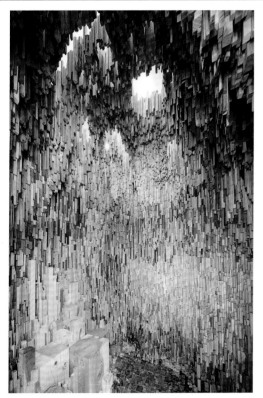

KATIE PATERSON AND ZELLER & MOYE, HOLLOW, 2016

Royal Fort Gardens, Royal Fort Road, Clifton, Bristol BS8 1TH

The wood fragments that make up this architectural artwork, created
in collaboration with the architecture firm Zeller & Moye, are sourced from
ten thousand distinct tree species—including from the world's oldest tree
and some of its youngest species. The piece evokes the sensory experience
of being in a forest and encourages visitors to reconsider how they inhabit
the natural landscape.

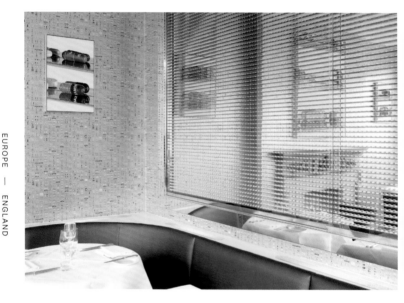

DAMIEN HIRST, INTERIOR OF "THE QUAY" RESTAURANT, ILFRACOMBE, 2004

●

The Quay Restaurant, 11 the Quay, Ilfracombe, Devon EX34 9EQ

Original artworks by Hirst, including butterfly wallpaper, spot paintings, and natural history and medicine cabinets, are displayed in this restaurant, which opened in 2004 and is co-owned by Hirst. Nearby, on Ilfracombe Pier, stands *Verity*, the artist's 65-foot-tall (19.8 m) bronze sculpture of a pregnant woman. It was the tallest sculpture in the United Kingdom when installed in 2012.

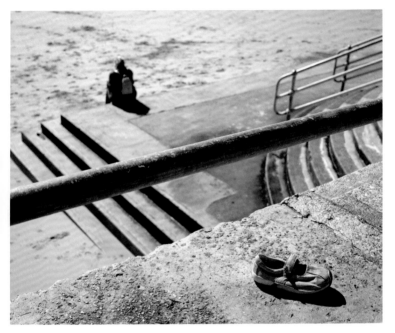

EUROPE — ENGLAND

TRACEY EMIN, BABY THINGS, 2008 ○

Sunny Sands Beach, The Stade, Folkestone, Kent CT19 6AB, and
other locations throughout the town

A Margate native, Emin could relate with the social and economic challenges
faced by British coastal towns in recent decades. Her bronze sculptures
of discarded baby clothes strewn across Folkestone point to the town's high
teenage pregnancy rate. A map reveals their locations, along with the sites
of permanent works by other artists who were commissioned by the
Folkestone Triennial.

CORNELIA PARKER, THE FOLKESTONE MERMAID, 2011

Sunny Sands Beach, The Stade, Folkestone, Kent CT19 6AB

⬤

A naked woman looks out across Folkestone Harbour in this reinterpretation of Copenhagen's *Little Mermaid* (1913) by Edvard Eriksen. Not wanting to create an idealized figure, Parker chose a local resident, an ordinary mother of two, as the model for the life-size seafront bronze sculpture. Commissioned for the 2011 Folkestone Triennial, the work belongs to the town's permanent sculpture trail.

51°04'52.3"N 1°11'24.2"E

CHRISTIAN BOLTANSKI, THE WHISPERS, 2008 ⬤

The Leas, Folkestone, Kent CT29 2DR

While sitting on this bench, looking out to sea, visitors can listen to voices reading letters sent to and from British servicemen during World War I. The piece references the town's history: soldiers passed through Folkestone on their way to the battlefields in France and Belgium. The piece was commissioned for the Folkestone Triennial and is now one of nearly thirty permanent works throughout the town.

51°04'27.8"N 1°10'03.4"E

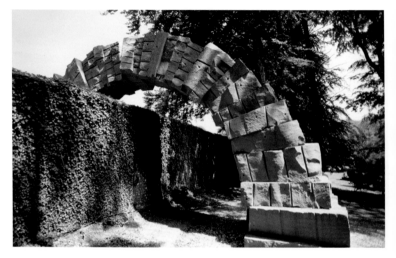

ANDY GOLDSWORTHY, SANDSTONE ARCH, GOODWOOD, SUSSEX, 2001

Cass Sculpture Foundation, New Barn Hill, Goodwood, Chichester
PO18 0QP

Goldsworthy's striking sandstone arch straddles a flint wall built by prisoners during the Napoleonic Wars. The bold sculpture is typical of the work at this tranquil, bucolic 26-acre (0.11 sq km) site, where artists are regularly invited to develop new projects. More than fifty large-scale sculptures by artists, including David Brooks, Bernar Venet, Bill Woodrow, and Lynn Chadwick, are on display.

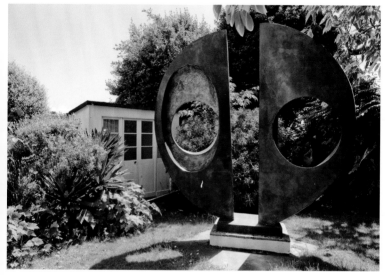

EUROPE — ENGLAND

BARBARA HEPWORTH, TWO FORMS (DIVIDED CIRCLE), 1969

Barbara Hepworth Museum and Sculpture Garden, Barnoon Hill, St. Ives TR26 1AD

Hepworth believed there were essential shapes in the materials with which she worked, and when she carved, she sought to achieve equilibrium between those shapes and the form she wished to create. This principle is evident in the sculptures found in this garden, part of Hepworth's former home and studio. The site is now a museum for the acclaimed British artist's works.

EUROPE — NORTHERN IRELAND

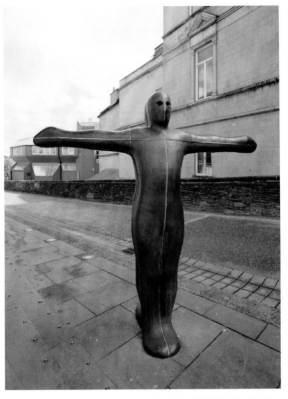

ANTONY GORMLEY, SCULPTURE FOR DERRY WALLS, 1987 ○

East Wall Bastion, The Millennium Forum Theatre, Newmarket Street,
Londonderry BT48 6EB

Originally one of three similar sculptures but now the only remaining, this
cast-iron piece consists of two identical figures standing back to back in a
cruciform pose. They represent Derry's Catholic and Protestant communities,
facing opposite directions but united by their Christianity and shared locale.
The eyes are completely hollow, allowing viewers to see through the eyes
of both of these symbolic figures.

NETHERLANDS, BELGIUM, LUXEMBOURG

NETHERLANDS

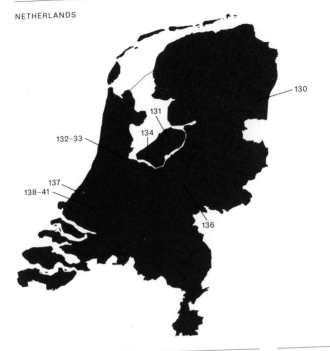

EUROPE

BELGIUM

LUXEMBOURG

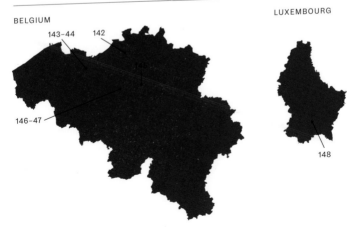

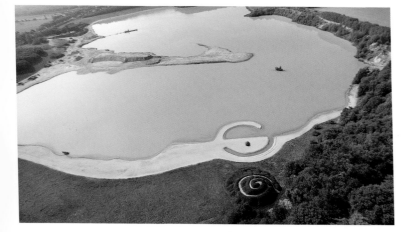

ROBERT SMITHSON, BROKEN CIRCLE/SPIRAL HILL, 1971

Emmerhoutstraat 150, 7814 XX Emmen

This monumental work was created on an industrial sandpit in Emmen. The "broken" circular plateau carved out of the shoreline is marked at the center by a boulder that preexisted on the site. Adjacent to it, on the sandbanks, is a hill that is cut with curving pathways. It is the only earthwork that Smithson ever produced in Europe.

EUROPE — NETHERLANDS

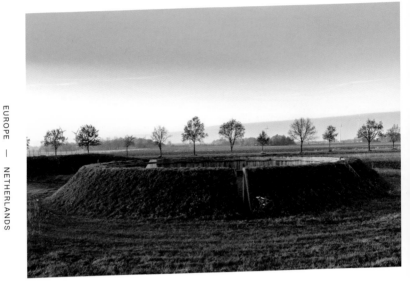

ROBERT MORRIS, OBSERVATORIUM, 1977

Swifterringweg and Houtribweg, Lelystad

Inspired by ancient sources, such as Stonehenge, Morris conceived this work of Land Art as a monument to the solstices. The wood and earth structure, made up of two large concentric circles, is accessed by a tunnel leading into the interior space. Stone wedges on either side of the circle align with the rising sun on the summer and winter solstices.

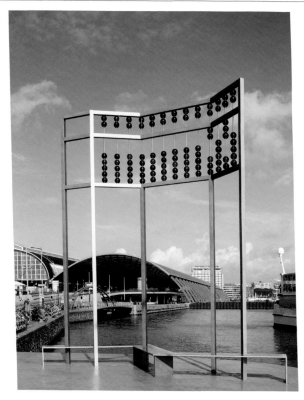

JEAN-MICHEL OTHONIEL, LIVING BY NUMBERS, AIDSMONUMENT AMSTERDAM, 2016

De Ruijterkade near Central Station, 1011 AB Amsterdam

Othoniel's monument to the AIDS crisis takes the form a large abacus, with blood-red beads made of hand-blown glass. The memorial, situated on the banks of the city's waterway, is a symbolic and inspiring countdown to the eradication of the virus, as well as a tabulation of its victims.

EUROPE — NETHERLANDS

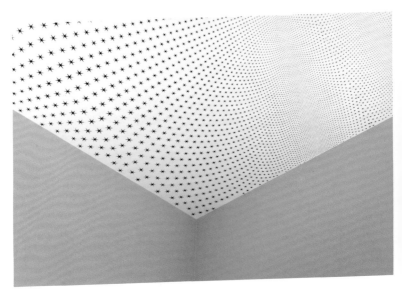

RICHARD WRIGHT, NO TITLE, 2013

Rijksmuseum, Museumstraat 1, 1071 XX Amsterdam

Wright's dazzling constellation of 47,000 black stars adorns two ceilings adjacent to one of the Rijksmuseum's key works: Rembrandt van Rijn's *The Night Watch* (1642). The dizzying spatial illusions created by this modern fresco were calculated mathematically, drawing on techniques dating to the Italian Renaissance. This is a rare permanent work by Wright, whose wall paintings are usually ephemeral.

52°21'35.6"N 4°53'05.7"E

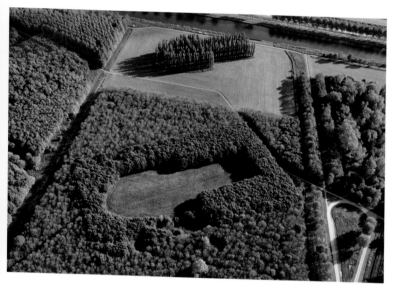

EUROPE — NETHERLANDS

MARINUS BOEZEM, GOTHIC GROWTH PROJECT ("GREEN CATHEDRAL"), 1978/1987–PRESENT

Kathedralenpad, near Tureluurweg, Almere

Situated on a knoll outside the city of Almere, this natural "cathedral" is a living art installation made with poplar trees. Boezem planted the poplars to correspond to the ground plan of Reims Cathedral. Concrete pathways laid between the trees evoke the cathedral's gothic rib vaulting. Nearby, a negative space in the shape of the same cathedral is framed by oak and hornbeam hedges.

52°19'18.9"N 5°19'03.0"E

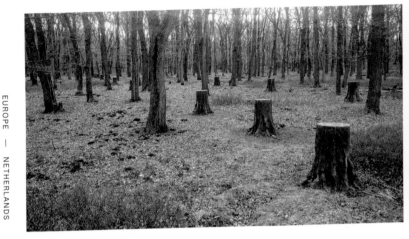

MARINUS BOEZEM, UNTITLED ("DE KATHEDRAAL") ["THE CATHEDRAL"], 1996–99

Kroondomein Het Loo, near Wieselseweg and Elspetergrindweg, Apeldoorn

Like Boezem's installation in Almere, these forty bronze tree stumps are arranged to echo the floor plan of France's Reims Cathedral. Representing the Gothic church's colonnades, each sawn-off stump is polished to reflect light that shines through the surrounding trees. The natural environment is central to Boezem's work, and this installation provides a space to contemplate humanity's eternal relationship with trees.

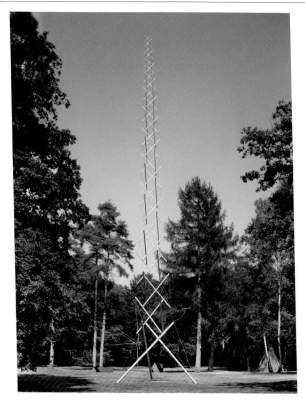

KENNETH SNELSON, NEEDLE TOWER, 1968

Kröller-Müller Museum Sculpture Garden, Houtkampweg 6,
6731 AW Otterlo

This tall, tapering tower is made from aluminum tubes and stainless steel
cables held in tension. Reaching 86.9 feet (26.5 m) into the air, the delicate-
looking sculpture is actually incredibly strong. It resides at the Kröller-Müller
Museum, whose large 61.8-acre (0.25 sq km) sculpture garden contains more
than 160 modern and contemporary sculptures.

52°05'44.8"N 5°48'58.9"E

EUROPE — NETHERLANDS

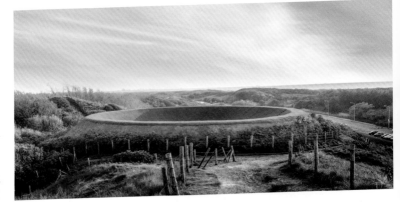

JAMES TURRELL, THE CELESTIAL VAULT, 1996

Machiel Vrijenhoeklaan 175, Kijkduin, 2555 NA The Hague

Visitors can lie in the grass or on the single stone bench at the center of this large artificial crater to experience a unique perspective: Turrell designed this huge earthwork so that the sky appears as a vast curved dome. Another stone bench, located outside the crater's center, offers views of the sea and surrounding landscape.

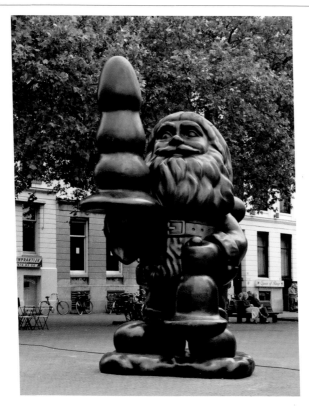

EUROPE — NETHERLANDS

PAUL MCCARTHY, SANTA WITH BUTT PLUG (LARGE), 2002 ⭘

Eendrachtsplein, 3012 Rotterdam

McCarthy's Santa Claus, depicted in patinated bronze and holding a sex toy, caused a scandal when it was commissioned as part of Rotterdam's expansive public-art initiative. After being rejected for its intended location in front of the orchestra building, it was permanently installed in all its cheeky glory at another central site in the city.

FRANZ WEST, DEN ANRAINERN ZULIEBE [FOR THE SAKE OF THE LOCALS], 2001

Eendrachtsweg between Westblaak and Witte de Withstraat,
3012 LB Rotterdam

West titled this work in reference to the fact that the aluminum and steel
sculptures also function as benches overlooking the Westersingel River.
The colors of the five pieces echo the pastel facades of nearby buildings.
Similar to other public artworks in Rotterdam, the group of sculptures was
given a nickname by locals. It is now fondly referred to as "the sausages."

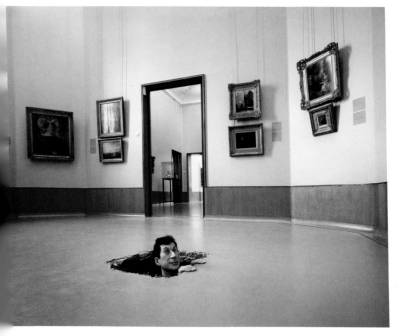

MAURIZIO CATTELAN, UNTITLED, 2001

Museum Boijmans Van Beuningen, Museumpark 18–20,
3015 CX Rotterdam

Cattelan, known for his humorous and often provocative art, shifts the gaze of visitors to this museum from the paintings on the walls to a gaping hole in the floor, from which an inquisitive man emerges. The figure is a life-size sculptural self-portrait, which acts as an irreverent counterpoint to the more traditional works that surround it.

JEFF WALL, LOST LUGGAGE DEPOT, 2001

Wilhelminakade 88, 3072 AR Rotterdam

This iron sculpture, cast from found objects, is installed on Wilhelmina pier, once the site where passengers boarded transatlantic ships bound for North America. Wall conceived of the work to commemorate the Dutch emigrants who made this historic passage—and what they left behind. *Lost Luggage Depot* is one of the many works in Rotterdam's collection of public sculptures.

51°54'15.5"N 4°28'59.4"E

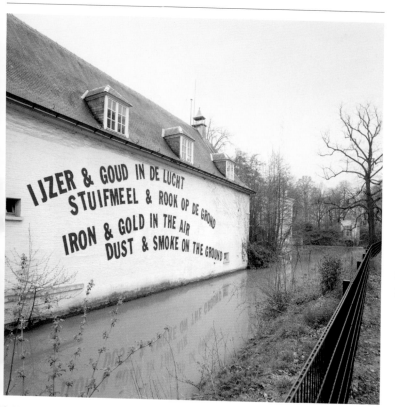

LAWRENCE WEINER, WIND & THE WILLOWS, 1995
Middelheim Museum, Middelheimlaan 61, 2020 Antwerp

It is up to the viewer to interpret Weiner's enigmatic statement, painted on the outside wall of a library in Dutch and English. His red text is one of more than two hundred works by modern and contemporary artists in the Middelheim Museum's expanding collection. With sculptures dating from 1900 to the present, the leafy site is one of the oldest open-air museums in the world.

51°10'49.4"N 4°24'47.4"E

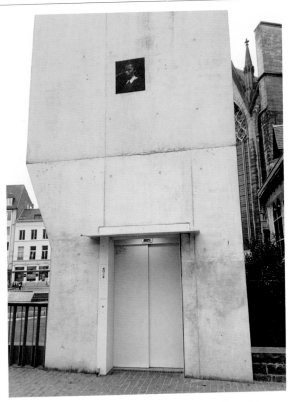

MICHAËL BORREMANS, DE MAAGD [THE VIRGIN], 2014

Goudenleeuwplein, near St. Nicholas's Church, 9000 Ghent

Borremans donated *The Virgin* to his hometown of Ghent. Displayed high on the side of a bell tower, the painting is a portrait of a girl, with white lines emanating from her eyes like lasers. Her gaze points toward the nearby City Hall. The slightly eerie image is typical of Borremans, who is known for his somber, enigmatic paintings.

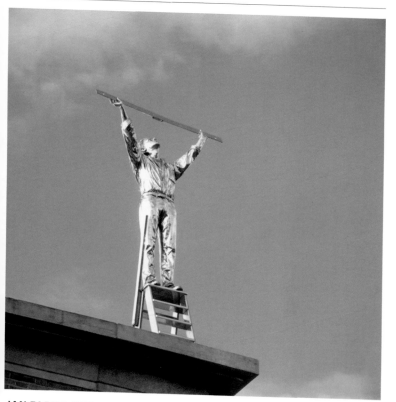

EUROPE — BELGIUM

JAN FABRE, THE MAN WHO MEASURES THE CLOUDS, 1998

S.M.A.K., Jan Hoetplein 1, 9000 Ghent

●

Atop the roof of this contemporary art museum is Fabre's bronze sculpture of a man who precariously stands on a stepladder and tries to measure the clouds in the sky. A self-portrait of the artist, the piece symbolizes the idea of attempting the impossible in the pursuit of knowledge.

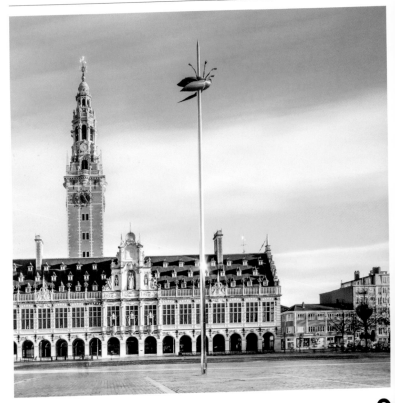

JAN FABRE, TOTEM, 2000–2004

Ladeuzeplein, 3000 Leuven

This fantastical monument—representing a massive jewel beetle impaled on a needle—stands 75 feet (22.9 m) high in front of the University Library in Leuven. It honors the university's 575th anniversary. Fabre conceptualized the beetle as though pinned in an insect collection—an homage to the preservation of knowledge and science and the lifework of the library.

EUROPE — BELGIUM

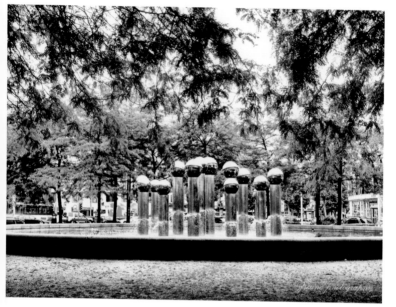

POL BURY, FOUNTAIN, 1995

Boulevard Roi Albert II and Boulevard Baudouin, 1000 Brussels

This civic fountain consists of twenty-one cylindrical poles, each topped
with a polished steel sphere that oscillates precariously as the water flows.
The spheres reflect the surrounding buildings as they wobble and quiver.
The piece is one of many kinetic fountains by the Belgian artist and one of
several permanent works by him in Brussels.

50°51'24.1"N 4°21'19.9"E

JAN FABRE, HEAVEN OF DELIGHT, 2002

Palais Royal, Place des Palais, 1000 Brussels

The carcasses of 1.6 million jewel beetles cover this palatial ceiling, which shimmers with iridescent blues, greens, and golds. Fabre often uses insects, and here they refer to Belgium's colonial history—specifically, King Leopold II's brutal exploitation of Congo, where the jewel beetles can be found. This is the first permanent artwork to be added to the palace since the nineteenth century.

50°50'33.6"N 4°21'45.4"E

EUROPE — LUXEMBOURG

MICHAEL CRAIG-MARTIN, ONE WORLD, 2005–8

European Investment Bank Headquarters, 98–100 Boulevard
Konrad Adenauer, 2950 Luxembourg

Depicting everyday objects is a hallmark of Craig-Martin's art. He created this
piece, which appears in the atrium of a European Investment Bank building,
by embedding colored strips of Corian—a surface material commonly used
for countertops—into the oak floor. The image depicts three globes that
share one sphere—a message of interconnectedness that is fitting for a place
devoted to international banking.

FRANCE

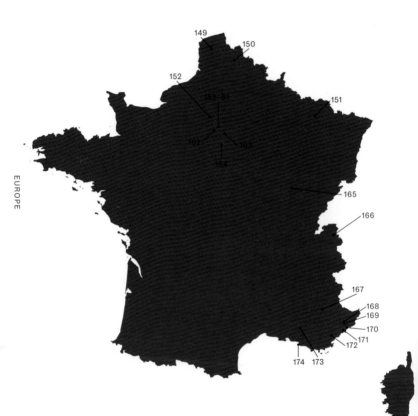

149
150
152
153–161
151
162
163
164
165
166
167
168
169
170
171
172
174 173

ANTHONY CARO, CHAPEL OF LIGHT, 2001/2008

Saint-Jean-Baptiste church, 26 place du Marché aux Chevaux, 59630
Bourbourg

The Saint-Jean-Baptiste church in France was nearly destroyed during
World War II. In 1999, Caro was invited to contribute to its restoration.
The resulting installation draws from the theme of creation and includes
monumental sculptures in terra-cotta, steel, and wood that enhance the
viewer's experience of the architecture.

EUROPE — FRANCE

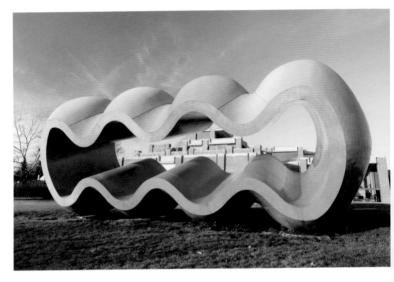

RICHARD DEACON, BETWEEN FICTION AND FACT, 1992 ●

Lille Métropole Musée d'art moderne, d'art contemporain et d'art
brut, 1 allée du Musée, 59650 Villeneuve d'Ascq

Commissioned for a sculpture park, this painted-metal piece responds to
the architecture of the nearby museum, Lille Métropole Musée d'art moderne,
d'art contemporain et d'art brut. The elongated sculpture echoes the
architecture's horizontality, and when its sinuous lines frame the building,
the curves seem to soften the museum's straitlaced geometries.

MARC CHAGALL, LES VITRAUX DE METZ [METZ STAINED-GLASS WINDOWS], 1958–64

Cathédrale Saint-Étienne [Metz Cathedral], 2 place de Chambre, 57000 Metz

The famed painter Chagall also designed stained glass. Metz Cathedral's ambulatory features three sets of his windows, on biblical themes. The two sets in the north apse depict biblical events, such as Jacob's dream and Moses's burning bush. The third set, on the west side of the north transept, illustrates the story of Adam and Eve.

49°07'11.8"N 6°10'33.6"E

EUROPE — FRANCE

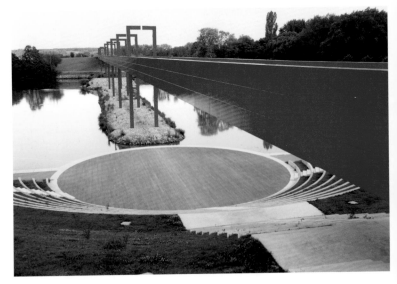

**DANI KARAVAN, AXE MAJEUR [MAJOR AXIS],
1980–PRESENT**

Rue de l'Esplanade de Paris, 95800 Cergy-Pontoise

Karavan's epic urban intervention runs for 1.86 miles (3 km) across Cergy-Pontoise, a French town near Paris. Incorporating an island, a lake, and a bridge, the unfinished long-term project provides residents with places to walk, relax, and attend festivals. It will eventually have twelve stations. This vibrant red footbridge is the latest addition, stretching from the amphitheatre to the River Oise.

49°02'31.3"N 2°02'17.0"E

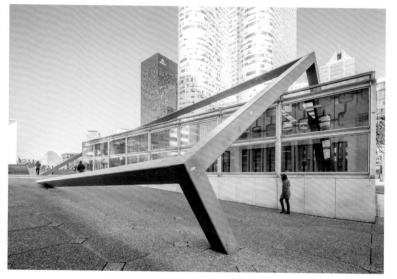

FRANÇOIS MORELLET, LA DÉFONCE, 1990 ⭘

Esplanade du Général de Gaulle, La Défense, 92800 Puteaux

One of nearly seventy outdoor works in the Paris La Défense Art Collection, Morellet's minimalist sculpture humorously plays with its environment. Its metal beams rest precipitously on the building at askew angles and seem to sink into the ground. The piece is one of the artist's so-called architectural disintegrations—works that interact with and destabilize the perception of the surrounding architecture.

ELLSWORTH KELLY, SPECTRUM VIII, 2014

Fondation Louis Vuitton, 8 avenue du Mahatma Gandhi, 75116 Paris

When Kelly was commissioned to create an artwork for the auditorium of the Fondation Louis Vuitton's new building, designed by Frank Gehry, he created this vibrant stage curtain (part of his *Spectrum* series), as well as monochrome panels that add pops of color elsewhere. The museum and cultural center also features site-specific pieces by Olafur Eliasson, Taryn Simon, and other well-known artists.

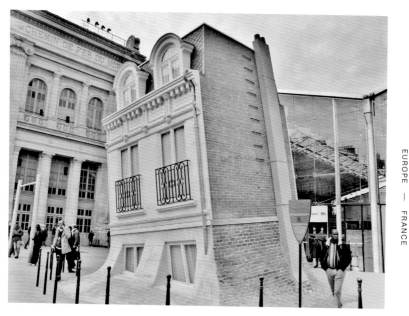

LEANDRO ERLICH, MAISON FOND, 2015

Gare du Nord, 18 rue de Dunkerque, 75010 Paris

This installation by Erlich, an artist known for his use of optical illusions, takes the form of a Directoire-style building that appears to be melting into the surrounding pavement. The piece is, in part, a commentary on the dangers of climate change, and the illusion that the structure is disintegrating in front of the viewer's eyes underscores the urgency of the issue.

48°52'47.5"N 2°21'22.3"E

EUROPE — FRANCE

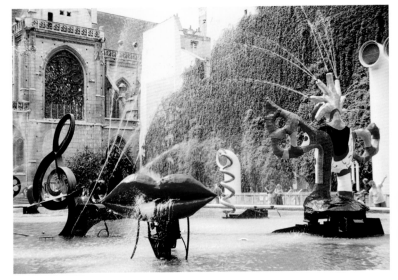

NIKI DE SAINT PHALLE AND JEAN TINGUELY, LA FONTAINE STRAVINSKY [STRAVINSKY FOUNTAIN], 1983

Place Igor-Stravinsky, 75004 Paris

Igor Stravinsky's buoyant score for *The Rite of Spring* (1913) inspired the sixteen sculptures collaboratively presented in this water fountain. De Saint Phalle's energetic pieces depict various animals (firebird, elephant, serpent). One of Tinguely's unadorned kinetic machines incorporates the symbol for the musical key of G. The lightweight fountain is located above a musical institute associated with the nearby Centre Pompidou.

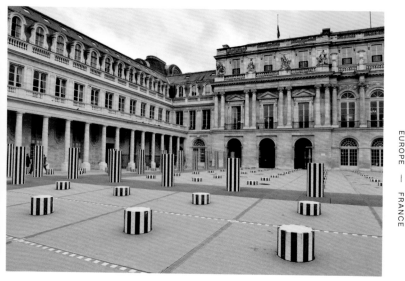

DANIEL BUREN, LES DEUX PLATEAUX [TWO LEVELS], 1986 ●

Palais Royal, 8 rue de Montpensier, 75001 Paris

Spanning an inner courtyard and a subterranean level of a former royal
palace that dates to the seventeenth century, Buren's installation comprises
260 striped marble columns of different heights. The minimalism of color
and form of Buren's columns contrasts the Baroque architectural setting.
Another courtyard features two stainless steel fountains by Belgian artist
Pol Bury.

48°51'49.1"N 2°20'13.5"E

EUROPE — FRANCE

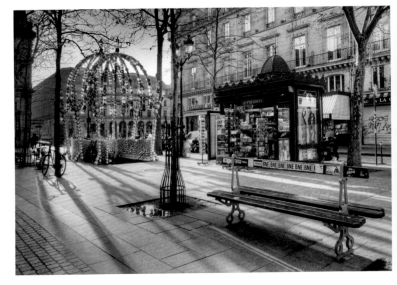

JEAN-MICHEL OTHONIEL, LE KIOSQUE DES NOCTAMBULES [THE KIOSK OF THE NIGHTWALKERS], 2000

Place Colette, 75001 Paris

Othoniel's structure of Murano glass orbs marks the stairway to the metro station at Place Colette. The bubbly kiosk consists of two cupolas, one red and one blue, signifying day and night. Othoniel's installation is typical of his large-scale glass sculptures and stands in marked contrast to the historical Art Nouveau style typical of the Paris metro.

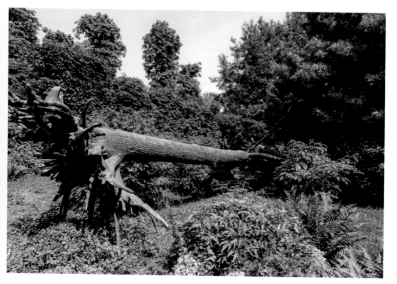

EUROPE — FRANCE

GIUSEPPE PENONE, L'ARBRE DES VOYELLES [TREE OF VOWELS], 1999

Tuileries Garden, 75001 Paris

This bronze sculpture depicts a lofty oak tree uprooted, as if by a storm. Lying horizontally with its roots exposed, the felled timber is surrounded by the lush greenery of Tuileries Garden. Opened in 1667, the historic location is also a public art destinations and includes permanent sculptures by Louise Bourgeois, Lawrence Weiner, Jean Dubuffet, and Auguste Rodin.

48°51'45.9"N 2°19'32.4"E

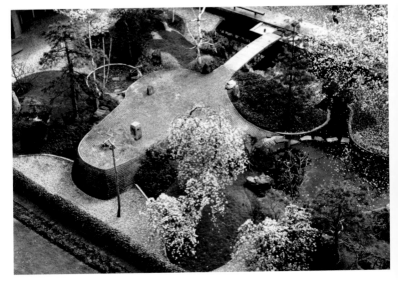

ISAMU NOGUCHI, GARDENS FOR UNESCO, PARIS, 1956–58 **A**

UNESCO Headquarters, 7 place de Fontenoy, 75007 Paris

Abstract formalism meets Zen tradition in this garden, reflecting Noguchi's Japanese heritage and involvement with modern Western art. Created for UNESCO's Paris headquarters, it is one of the twentieth century's most influential projects of landscape architecture. The serene garden, which took three years to build, is intended as a contemplative space and was designed to be enjoyed on foot.

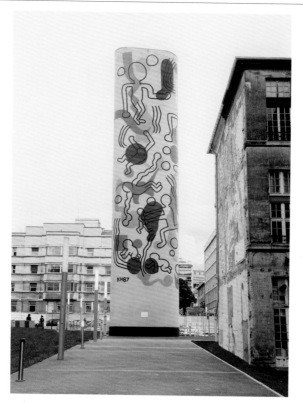

EUROPE — FRANCE

KEITH HARING, UNTITLED, 1987

Necker–Enfants Malades Hospital, 149 rue de Sèvres, 75015 Paris

⬤

Haring created this mural on the exterior of a stairwell "to amuse the sick children in this hospital, now and in the future," he wrote in his diary. Created in freehand in his signature style, the colorful mural—now a free-standing structure—exudes energy, with its profusion of exuberant figures and crawling babies. With the help of his boyfriend, Haring completed it in three days, using a crane.

48°50'43.4"N 2°18'56.0"E

ARMAN, LONG TERM PARKING, 1982

Domaine du Montcel, 1 rue de la Manufacture-des-toiles-de-jouy,
78350 Jouy-en-Josas

This monument to modernity contains sixty cars encased in concrete.
Standing 59.1 feet (18 m) tall, it took Arman seven years to complete. The
artist is best known for his *Accumulations*, which gather together banal
objects and elevate them to the status of art. His work often critiques
the excesses of consumer culture, drawing attention to the shortcomings
of utopian modernism.

JEAN DUBUFFET, CLOSERIE AND VILLA FALBALA, 1971–73 **A**

Fondation Jean Dubuffet, Sentier des Vaux, 94520 Périgny-sur-Yerres

This multifaceted, monumental installation by Dubuffet covers a total of 0.4 acres (1,610 sq m). The outermost area—the *Closerie*—evokes the space of a walled garden. Standing at the *Closerie*'s center is the *Villa Falbala*, a structure that houses the *Cabinet logologique*. In this room, visitors will find a graffiti-like work in red, blue, and black covering the walls.

48°41'40.5"N 2°32'51.1"E

JEAN TINGUELY, LE CYCLOP, 1969–94

91490 Milly-la-Forêt

Started in 1969 by Tinguely, this colossal 350-ton (317 t) sculpture was completed and opened to the public in 1994. Niki de Saint Phalle and other artists—including Arman and Jesús Rafael Soto—contributed to its idiosyncratic materiality and form. De Saint Phalle, for instance, produced a mirrored mosaic. A network of interior staircases leads to viewing decks and theater inside the Cyclops's head.

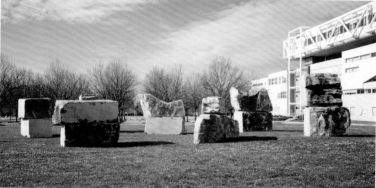

ALAIN KIRILI, IMPROVISATION TELLEM, 2000

Université de Bourgogne, Campus de Dijon, Esplanade Erasme,
21078 Dijon

Kirili's works often rely on the act of stacking, as does this piece, made up
of seven stacks of two rectangular blocks each. For Kirili, natural materials,
like the stone used here, represent the origins of life and of art. The work
offers a meditative space and invites interaction—the viewer experiences
the piece by moving through and around it and by touching it.

VICTOR VASARELY, TRIDIM, 1973

Flaine Forum, 74300 Flaine

This geometric abstract sculpture relies on the careful sequencing of bold colors and shapes to produce a mesmerizing optical illusion. It is typical of the op art movement in which Vasarely was a leading figure. Installed at Flaine, a purpose-built ski resort designed by the Bauhaus architect Marcel Breuer, it is displayed alongside sculptures by Picasso, Jean Dubuffet, and Pol Bury.

ANDY GOLDSWORTHY, REFUGE D'ART—LE VIEIL ESCLANGON [ART REFUGE—OLD ESCLANGON], 2005

Several locations near Digne-les-Bains

Refuge d'Art is a multipart artwork that appears at various points along a 93-mile (150 km) walk, to be viewed over several days of hiking. Goldsworthy created three stone cairns, or "sentinels," that appear in valleys along the way, and other sculptures can be found inside "refuges" (disused structures such as farms, chapels, and sheepfolds).

44°06'53.4"N 6°14'28.5"E

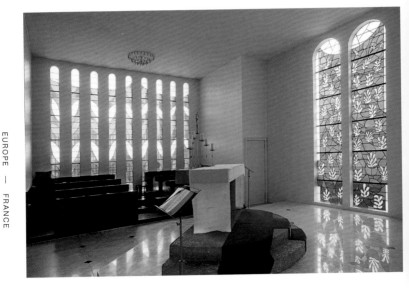

HENRI MATISSE, CHAPELLE DU ROSAIRE [ROSARY CHAPEL], 1948–51

A

466 avenue Henri Matisse, 06140 Vence

This exquisite chapel—often referred to as the Matisse Chapel—in the South of France was conceived and designed by Matisse during the last years of his life. It is dedicated to a Dominican nun who was his nurse. Matisse designed every facet of the chapel—from the mosaics and ceramics to the priests' vestments. Most notable are the brilliant stained glass windows.

GEORGES BRAQUE, LES POISSONS [THE FISH], 1963 ●

Fondation Marguerite et Aimé Maeght, 623 chemin des Gardettes,
06570 Saint-Paul de Vence

Braque's aquatic mosaic, specifically designed for this patio pool, is one of
several permanent artworks at the Maeght Foundation on the French Riviera.
Established by Marguerite and Aimé Maeght and inaugurated in 1964,
the foundation owns one of Europe's largest private collections of twentieth-
century art. Other site-specific works include Alberto Giacometti's courtyard,
Marc Chagall's mural mosaics, and Joan Miró's labyrinth filled with ceramics.

GERMAINE RICHIER, LE GRAIN [THE SEED], 1955

Musée Picasso, Place Mariejol, 06600 Antibes

This darkly tarnished bronze, one of several sculptures by Richier at the Picasso Museum in Antibes, sits on a terrace overlooking the Mediterranean. Richier was part of a figurative tradition in sculpture that included Alberto Giacometti—whom she met through one of her teachers—and Picasso. Filled with tension, this piece typifies her postwar work, which is associated with existentialism.

EUROPE — FRANCE

EUROPE — FRANCE

PABLO PICASSO, WAR AND PEACE, 1952–54

Musée National Picasso La Guerre et la Paix, Place de la Libération,
06220 Vallauris

Leo Tolstoy's *War and Peace* (1867) inspired Picasso's vibrant murals in this
Vallauris chapel. The installation features two allegorical compositions.
In *War* there are armed figures, including one with a bloody sword and a sack
of skulls; in *Peace* there is dancing, playing, and relaxation. The chapel is
testament to Picasso's desire for world peace.

EUROPE — FRANCE

GIANNI MOTTI, SUCCESS FAILURE, 2014

Domaine du Muy, 83 chemin des Leonards, 83490 Le Muy

This humorous signpost invites visitors to Domaine du Muy sculpture park to choose between two paths: success and failure. It is one of thirty-four sculptures by new and established artists at the 20-acre (0.81 sq km) site in France's Bonne Eau Valley. The walking trail winds through wild, unkempt scenery (unlike the pristine environment at other parks) with some artworks placed high in the hills.

43°25'56.0"N 6°35'08.7"E

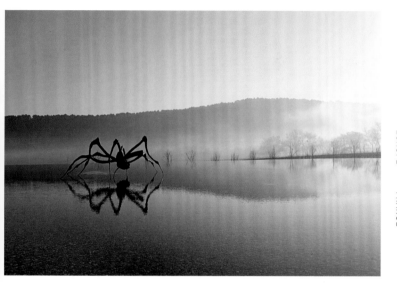

EUROPE — FRANCE

LOUISE BOURGEOIS, CROUCHING SPIDER, 2003 ●

Château La Coste, 2750 route de la Cride,
13610 Le Puy-Sainte-Réparade

Bourgeois's maternal spider stands poised on a watery pool amid the rolling
Provençal landscape of Château La Coste. More than thirty outdoor artworks
by international artists are scattered across the 500-acre (2.02 sq km) estate,
which boasts vineyards, a fine dining restaurant, and a vegetable garden.
The walking trail includes major works by Alexander Calder, Hiroshi Sugimoto,
Tatsuo Miyajima, and Ai Weiwei.

43°38'06.7"N 5°25'12.5"E

EUROPE — FRANCE

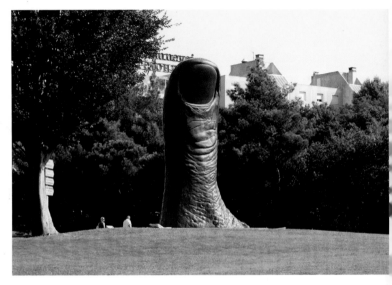

CÉSAR, LE POUCE [THE THUMB], 1988

Rond-Point Pierre Guerre, 13008 Marseille

This oversize replica of a thumb, one of many that the artist has created at various scales, is located in the roundabout Pierre Guerre, near Marseille's Musée d'Art Contemporain. Made of gilt bronze and standing about 20 feet (6 m) high, one might think a giant hitchhiker is looking for a ride.

ANDORRA, SPAIN, PORTUGAL

ANDORRA

SPAIN

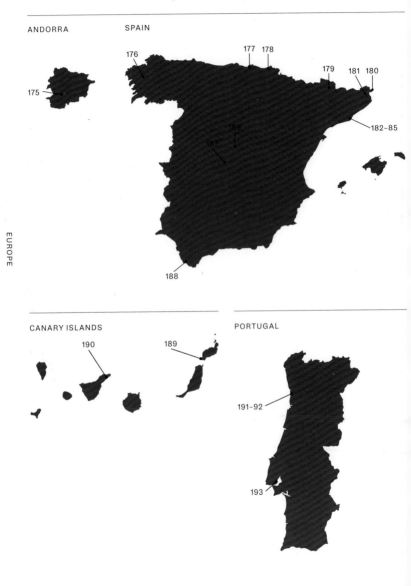

175

176

177 178

179 181 180

182–85

186

187

188

CANARY ISLANDS

190

189

PORTUGAL

191–92

193

JAUME PLENSA, 7 POETS, 2014

Plaça Lídia Armengol Vila, Avinguda Prat de la Creu and
Carrer Doctor Vilanove, AD500 Andorra la Vella

Seven translucent figures placed on top of tall poles sit quietly above the
busy traffic in Lidia Armengol Square. These poets, who silently contemplate
the world below, engender an air of calm amid the urban hubbub. Each poet
represents one of the seven parishes that constitute Andorra. At night they are
lit with different colors, illuminating the night sky like multihued street lamps.

42°30'23.0"N 1°31'17.4"E

DAN GRAHAM, TRIANGULAR PAVILION, 1997

Centro Galego de Arte Contemporánea, rúa Valle Inclán 2,
15703 Santiago de Compostela

Since the 1980s, Graham has become well known for his pavilions—
architectural sculptures that often deploy the technique of a two-way mirror
to create simultaneous transparency and reflectivity. On the rooftop terrace of
the Centro Galego de Arte Contemporánea, viewers can experience reflected
beams of light and views of the surrounding terrace and skyline in the polished
surface of Graham's triangular pavilion.

JEFF KOONS, PUPPY, 1992

Guggenheim Museum Bilbao, Avenida Abandoibarra 2, 48009 Bilbao

Koons's *Puppy* stands guard outside the Guggenheim Museum Bilbao. Covered in bedding plants, the sculpture evokes eighteenth-century European garden design while, like much of Koons's work, referencing the boldness and optimism of contemporary advertising. The Frank Gehry–designed building, known for its site-specific works, also houses Richard Serra's *Snake* (1994–97) and Jenny Holzer's *Installation for Bilbao* (1997).

43°16'03.6"N 2°56'04.3"W

EUROPE — SPAIN

EDUARDO CHILLIDA, EL PEINE DEL VIENTO [THE WIND'S COMB], 1977 ⬤

Paseo de Eduardo Chillida, Bay of La Concha, 20008 San Sebastián

Three steel sculptures, each weighing about 10 tons (9 t), are embedded in the rocks at La Concha bay in San Sebastián. The architectural-sculptural ensemble was designed by Chillida and installed by architect Luis Peña Gancheguí. Its title refers to the twisted comb shape of the pieces and the wind common to the area.

43°19'18.5"N 2°00'19.3"W

SANTI MOIX, ST. VICTOR MURALS, 2015–17

Església de Sant Víctor de Saurí, 25567 Saurí

The drab stone exterior of St. Victor, a Catholic church in the Spanish Pyrenees, belies the vividly colored scene inside. Starting in 2015, Moix covered the interior walls and vaulted ceilings of this eleven-hundred-year-old Romanesque structure with his energetic frescoes. Alternating between abstract and figural elements, the fauvist interpretations of flora and fauna conjure a fantastical Eden.

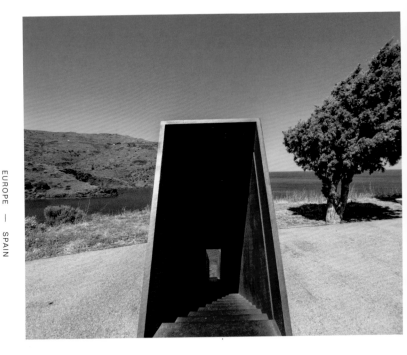

DANI KARAVAN, PASSAGES, HOMAGE TO WALTER BENJAMIN, 1990–94

Walter Benjamin Memorial, Passeig de la Sardana 11, 17497 Portbou

A prominent German intellectual of the interwar years, Walter Benjamin committed suicide in Portbou, Spain, in 1940 and was buried in the local cemetery. Karavan, an Israeli sculptor, created this memorial at the cemetery. Its chief feature is a stepped, iron passage that leads to a glass wall via a vertiginous drop. An inscription on the transparent panel quotes Benjamin.

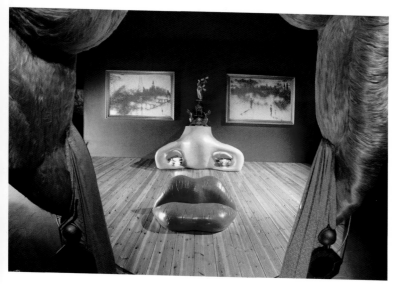

SALVADOR DALÍ, MAE WEST ROOM, 1974

Teatro-Museo Dalí, Plaça Gala i Salvador Dalí 5, 17600 Figueres

This sculptural installation at the Dalí Theatre-Museum is a 3-D rendition of a famous collage by the artist, *Mae West's Face Which May be Used as a Surrealist Apartment* (1934–35). When viewed from a particular angle, Dalí's individual artworks together resemble the American actress's face: the doorway is her mane; the couch, her lips; the paintings on the wall, her eyes.

EUROPE — SPAIN

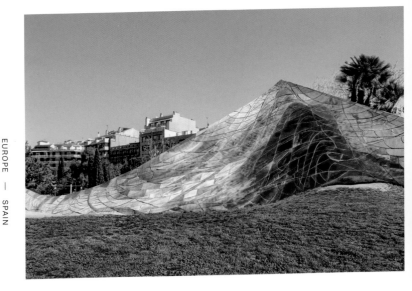

BEVERLY PEPPER, CEL CAIGUT [FALLEN SKY], 1992 ⭕

Parc de l'Estació del Nord, Carrer Nàpols 70, 08018 Barcelona

Pepper collaborated with local architects to create a huge earthwork titled *Sol i Ombra* [Sun and Shade], of which *Cel Caigut* is a part. Clad with ceramic tiles that acts as a sun-trap, the piece transforms the park into a contemplative landscaped environment. A sunken ceramic spiral provides a shady spot to relax. All the vegetation was carefully chosen to enhance the art.

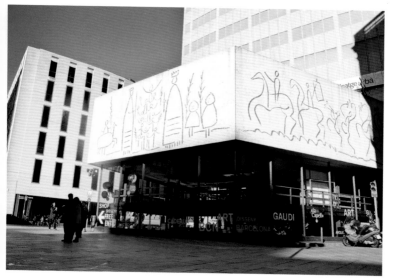

PABLO PICASSO, ENGRAVED WALLS, 1960–61

Col·legi d'Arquitectes de Catalunya, Plaça Nova 5, 08002 Barcelona

Picasso's friezes on the facade of the Architect's College of Catalonia are the artist's only outdoor works in Barcelona. Popular Catalan themes inspired the cartoonlike designs, which depict giants, dancing children, and the traditional Sant Medir festival. Picasso created drawings on paper, which were then enlarged and ultimately engraved in concrete by Carl Nesjar. Two additional friezes are located inside the building.

41°23'04.3"N 2°10'30.4"E

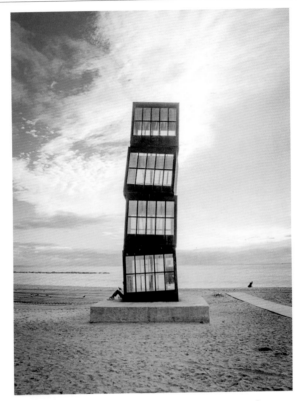

REBECCA HORN, L'ESTEL FERIT [THE WOUNDED STAR], 1992

Playa de la Barceloneta, 08003 Barcelona

Four iron cubes stacked like a crooked lighthouse sit on Barceloneta beach in Barcelona. Known locally as "the cubes," Horn's tower pays tribute to the area's maritime past. Its large windows reveal a mast-like structure and lighting elements that illuminate the sculpture at night. The sculpture is one of eight site-specific installations debuted on the occasion of the 1992 Barcelona Olympics.

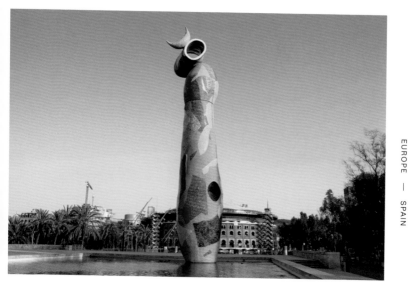

JOAN MIRÓ, WOMAN AND BIRD, 1983 ⬤

Parc de Joan Miró, Carrer d'Aragó 2, 08015 Barcelona

This 72.2-foot-tall (22 m) concrete sculpture is the centerpiece of Barcelona's first post-Franco urban park, fittingly built over an abattoir. Clad in ceramic tiles by Miró's frequent collaborator Joan Gardy Artigas, the attenuated female form has a pronounced aperture down the side. Miró often paired women and birds in his work from the 1940s on, producing an iconography grounded in elemental ideas.

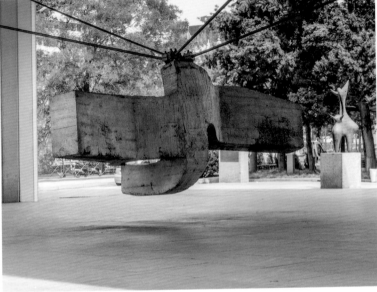

EDUARDO CHILLIDA, LA SIRENA VARADA [THE STRANDED MERMAID], 1972

Museo de Escultura al Aire Libre de la Castellana, Paseo de la Castellana 40, 28046 Madrid

One of seventeen works in this open-air museum, located under the Enrique de La Mata Gorostizaga bridge in Madrid, Chillida's enormous 6.8-ton (6.150 t) sculpture hangs from four thick steel cables, challenging the laws of gravity. The outdoor museum was the idea of Spanish artist Eusebio Sempere as a way to bring modern art closer to the everyday lives of passersby.

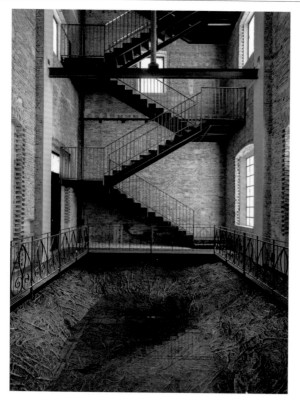

CRISTINA IGLESIAS, TRES AGUAS [THREE WATERS], 2014

Universidad de Castilla–La Mancha, Campus Tecnológico de la
Antigua Fábrica de Armas, Entrada Puerta de Obreros, Edificio 38,
Avenida de Carlos III s/n, 45701 Toledo

Iglesias's sculptural intervention in Toledo traverses three spaces of the city:
the Water Tower (pictured here), the City Council square, and the Convent of
Santa Clara. Using water as the unifying material and metaphorical element,
Iglesias references Toledo's relationship to its river, the Tagus, while also
alluding to the three religions—Christianity, Judaism, and Islam—that have
shaped the region.

EUROPE — SPAIN

MARINA ABRAMOVIĆ, HUMAN NESTS, 2001

Fundación NMAC, Dehesa de Montenmedio, Carretera A-48 (N-340)
Km. 42.5, 11150 Vejer de la Frontera

Carved into the wall of an abandoned quarry are several cavities just large
enough to sit in. Accessible by rope ladders, these niches provide space
for contemplation. This site-specific intervention by Abramović is one of many
works at this vast site, where artists are encouraged to respond sensitively
to the local environment. The expanding collection includes pieces by
Aleksandra Mir, Maurizio Cattelan, and Santiago Sierra.

36°14'34.2"N 5°54'26.7"W

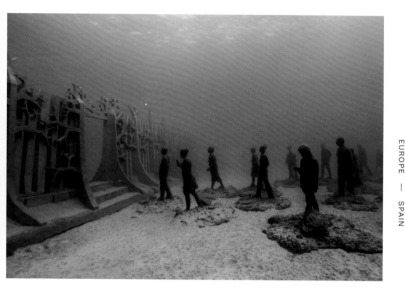

EUROPE — SPAIN

JASON DECAIRES TAYLOR, CROSSING THE RUBICON, 2017 **A**

Museo Atlántico, Calle Lanzarote 1, 35580 Playa Blanca, Lanzarote, Canary Islands

Museo Atlántico is Europe's first underwater sculpture park. Located near Lanzarote, the park features Taylor's growing cast of concrete figures and architectural pieces. His figures express many moods: selfie-taking digerati are juxtaposed with a sunken raft referencing Europe's refugee crisis. Like his underwater work off Grenada, Taylor's sculptures also have an ecological purpose—they create an artificial reef.

28°51'44.3"N 13°51'15.2"W

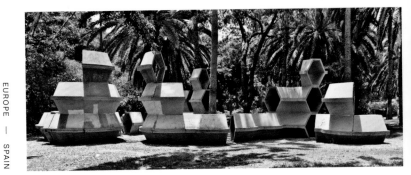

EDUARDO PAOLOZZI, HOMAGE TO GAUDÍ, 1973

Parque García Sanabria, 38004 Santa Cruz, Tenerife, Canary Islands

This striking arrangement of hexagonal modules is a tribute to Spanish architect Antoni Gaudí and his hexagonal tile design. The installation was created for Tenerife's first International Exhibition of Sculpture in the Street held in 1973–74. Other artists from Spain and around the world—including Joan Miró and Henry Moore—contributed to the pivotal exhibition. Today the remaining works form a vibrant sculpture trail.

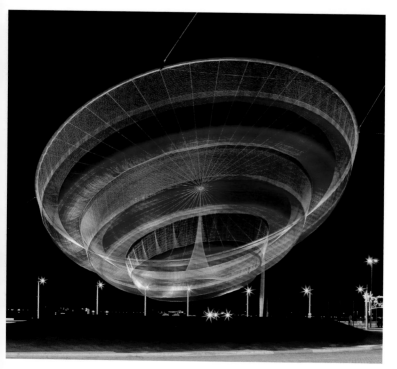

JANET ECHELMAN, SHE CHANGES, 2005

Praça da Cidade do Salvador, Matosinhos, 4450-208 Porto

In characteristic fashion for a work by Echelman, this soft and airy sculpture ripples in the wind. Made of a UV-resistant, colorfast fiber, the net is suspended between three steel poles, which are painted white and red to evoke local lighthouses and smokestacks. The form of the net references this waterfront site's history of fishing.

EUROPE — PORTUGAL

FERNANDA GOMES, UNTITLED, 2008–9

Parque de Serralves, Rua D. João de Castro 210, 4150-417 Porto

At first glance, this piece—one of about a dozen artworks in the Serralves Museum's park—looks like a giant spider web. Gomes's nylon net offers visitors a location where they can recline and absorb forest sights, sounds, and smells they might otherwise have overlooked. The 44.5-acre (0.18 sq km) park also features sculptures by Richard Serra, Dan Graham, and others.

EUROPE — PORTUGAL

RUI CHAFES, HORAS DE CHUMBO [HOURS OF LEAD], 1998

Alameda dos Oceanos and Largo Bartolomeu Dias, Parque das Nações, 1990-221 Lisbon

Looking like elongated bullhorns or binoculars on the waterfront, these black steel cones point toward the sea. Like many of Chafes's large-scale steel sculptures, the heavy metal forms appear light and airy. Inviting playful exploration and participation, the cones, which are large enough to crawl into, amplify visitors' voices while providing distant views of the local landscape.

38°45'54.2"N 9°05'42.4"W

GERMANY AND AUSTRIA

GERMANY

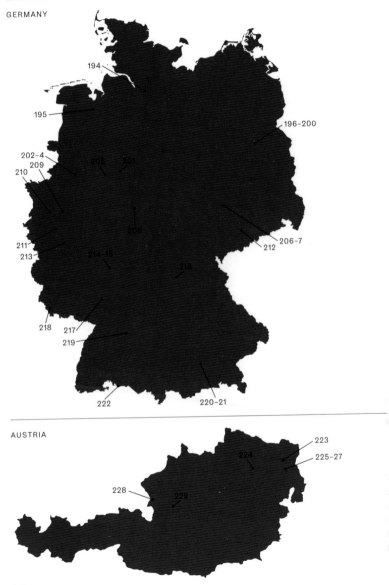

194

195

196–200

202–4
209
210

205 201

208

206–7
212

211
213

214–15

216

218 217
219

222 220–21

AUSTRIA

223
224
225–27

228 229

STEPHAN BALKENHOL, FIGURE ON BUOY, 1993

Elbe River near Övelgönne, 22763 Hamburg

EUROPE — GERMANY

Figure on Buoy is one of four floating sculptures by Balkenhol in Hamburg, all carved from oak trunks. The figures appear simple and stoic. Their faces are expressionless; they wear generic clothing—each dons the same white shirt and dark trousers—and lack specific identifies. From March to October, the buoys float in different bodies of water around the city: on Alster Lake, the Southern Elbe, the Elbe, and the Serrahn.

EUROPE — GERMANY

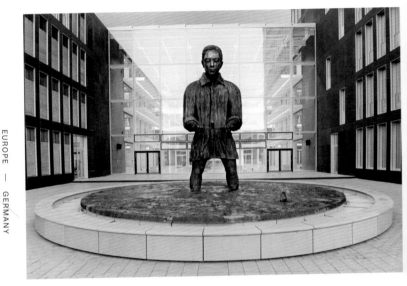

**THOMAS SCHÜTTE, MANN IM MATSCH—DER SUCHENDE
[MAN IN THE MUD—THE SEEKER], 2009**

Landessparkasse zu Oldenburg, Berliner Platz 1, 26123 Oldenburg

The partially submerged figure with a divining stick—a 18-foot-tall (5.5 m)
bronze sculpture—is an enigmatic cipher. Schütte first depicted the figure
as an expressive older man in 1982, then developed the idea in watercolor
in 1989. Schütte's ambiguous seeker finally achieved a monumental scale
with this commission, installed outside a savings bank in Oldenburg, the
artist's birthplace.

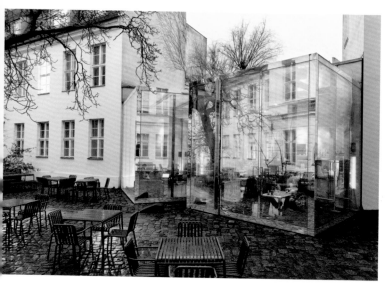

DAN GRAHAM, CAFÉ BRAVO, FOR KUNST-WERKE, BERLIN, 1999

KW Institute for Contemporary Art, Auguststrasse 69, 10117 Berlin

This café has the appearance of a minimalist sculpture. The structure—two large angled cubes covered with one-way-mirror glass—at times reflects its surroundings, and at others seems transparent. Designed with architect Johanne Nalbach, Graham's Café Bravo is the only permanent work at the KW Institute, which promotes the production, display, and dissemination of contemporary art.

52°31'36.4"N 13°23'41.9"E

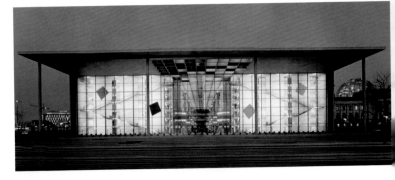

ELLSWORTH KELLY, BERLIN PANELS, 2000

Paul Löbe Haus, Konrad-Adenauer-Strasse 1, 10557 Berlin

Kelly was commissioned by the German parliament to create this piece
for the windows of the Paul Löbe Building, part of the Bundestag in Berlin.
The installation consists of four aluminum diamond-shaped panels—
a translation of the artist's signature shaped canvases—that bring a sense
of color and geometric playfulness to the building's modernist facade.

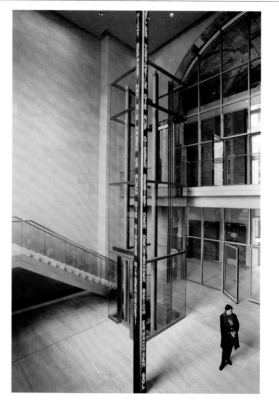

EUROPE — GERMANY

JENNY HOLZER, INSTALLATION FOR REICHSTAG, 1999 **A**

Reichstag Building, Platz der Republik 1, 11011 Berlin

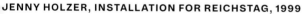

The words scrolling from floor to ceiling in this towering LED column
reproduce speeches delivered by members of the German parliament from
1871 to 1999. Each of the pillar's four sides displays a different speech
on the same topic. Using her signature medium—text—Holzer highlights the
many viewpoints represented by the Reichstag building, the meeting place
of Germany's parliament.

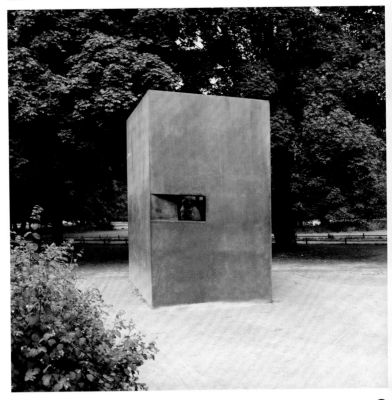

**ELMGREEN & DRAGSET, MEMORIAL FOR THE
HOMOSEXUAL VICTIMS OF THE NAZI REGIME, 2008**

Tiergarten, Ebertstrasse and Hannah-Arendt-Strasse, 10117 Berlin

Elmgreen & Dragset won a German competition to design a national
monument commemorating the people who were victimized for their sexual
orientation by the Nazis. The memorial consists of a concrete cube with
a small window through which viewers can watch a video loop of two men
kissing. The video will change every two years to allow different artists
to participate.

EUROPE — GERMANY

NGES IDEE, PEOPLE, 2000

●

3erliner Verkehrsbetriebe (BVG), Tempelhofer Ufer 31, 10963 Berlin

igures—250 of them—wearing brightly colored clothing are suspended from he vestibule ceiling of this office building. Men and women, old and young, eem to float in the tall, enclosed space, their appearance contrasting with he linearity of the modern architecture. This anonymous crowd, created y the German art collective Inges Idee, alludes to the passengers and ommuters who ride the elevated train line that passes by the building.

EUROPE — GERMANY

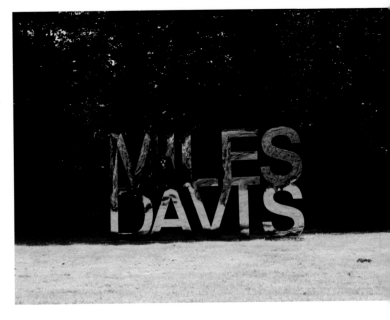

GEORGE CONDO, MILES DAVIS, 2002

Schlosspark Wendlinghausen, Am Schloss 4, 32694 Dörentrup

Thanks to the Garten_Landschaft OstWestfalenLippe, a project that promotes art in green spaces, this region's parks and gardens are rich with public art. Condo's sculpture reflects the surrounding environment on the polished surface of its letters, which spell the name of jazz legend Miles Davis. It is part of a series of sculptures by the artist that reference renowned jazz musicians.

EUROPE — GERMANY

BRUCE NAUMAN, SQUARE DEPRESSION, 1977/2007

University of Münster—Institute for Theoretical Physics, Wilhelm-
Klemm-Strasse 9, 48149 Münster

This sculptural installation, designed in 1977 and realized in 2007 for the
Münster's public art initiative Skulptur Projekte, is a large inverted pyramid
built into the ground. As a part of the title, the word "depression" plays
on the project's spatial orientation and the sense of isolation and confusion
experienced when walking in it.

51°57'59.5"N 7°35'57.4"E

EUROPE — GERMANY

HANS-PETER FELDMANN, WC-ANLAGE AM DOMPLATZ [PUBLIC TOILET ON CATHEDRAL SQUARE], 2007

Domplatz, 48143 Münster

Feldmann designed these public bathrooms in Münster as a civic and conceptual project, commissioned for the city's Skulptur Projekte program. The toilets are remarkable for their cheeriness, partitioned with bright-green mosaics and decorated with floral prints and a plastic chandelier. The site is a commentary on public and private spaces and on municipal resources.

JORGE PARDO, PIER, 1997

Aasee, south of Annette-Allee, 48149 Münster

This 131-foot-long (40 m) pier is situated on the Aasee, a lake popular among German residents for recreational use. The pier is made from California redwood and features an observation platform and pavilion. Typical of Pardo's work, the pier blurs the lines between art and functional design. It was commissioned and installed by the City of Münster for Skulptur Projekte.

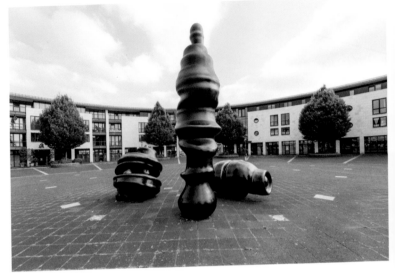

TONY CRAGG, AUF DER LICHTUNG [IN THE CLEARING], 1997

Reichowplatz, 33689 Bielefeld

The emotional and organic qualities of geometry are of particular interest to Cragg. Naturally occurring forms have underlying geometries, like Cragg's sculptures, such as these three bronze works that are reminiscent of seashells or seedpods in their volumes and voids. The title evokes a comparison between the tree-lined urban site and a forest glade.

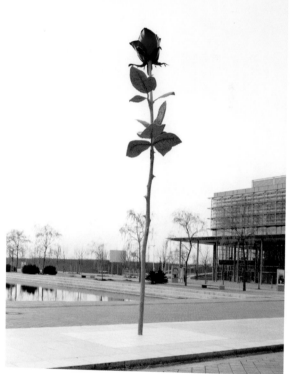

EUROPE — GERMANY

ISA GENZKEN, ROSE, 1993/1997

Glass Hall, Leipziger Messe, Messe-Allee 1, 04356 Leipzig

A colossal, single-stemmed rose towers above visitors to the Leipziger Messe, a major trade exhibition venue in one of Germany's largest industrial cities. Created from stainless steel, Genzken's vulnerable-looking rose is located outside the world's largest glass hall, standing as a symbol for love, pain, and the passing of time.

51°23'49.1"N 12°23'58.1"E

JOSEF ALBERS, WINDOWS, 1926–27

Grassi Museum of Applied Arts, Johannisplatz 5-11, 04103 Leipzig

In 1926, Albers designed eighteen large glass windows—the largest flat-glass works at the time—for the main staircase of the Grassi Museum. The interplay of color, light, and linear composition in these glass compositions is characteristic of Albers's work in other mediums. The current windows are a 2011 reconstruction of the originals, which were destroyed during World War II.

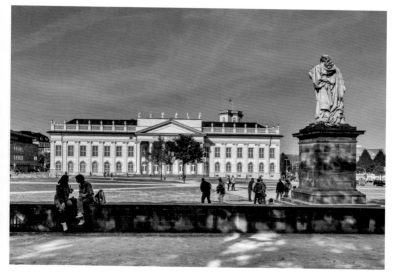

WALTER DE MARIA, VERTICAL EARTH KILOMETER, 1977 ⭕

Friedrichsplatz, 34117 Kassel

All that is visible of this work, which marks the intersection of four footpaths
in Kassel's Friedrichsplatz, is a brass circle 2 inches (5 cm) in diameter
that is level with the ground. The circle is the end of a 0.62-mile-long (1 km)
brass rod driven into the ground—a rod similar to those used in De Maria's
The Broken Kilometer (1979) in New York.

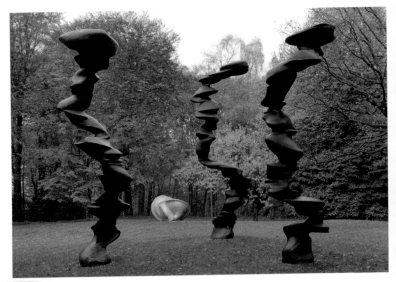

TONY CRAGG, POINTS OF VIEW, 2007 ●

Skulpturenpark Waldfrieden, Hirschstrasse 12, 42285 Wuppertal

Cragg, a British artist living in Wuppertal, founded this sculpture park in a forest, which features a mix of his work and that of other well-known artists. Cragg is inspired by naturally occurring geometries and organic forms, two influences that can be seen in his work *Points of View*, whose three narrow columns seem to have been shaped through wind erosion.

MICHAEL HEIZER, WINDOWS AND MATCHDROPS, 1969

Kunsthalle Düsseldorf, Grabbeplatz 4, 40213 Düsseldorf

<div style="writing-mode: vertical">EUROPE — GERMANY</div>

Outside the entrance to the Kunsthalle Düsseldorf, there are two small
"windows" and a series of matchstick-like depressions in the sidewalk. Heizer
has often repeated forms in different scales across works, and the shapes
in this piece may derive from his large-scale work *Dissipate* (1968), no longer
visible, for which he derived a random pattern by dropping matches.

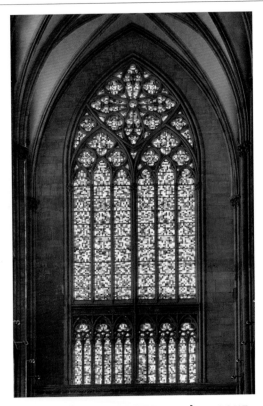

GERHARD RICHTER, KÖLNER DOMFENSTER [COLOGNE CATHEDRAL WINDOW], 2007

Cologne Cathedral, Domkloster 4, 50667 Cologne

This stained glass window, commissioned for the south transept of Cologne Cathedral, is made up of 11,500 pieces of glass rendered in seventy-two distinct colors. To create the work, Richter consulted experts in medieval restoration and used formulas for glassmaking from the Middle Ages. Each glass square is arranged in the window according to a computer-generated color sequence.

50°56'27.9"N 6°57'30.6"E

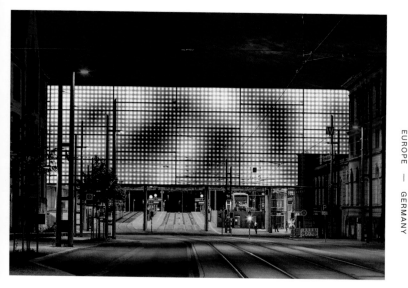

EUROPE — GERMANY

RANDOM INTERNATIONAL, SWARM STUDY / IX, 2016

Chemnitz Central Railway station, Bahnhofstrasse 1, 09224 Chemnitz

Occupying the facade of this railway station is a wall of LEDs that translates the elegant movements of flocking birds into an ever-morphing light show. The installation is one of several *Swarm Studies* by the art group that create sensory environments to explore the intelligence of self-organizing systems. Viewers are invited to experience architecture as an organic phenomenon.

50°50'22.3"N 12°55'46.9"E

EUROPE — GERMANY

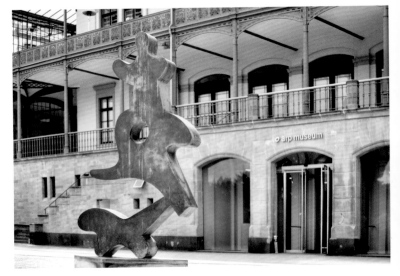

HANS ARP, BEWEGTES TANZGESCHMEIDE [MOVING DANCE JEWELERY], 1960/1970

Arp Museum Bahnhof Rolandseck, Hans-Arp-Allee 1, 53424 Remagen

Arp is known for his organic, biomorphic forms. This huge abstract sculpture belongs to a group of works by the artist referred to as *Schwellenplastiken* [threshold sculptures], which are more architectural than organic in style. The large bronze piece marks the start of a riverside sculpture trail, which features thirteen works along an 8.7-mile (14 km) stretch of the Rhine.

EUROPE — GERMANY

ROSEMARIE TROCKEL, FRANKFURTER ENGEL [FRANKFURT ANGEL], 1994

Klaus-Mann-Platz, 60547 Frankfurt am Main

This statue of an angel with its right wing cut and its head nearly severed from its neck—symbolizing resilience despite pain and injury—is a memorial to homosexuals persecuted and murdered in Nazi Germany. A brief text in German on the base remembers the men and women who suffered.

NAM JUNE PAIK, PRE-BELL-MAN, 1990

Museum for Communication Frankfurt, Schaumainkai 53,
60596 Frankfurt am Main

Paik's robot knight on horseback stands guard outside the Museum for
Communication Frankfurt. The bronze steed is based on an ornament
the artist acquired from a thrift store, and the figure is constructed from old
television sets, Bakelite radios, and various antiquated equipment that
reflect the museum's contents. Paik was known for his vintage tech robots.
This one even lights up at night.

EUROPE — GERMANY

HERMAN DE VRIES, THE MEADOW, 1986

Near Eschenau, 97478 Knetzgau

De Vries purchased this land, about 0.3 miles (0.5 km) south of Eschenau, in 1986 and allowed it to remain irregular and uncultivated. In this state, the site becomes a commentary on the agricultural development of the Bavarian countryside—a reminder of the dwindling forest in the area and a bulwark against the surrounding commercialized land.

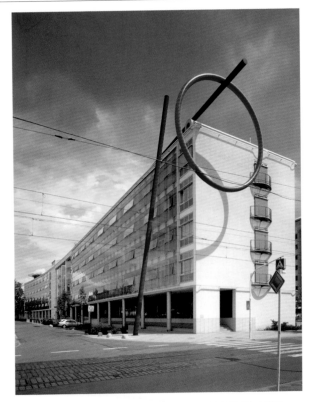

KAZUO KATASE, RING DES SEYNS [RING OF BEING], 1999

Klinikum Ludwigshafen, Bremserstrasse 79,
67063 Ludwigshafen am Rhein

This monumental sculpture by Japanese conceptual artist Katase displays both balance and tension. An 82-foot-high (25 m) Cor-Ten steel tube reclines against the exterior of Ludwigshafen Hospital, while a red ring 32.8 feet (10 m) in diameter hangs from another tube that rests on the roof. The piece continues inside, where a neon ring that illuminates when it darkens outside alludes to the cycle of life.

EUROPE — GERMANY

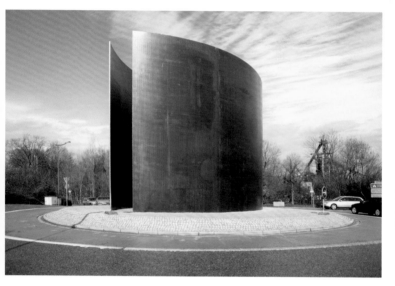

EUROPE — GERMANY

RICHARD SERRA, VIEWPOINT, 2006 ⭕

Roundabout at Saarlouiser Strasse and Merziger Strasse,
66763 Dillingen

This gargantuan sculpture, composed of two curved steel plates that stand
29.5 feet (9 m) tall, towers over a roundabout near the headquarters
of Dillinger Hütte, the company that fabricated many of Serra's best-known
works. A gift to the city of Dillingen, the sculpture stands in recognition of
the close relationship between the city, the steelworks, and Serra.

49°21'01.9"N 6°43'52.6"E

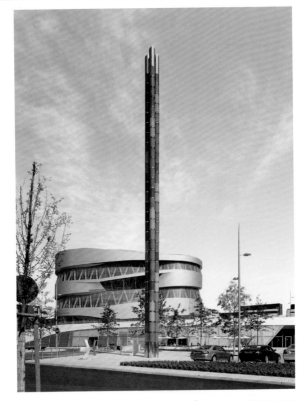

MAX BILL, BILDSÄULEN-DREIERGRUPPE [THREE STANDING FIGURES], 1989

Mercedes-Benz Museum, Mercedesstrasse 100, 70372 Stuttgart

The ground plan of this multicolored sculptural tower is derived from the three-pointed Mercedes star, which has been the German car manufacturer's logo since 1909. The three slender steel columns are colored according to a set of strict mathematical rules. It typifies the interdisciplinary approach developed by Bill, whose abstract works proposed a synthesis of painting, sculpture, and architecture.

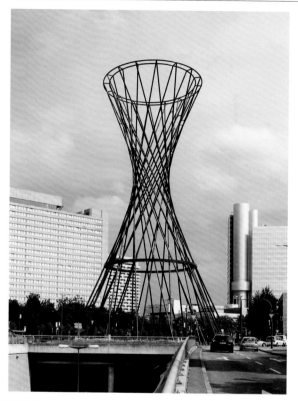

RITA MCBRIDE, MAE WEST, 2011

Effnerplatz, 81679 Munich

This enormous sculpture resembles the hourglass figure of Mae West, the voluptuous 1930s movie star. Towering above motorists, the 170.6-foot-tall (52 m) structure is made from carbon fiber, a material chosen for its aesthetic qualities and sculptural versatility. Indeed, McBride's ambitious work, which fuses elements of minimalism, industrial design, and architecture, would have been virtually impossible to realize in steel.

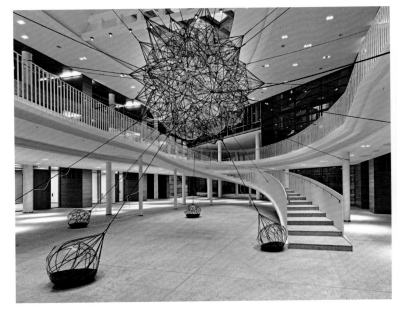

TOMÁS SARACENO, FLYING GARDEN (M32), 2007

European Patent Office, Bob-van-Benthem-Platz 1, 80469 Munich

A cloud of transparent balloons is held in place by a network of black cords. Located in a central stairwell, the experimental sculpture is a proposition for floating housing. It belongs to the artist's *Air-Port-City* project, which suggests alternative, sustainable living arrangements. Like a utopian architect, Saraceno develops innovative approaches to inhabiting our overpopulated planet.

EUROPE — GERMANY

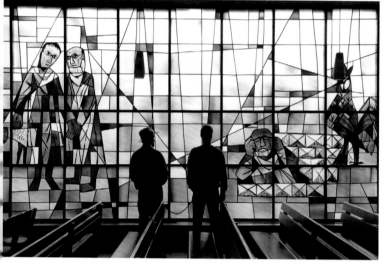

OTTO DIX, CHRISTUS UND PETRUS [CHRIST AND PETER], 1959

Petruskirche in Kattenhorn, Oberhaldenstrasse 1, 78337 Öhningen

For a small protestant church near his home, Dix created two stained glass windows, colorfully rendered in the angular, expressionist style of his painting. Behind the altar, Jesus is depicted with fish; along the sidewall, the story of the Denial of Peter, with a crowing rooster. Nearby, Dix's former home and studio is now a museum, displaying original furniture and artwork.

EUROPE — AUSTRIA

JITISH KALLAT, HERE AFTER HERE AFTER HERE, 2012–15

Roundabout off Donauufer Autobahn, 2000 Stockerau

This looping steel sculpture was commissioned for a traffic roundabout near Vienna. Kallat designed the work to evoke mythic diagrams of eternity and geometry with the symbols of today's world (the color and font mimic European road signage). The twisted signs announce the actual distances to faraway world capitals.

BRIGITTE KOWANZ, FOUNTAIN, 2015–17

Glanzstoff Austria Factory, Herzogenburger Strasse 69,
3100 St. Pölten

A curved beam of light emerges from the top of the tower of this former
textile factory, arcing toward the ground below. The busy Glanzstoff plant
was a prominent presence in St. Pölten until a fire forced its closure in
2008. Kowanz, using light as her medium, reinvigorated the site, suggesting
an optimistic, postindustrial future.

48°13'01.8"N 15°38'11.4"E

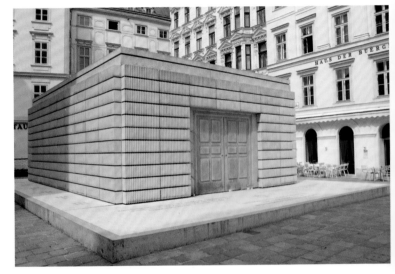

RACHEL WHITEREAD, HOLOCAUST MEMORIAL, 2000 ⭕

Judenplatz, 1010 Vienna

This memorial, also known as the "Nameless Library," is a part of a pedestrian square in Vienna. Dedicated to the 65,000 Austrian Jews killed during the Holocaust, its exterior is surfaced with cast library shelves lined with thousands of nameless books (their spines face inward) to represent Jews as the People of the Book and to highlight the immense number of victims.

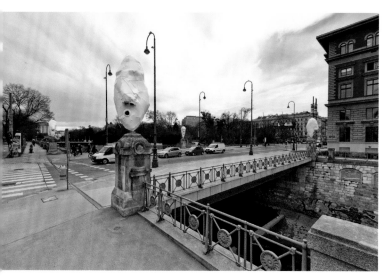

EUROPE — AUSTRIA

FRANZ WEST, 4 LARVAE (LEMUR HEADS), 2001 ⬤

Stubenbrücke, 1030 Vienna

During an interview, West once described an expression that refers to people seeing lemurs in the bed as a way of describing the peculiar sensation of awakening with a hangover. These lemur heads adorn the pylons of the Stubenbrücke, where their connection to the Wien river below prompts associations of free-flowing creativity.

EUROPE — AUSTRIA

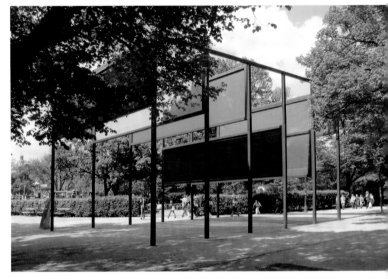

DONALD JUDD, STAGE SET, 1991

Stadtpark, 1030 Vienna

Six rectangles of colored fabric are mounted within a frame of gray steel.
Hung at varying heights, the panels of material introduce an ordered visual
rhythm to Stadtpark that contrasts with the nearby trees and plants.
The simplicity of this work is typical of Judd, who created objects that
referred to nothing outside of themselves.

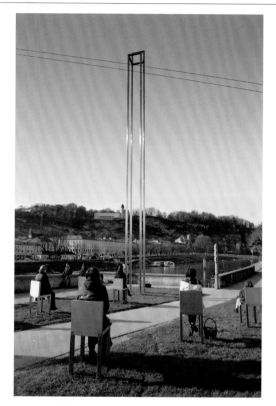

EUROPE — AUSTRIA

MARINA ABRAMOVIĆ, SPIRIT OF MOZART, 2004

Schwarzstrasse and Staatsbrücke, 5020 Salzburg

Salzburg's Walk of Modern Art features works that offer visual interpretations of the cultural and historical identity of Salzburg. Thirteen prominent artists created the pieces, including Abramović. Her *Spirit of Mozart* is an installation designed to let visitors sit in tranquil contemplation, in the company of the spirit of a certain famous composer. (He's in the tall chair.)

**FLORIAN HÜTTNER, UNTERSCHLUPF (SCHILDKRÖTE),
[HIDEAWAY (TURTLES)], 2015**

Near Blaa Alm, Lichtersberg 73, 8992 Altaussee

What appears to be a prehistoric cave painting is actually a rendition of a 1941 underground anti-fascist group poster, "Partisans, on the weapons!" The piece is situated in the Ausseerland—a contentious area of Austria during World War II—along a mountain trek that includes politically engaged works by Clegg & Guttmann, Eva Grubinger, and others.

SWITZERLAND

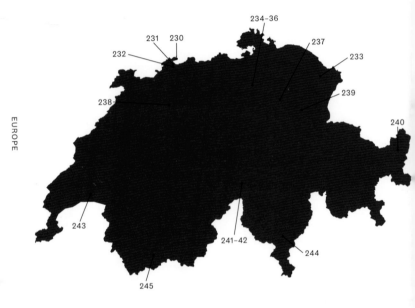

234–36
231 230
232
237
233
238
239
240
243
241–42
244
245

EUROPE — SWITZERLAND

THOMAS SCHÜTTE, HASE [HARE], 2013

Fondation Beyeler, Baselstrasse 101, 4125 Riehen/Basel

The rumpled, squat form of Schütte's grotesquely anthropomorphic hare originally emerged while he was working with modeling clay. Installed in a pond, the sculpture is based on a small figure made by the artist's daughter to celebrate Easter, which was stationed on Schütte's desk for years. The initial clay version was eventually enlarged and cast in bronze, and it now permanently inhabits the Beyeler Foundation's garden.

EUROPE — SWITZERLAND

ILYA KABAKOV, DENKMAL FÜR EINEN VERLORENEN HANDSCHUH [MONUMENT TO A LOST GLOVE], 1998

Rheinpromenade, opposite Kunstmuseum Basel | Gegenwart, 4052 Basel

On a small plot of land near the Rhine in Basel lies a red glove surrounded by nine metal tablets on poles. A narrative describing an individual's encounter with the lost glove is engraved onto each tablet. These emotive accounts offer evidence that an ordinary inanimate, innocuous object can acquire emotional value if it triggers a memory.

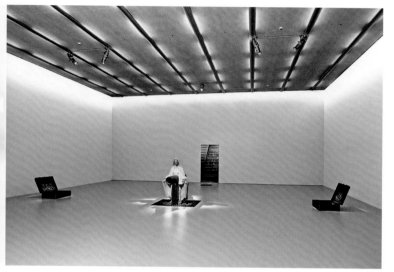

ROBERT GOBER, UNTITLED, 1995–97 ●

Schaulager, Ruchfeldstrasse 19, 4142 Münchenstein

At the center of this multiple-part installation is a large concrete Madonna with a pipe jutting from her abdomen. She is framed by two open suitcases, which offer views into a grotto below. Behind her, water flows down a set of wooden stairs into a floor drain. Water and drains, common references in Gober's work, suggest a drive toward cleanliness and purity.

47°31'41.6"N 7°36'38.9"E

PIPILOTTI RIST AND CARLOS MARTINEZ ARCHITEKTEN, STADTLOUNGE [CITY LOUNGE], 2005

Raiffeisenplatz, 9000 St. Gallen

This collaboration between Rist and Carlos Martinez Architekten brightens St. Gallen's financial district and encourages visitors to linger outdoors. Intended as a public living room, the all-red *Stadtlounge* includes built-in tables and chairs for picnicking, sofas for lounging, and benches with full-length tables large enough for hosting outdoor meetings.

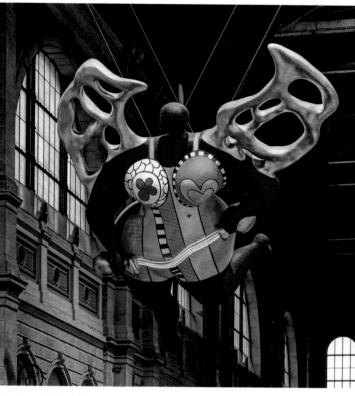

EUROPE — SWITZERLAND

NIKI DE SAINT PHALLE, L'ANGE PROTECTEUR [GUARDIAN ANGEL], 1997 ⭕

Zurich Central Station, Bahnhofplatz, 8001 Zurich

A voluptuous, brightly colored angel dangles gracefully from the ceiling of Zurich's main railway station. Whether commuters are guarded by this opulent sculpture is second to her undimmed energy, which steers their gazes upward. The figure is the same as the one standing atop the chapel in de Saint Phalle's Tarot Garden in Italy and represents the Temperance card of the tarot deck.

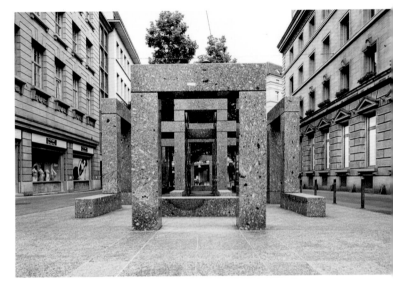

MAX BILL, PAVILLON SKULPTUR [PAVILION SCULPTURE], 1983

Bahnhofstrasse and Pelikanstrasse, 8001 Zurich

This granite piece is indeed both a pavilion and a sculpture, as the title suggests. It is composed of identical slabs configured vertically and horizontally. Beyond its aesthetic appeal, it has a pragmatic use: people can sit on some of the horizontal slabs. Bill was multitalented, with interest in art and architecture, among other fields.

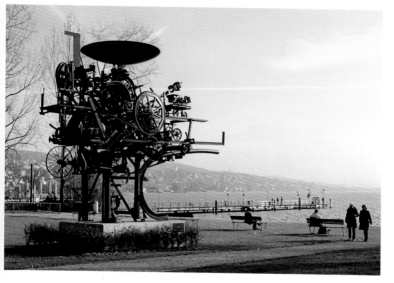

JEAN TINGUELY, HEUREKA [EUREKA], 1964

Zürichhorn, 8008 Zurich

○

This kinetic sculpture is Tinguely's first public commission. Originally exhibited at Expo64 in Lausanne, Switzerland, it was relocated to Zürichhorn in 1967. The work's title is Ancient Greek for "I have found [it]" and suggests the concepts of problem-solving and learning. Its antic form, weathered surfaces, and clattering mechanics are a riposte to increasingly anonymous, shiny, and noiseless technologies.

47°21'10.9"N 8°33'08.3"E

EUROPE — SWITZERLAND

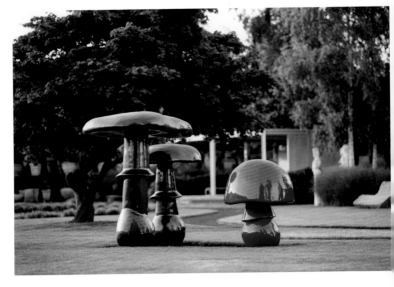

SYLVIE FLEURY, MUSHROOMS, 2013

Enea Baummuseum, Buechstrasse 12, 8645 Rapperswil-Jona

These fiberglass mushrooms are coated with metallic auto paint. Their artificial colors and oversize proportions evoke the fantastic fungi of *Alice's Adventures in Wonderland* (1865) or psychoactive plants used by shamans. The Enea Tree Museum, where Fleury's piece resides, was designed by Swiss landscape architect Enzo Enea and boasts more than twenty-five species of trees alongside sculptures by contemporary artists.

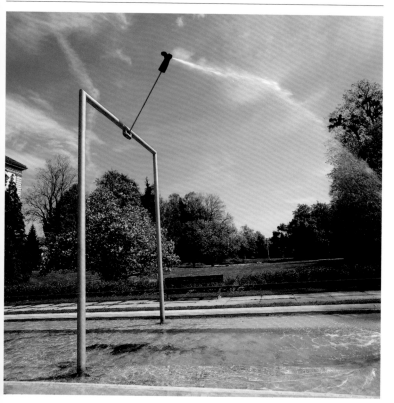

ROMAN SIGNER, BOOT (FOUNTAIN SCULPTURE), 2004

Kunstmuseum Solothurn, Werkhofstrasse 30, 4500 Solothurn

EUROPE — SWITZERLAND

This unusual fountain consists of an old boot hanging from a metal frame over a pool of water. Every so often a jet of water shoots out of the heel, propelling the footwear forward and leaving it swinging like a pendulum. Displayed in front of the Kunstmuseum Solothurn, Signer's fountain is typical of the artist's dynamic "action sculptures."

ANYA GALLACCIO, BLESSED, 1999

Atelier Amden, 8873 Amden

Atelier Amden, which is geared toward fostering and exhibiting nature-based art, was a natural destination for Gallaccio, who favors organic materials. While there, she created multiple artworks involving apple trees, including *Blessed*, a row of seven trees that she planted. The trees later inspired some ephemeral projects, including one in which she hung gilded apples from them.

NOT VITAL, STAGE, 2011

Not dal mot, Via Veglia Vers Scuol, 7554 Sent

A

In a clearing in the Swiss Alps, an iron staircase leads from the soil to a raised platform. This deconstructed stage lacks an auditorium, a backstage area, and an audience, but it remains theatrical against the picturesque backdrop. The park where the piece resides includes a number of sculptures by Vital, all of which, like *Stage*, play to the scenic condition of the surrounding landscape.

46°48'57.1"N 10°19'52.0"E

DANIEL BUREN, UNTITLED, 1987

Hotel Furkablick, Furka Pass

The painted shutters of this former nineteenth-century hotel are characteristic of Buren's work, which has employed uniform stripes since the 1960s. Prior to its restoration in the late 1980s by the architecture firm OMA, the hotel was bought by gallerist Marc Hostettler, who invited artists, including Buren, to perform and intervene in the building's landscape. Buren painted the shutters with pigment designed to resist fading from sun exposure.

46°34'34.9"N 8°25'18.1"E

JENNY HOLZER, UNTITLED, 1991

Hiking trail above Hotel Furkablick, Furka Pass

"Your oldest fears are the worst ones," reads a phrase engraved on a stone beside the narrow Furka Pass, one of several texts from Holzer's *Truisms* (1977–79) discreetly inserted by the artist into the picturesque Alpine landscape. Based on clichés and intended to critique marketing jargon, Holzer's *Truisms* have regularly appeared in the public realm on billboards and electronic displays and, as here, engraved into stone.

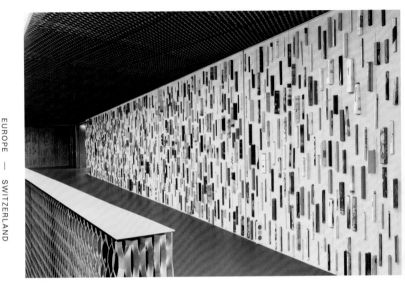

SOPHIE BOUVIER AUSLÄNDER, WAYS OF WORLDMAKING, **A**
2016

Gymnase de Renens, Avenue du Silo 1, 1020 Renens

For a Swiss high school, Bouvier Ausländer created an open library with a long
wall filled with 1,300 art books. In a world of computers and smartphones,
the library engages digitally native students with physical books. Her selection
is arranged according to color and size, and each volume is housed in a made-
to-measure compartment.

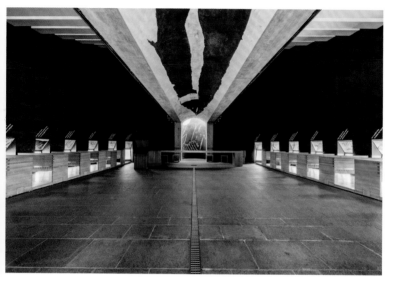

EUROPE — SWITZERLAND

ENZO CUCCHI, LA DISEGNA [THE DRAWING], 1994 ●

Santa Maria degli Angeli Chapel, Alpe Foppa, Monte Tamaro,
6802 Rivera

Paintings by Cucchi adorn two areas of this innovative chapel designed
by architect Mario Botta. On the vaulted ceiling above the footbridge
is an elongated cypress tree, perhaps symbolizing the limits of this world.
The apse—painted a deep blue—features a pair of cupped, open hands
that evoke a sense of offering, welcome, and reception.

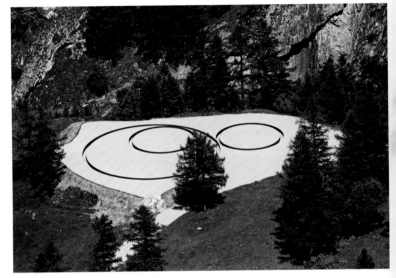

**MICHAEL HEIZER, TANGENTIAL CIRCULAR
NEGATIVE LINE, 1968–2012**

Mauvoisin, Bagnes

During the 1960s, Heizer created ephemeral circular drawings in the Nevada
desert by riding his motorcycle. More than forty years later, he made a
permanent version of the piece in the Swiss Alps—a more varied landscape
than the vast and mostly uniform desert terrain. Here, the circles that were
originally wheel tracks in the sand are made from steel trenches in gravel.

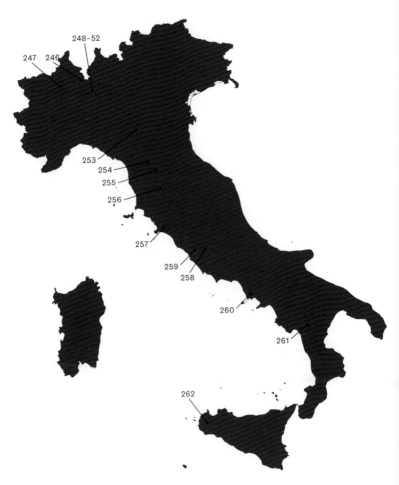

248–52

247 246

253

254

255

256

257

259

258

260

261

262

EUROPE — ITALY

ROBERT IRWIN, VARESE PORTAL ROOM, 1973–76

Villa Panza, Piazza Litta 1, 21100 Varese

Collector Giuseppe Panza di Biumo was an early enthusiast of the Light and Space movement. His former estate—now a museum showcasing artworks from his collection—includes a number of site-specific installations, including this one by Irwin. A subtle intervention in a simple white room, Irwin's piece plays with natural light and the building's architecture to shift the viewer's perception of the space.

45°49'30.2"N 8°49'44.0"E

ROMAN SIGNER, HORLOGE [CLOCK], 2012

Lanificio Zegna, Via Roma 99, 13835 Trivero

This clock has no hands. Instead, time is marked by a jet of steam that blasts from its face every fifteen minutes. Signer's simple yet powerful meditation on the fleeting nature of time is part of Fondazione Zegna's growing collection of contemporary artworks. It is on display at the wool mill of Zegna, the Italian luxury menswear brand, in the Trivero mountains.

45°40'08.6"N 8°09'40.6"E

ANSELM KIEFER, THE SEVEN HEAVENLY PALACES, 2004–15 ●

Pirelli HangarBicocca, Via Chiese 2, 20126 Milan

This installation, conceived by the artist for a contemporary art space in Milan in 2004, originally featured towers of shipping-container "palaces." In 2015 it opened to the public, augmented with five large-scale paintings. It offers an immersive, 3-D experience of many of the themes that permeate Kiefer's work: the heavens, the earth, and the detritus of human history.

WOLF VOSTELL, QUINTA DEL SORDO, DAS HAUS DES TAUBEN [DEAF MAN'S VILLA, PIGEON COUP], 1974

Fondazione Mudima, Via Alessandro Tadino 26, 20124 Milan

Inspired by Francisco Goya's black paintings, Vostell's installation consists of a black-tiled swimming pool surrounded by fourteen panels depicting scenes from the Vietnam War and a series of monitors set on different frequencies. Originally presented at documenta 6 in Kassel, it was relocated to Milan in 1989, where it is visible through a basement door and a glass manhole on the upper floor.

EUROPE — ITALY

MAURIZIO CATTELAN, L.O.V.E., 2010

Piazza Affari, 20123 Milan

Cattelan's colossal middle finger sends an unambiguous message in front of the Italian stock exchange (located in a fascist-era building). The title of the work, inscribed on the sculpture, is an acronym (translated from Italian) for "freedom, hate, vengeance, eternity." The other fingers on the hand are severed, suggesting an amputated fascist salute.

ROBERT GOBER, UNTITLED, 2014–15,
ARMS AND LEGS WALLPAPER, 1995–2015

A

Fondazione Prada, Largo Isarco 2, 20139 Milan

Gober's installation at Fondazione Prada is located in a semisecluded part of the former distillery dubbed the "Haunted House." Visitors climb four floors to experience a series of intimate and uncanny sculptures displayed across several rooms, including *Untitled* and *Arms and Legs Wallpaper*, pictured here. Also on display in the Haunted House are two works by Louise Bourgeois.

DAN FLAVIN, UNTITLED, 1997

Santa Maria Annunciata in Chiesa Rossa, Via Neera 24, 20141 Milan

The priest of Santa Maria Annunciata invited Flavin to create a site-specific work for the 1930s-era church as part of its restoration project. Flavin's resulting light installation suffuses the church space with shifting hues that guide the progression through the nave and evoke the gradual transition between night, dawn, and finally daylight.

45°25'58.6"N 9°10'41.0"E

JASON DODGE, A PERMANENTLY OPEN WINDOW, 2013

Via Fratelli Cervi 61, 42124 Reggio Emilia

Dodge created a subtle three-part intervention in a former electrical power plant, visible only to those aware of the presence of an artwork— a permanently opened window on top of the tower, two double wooden doors, and a sculpture inside. The invisible network formed by this triptych replaces the high-voltage cables that once ran through the tower.

EUROPE — ITALY

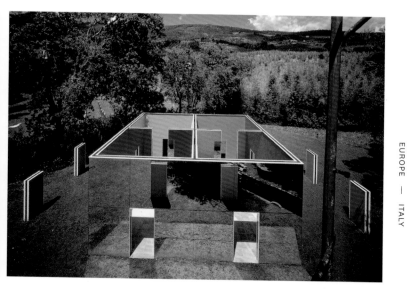

EUROPE — ITALY

DANIEL BUREN, LA CABANE ÉCLATÉE AUX 4 SALLES [THE EXPLODED CABIN WITH 4 ROOMS], 2005

●

Collezione Gori, Fattoria di Celle, Via Montalese 7,
51100 Santomato di Pistoia

The Italian collector Giuliano Gori founded Fattoria di Celle (Celle Farm)
to display what would grow to become a collection of nearly seventy site-
specific works that respond to the surrounding landscape. Buren's mirror-
covered structure plays with the viewer's perception, its edges blurring and
vanishing into its setting. Door-sized openings reveal the visual trick and
offer glimpses of the multicolored interior.

43°56'49.3"N 10°58'55.1"E

EUROPE — ITALY

MICHELANGELO PISTOLETTO, DIETROFRONT [ABOUT-TURN], 1981–84

Piazzale di Porta Romana, 50125 Florence

In this arresting sculpture, a female figure is balanced precariously on the head of another. From the roundabout in front of Porta Romana gate, where it is installed, one woman faces toward Rome while the other faces back toward the historic center. Pistoletto reminds viewers that modernity's roots are found in Renaissance Florence, the city that transformed the world.

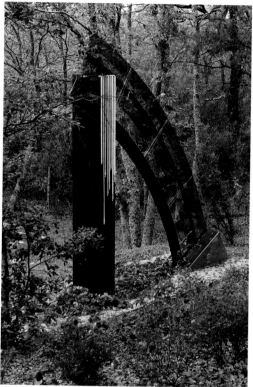

EUROPE — ITALY

FEDERICA MARANGONI, RAINBOW CRASH, 2002

Parco Sculture del Chianti, Loc. La Fornace 48/49, 53010 Pievasciata

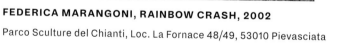

Marangoni used colored Murano glass and neon in this sculpture at Chianti Sculpture Park. Her rainbow is vibrant but broken, its colors smashed to the ground in the form of glass shards. The fragility of nature is a recurring theme in many of the artworks here, nestled in the Tuscan woodland setting.

43°23'40.1"N 11°22'50.8"E

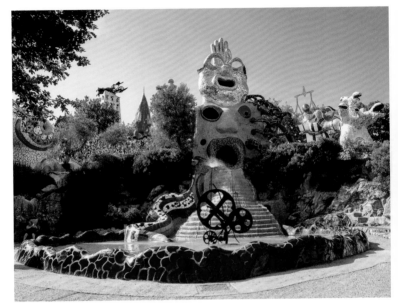

NIKI DE SAINT PHALLE, IL GIARDINO DEI TAROCCHI [TAROT GARDEN], 1979–98

●

Il Giardino dei Tarocchi, Località Garavicchio, 58011 Pescia Fiorentina

This magical site in Tuscany is a garden of monumental sculptures, created from concrete and mosaic, depicting the twenty-two Major Arcana cards of the tarot deck. De Saint Phalle began her work on Giardino dei Tarocchi in 1978, conceiving the space as a kind of wonderland. The garden opened to the public in May 1998, and the artist continued to work on it until her death in 2002.

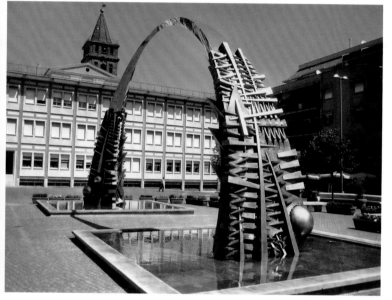

EUROPE — ITALY

**ARNALDO POMODORO, ARCO PER TIVOLI
[THE TIVOLI ARCH], 2007**

Piazza Garibaldi, 00019 Tivoli

The two bases of an arch, wrapped in complex meshes of geometric bronze, are anchored into two adjacent pools. As the bases rise to meet, the arch sheds the mesh and reveals its smooth steel. Pomodoro's sculpture suggests the rising of order from chaos but also seems to warn of a return to disarray. It stands in Tivoli's Piazza Garibaldi as a gateway to the town's historic center.

41°57'41.1"N 12°47'47.7"E

ARNALDO POMODORO, SFERA CON SFERA [SPHERE WITHIN A SPHERE], 1989–90

Cortile della Pigna, Vatican Museums, 00120 Vatican City

Fractured bronze orbs are Pomodoro's signature form. His piece for the Vatican became the first in a series of *Sfera con Sfera* sculptures, in which the crack reveals another smaller sphere inside. Here, the two spheres symbolize the relationship between mankind and religion. From its location in the Pinecone Courtyard, the sculpture also echoes the shape of the nearby dome of St. Peter's Basilica.

EUROPE — ITALY

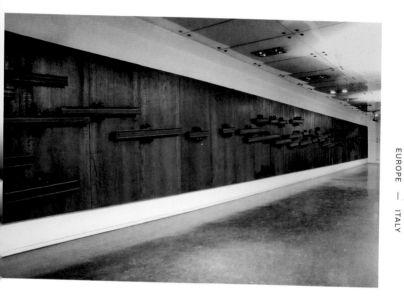

JANNIS KOUNELLIS, UNTITLED, 2001

Dante metro station, Piazza Dante, 80135 Naples

Kounellis often used industrial materials to create dynamic installations, a familiar technique among artists associated with Arte Povera. His piece in the train station of Piazza Dante in Naples depicts traveling as a metaphor for life. Horizontal beams, resembling railroad tracks, are attached to a metal sheet, and a hat, a coat, shoes, and toy trains serve as anchors while also suggesting the presence of people.

40°50'55.8"N 14°14'58.9"E

ANISH KAPOOR, EARTH CINEMA, 1995

Terme Lucane, Contrada Calda, 85043 Latronico

This artwork in Pollino National Park allows visitors to explore and experience space below the earth's surface. The installation is a 148-foot (45 m) passageway that has been cut into and through a small hill. Inside this subterranean corridor, visitors encounter a void that functions like a cinema screen, displaying shadows of the vegetation above.

EUROPE — ITALY

ALBERTO BURRI, GRANDE CRETTO GIBELLINA [THE LARGE CRACK OF GIBELLINA], 1985–2015

Ruderi di Gibellina, Gibellina, Sicily

Years after a 1968 earthquake destroyed the town of Gibellina, Burri was invited to create a monument to the Sicilian city and its inhabitants. The artist began covering the ruins in his trademark cracked white concrete, preserving only the street layout. The epic project was finally completed twenty years after Burri's death.

37°47'17.1"N 12°58'16.6"E

RUSSIA, ESTONIA, LITHUANIA, POLAND, CZECH REPUBLIC, ROMANIA

RUSSIA

263–64

ESTONIA

265

LITHUANIA

266

POLAND

268

267

CZECH REPUBLIC

269

270

ROMANIA

271

ALEKSANDR DEINEKA, 24 HOURS IN THE LANDS OF THE SOVIETS, 1938

O

Mayakovskaya metro station, Triumfalnaya Square, 125047 Moscow

Moscow is renowned for the opulent stations of its metro system, which was built during Stalin's rule. One of the most famous is Mayakovskaya station. Along the platform, stainless steel arches alternate to create thirty-four domed niches in the ceiling, each of which is decorated with an intricate mosaic illustration of scenes of the sky.

EUROPE — RUSSIA

**MIHAIL CHEMIAKIN, CHILDREN ARE THE VICTIMS
OF ADULT VICES, 2001**

Bolotnaya Square, 119072 Moscow

A menagerie of evil creatures, each representing a different adult vice—including
drug addiction, prostitution, and alcoholism—threatens two blindfolded children.
Amid the beasts is a four-armed figure that embodies indifference. Located in a
Moscow park close to the Kremlin, Chemiakin's fifteen-figure sculpture implores
viewers to fight for the safety of future generations.

LUKAS KÜHNE, CROMATICO, 2011

Tallinn Song Festival Grounds, Narva maantee 95, 10127 Tallinn

This tiered, concrete sculpture resides on Tallinn's Song Festival grounds. The city hosts tens of thousands of amateur choral singers for the festival—a national tradition since the nineteenth century. Kühne created *Cromatico* as an experiential and architectural realization of the musical scale, with each of the twelve echoing chambers producing sound at distinctive pitches.

EUROPE — LITHUANIA

SOL LEWITT, DOUBLE NEGATIVE PYRAMID, 1999

Europos Parkas, Joneikiskiu k., 15148 Vilnius

The hills, woods, and grasslands of this 135.9-acre (0.55 sq km) sculpture park include more than one hundred modern works by international artists, including the park's founder, Gintaras Karosas. One notable large-scale piece is LeWitt's 18.4-foot-high (5.6 m), 39.4-foot-wide (12 m) pyramid made of concrete blocks. The sculpture's strong visual presence is amplified by its reflection in the water.

54°49'50.6"N 25°21'05.9"E

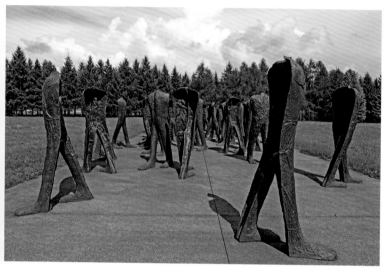

MAGDALENA ABAKANOWICZ, NIEROZPOZNANI [UNRECOGNISED], 2001–2

Park Cytadela, Aleja Armii Poznań and Szelągowska, 60 101 Poznań

A vast hillside park, formerly the site of a nineteenth-century Prussian fort, displays Abakanowicz's group of 112 cast-iron figures. Their rusty, headless bodies are hollowed out, forming a ghostly horde of striding torsos that prompt meditation on the human condition. A smaller group of Abakanowicz's mysterious figures are displayed in the inner court of Poznań's Imperial Castle.

52°25'18.9"N 16°56'08.1"E

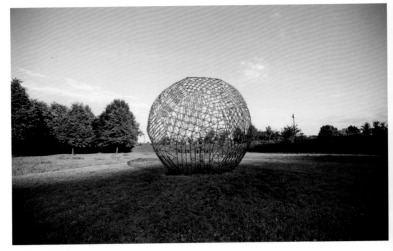

MONIKA SOSNOWSKA, GRATING, 2009

Bródno Sculpture Park, Kondratowicza and Chodecka,
03 337 Warsaw

This spherical sculpture made from steel bars is inspired by the patterns of the window gratings protecting local apartments and stores in the Bródno district of Warsaw. The residential area is also home to Bródno Sculpture Park, formerly a local park and now an open-air gallery, which aims to make contemporary art a part of everyday life.

EUROPE — POLAND

DAVID ČERNÝ, HOSTINA OBRŮ [FEAST OF GIANTS], 2005

Sokolská u zdi Bus Stop, Náměstí Dr. E. Beneše and Sokolská, 460 01 Liberec

Černý's bus shelter in Liberec conveys a caustic critique of the city's connection to Nazism during World War II. Various symbolic items sit on the bronze table, including Czech and German beer steins, a toppled menorah, and a vase of Venus flytraps. The head of former Czech politician Konrad Henlein, a member of the Nazi Party, appears to be the main course.

50°46'15.6"N 15°03'33.9"E

DAVID ČERNÝ, TOWER BABIES, 1995/2000

Žižkov Television Tower, Mahlerovy sady 1, 130 00 Prague 3

Following an invitation to create a sculptural intervention on Žižkov Television Tower, a Communist-era structure in Prague, Černý created ten massive fiberglass babies, which are installed to appear as if they are crawling on the side of the tower. The project was intended to be short term, but it was so popular with local residents that it was permanently installed.

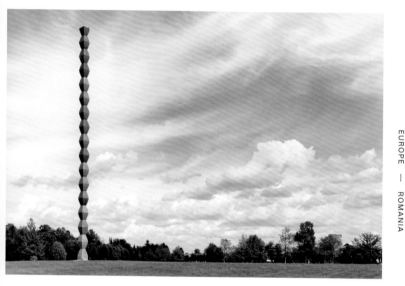

EUROPE — ROMANIA

CONSTANTIN BRANCUSI, ENDLESS COLUMN, 1938 ⭕

Endless Column Park, Calea Eroilor 94, Târgu Jiu

Brancusi's famous column—composed of truncated pyramids connected at their bases and their tops—symbolizes infinity and manifests the potential for vertical expansion in sculpture. The column and its nearby companion sculptures, *Table of Silence* and *The Kiss Gate*, together comprise Brancusi's Sculptural Ensemble (1937–38), which commemorates the Romanian heroes of World War I.

45°02'14.7"N 23°17'07.3"E

ALBANIA, GREECE, TURKEY

ALBANIA

GREECE

272

273

274

TURKEY

275

EUROPE — ALBANIA

ALBANIAN UTOPIA—TIRANA, 2000 ⬤

Various locations throughout Tirana

After he was elected mayor of Tirana in 2000, the artist Edi Rama initiated a project to paint the city's buildings—gray and dilapidated—in bright colors and ornate patterns. Rama believed that beauty could enhance people's lives and revive a sense of civic responsibility. The initiative lives on, with international artists realizing designs for facades throughout the city.

EUROPE — GREECE

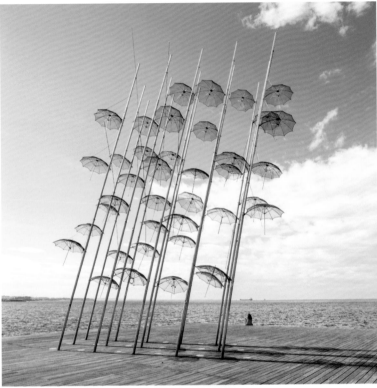

GEORGE ZONGOLOPOULOS, UMBRELLAS, 1997

Nea Paralia, Leoforos Megalou Alexandrou, Thessaloniki 54641

A cloud of Zongolopoulos's signature umbrellas rises high above the wooden decking on Thessaloniki's seafront. Attached to thrusting diagonal poles, the transparent canopies change color with the weather. At night, the installation is illuminated by electric light. Installed during the year that the city was designated the European Capital of Culture, the playful sculpture has become a popular local landmark.

40°37'18.7"N 22°57'05.0"E

EUROPE — GREECE

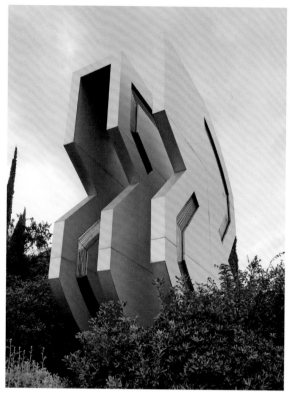

CHRYSSA, CLYTEMNESTRA, 1992

Megaron Concert Hall, Vasilissis Sofias and Petrou Kokkali,
Athens 11521

This abstract sculpture was inspired by a 1968 production of Euripides's
Greek tragedy *Iphigenia in Aulis*, in which Irene Pappas starred as
Clytemnestra. Pappas's powerful performance moved Chryssa to design this
abstract steel form named after her character. Chryssa, a pioneer of light art,
designed the piece to be illuminated by colored neon at night.

37°58'52.4"N 23°45'17.4"E

EUROPE — TURKEY

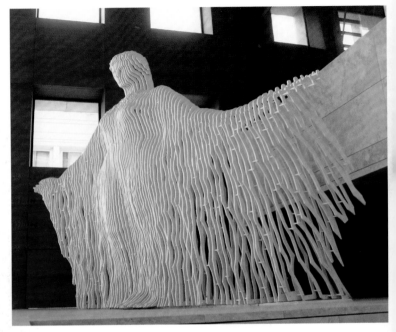

ILHAN KOMAN, AKDENIZ, 1978–80

Yapı Kredi Kültür Sanat, İstiklal Caddesi No. 161, 34433 Beyoğlu, Istanbul

Through the multistory glass wall of Istanbul's newly renovated Yapı Kredi Culture and Art center, passersby on Istiklal Avenue—one of the city's most famous streets—can catch a glimpse of Koman's sculpture standing majestically with open arms in the exposed stairway. This is the sculpture's new home, relocated after being damaged during protests in 2014 at its original location in the Levent district.

AFRICA

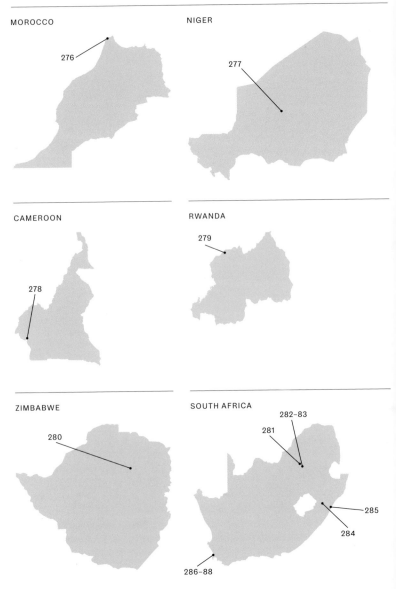

MOROCCO

276

NIGER

277

CAMEROON

278

RWANDA

279

ZIMBABWE

280

SOUTH AFRICA

282–83

281

285

284

286–88

Text visible in image: · GRANDE SALLE · صندوق · CAISSE · AUTOURD'HUI OPERATION 171 CASABLANCA DIMANCHE 16h ... CENTRAL PARK 19h30

AFRICA — MOROCCO

YTO BARRADA, CINÉMATHÈQUE DE TANGER [TANGIER CINEMA], 2006

Place du 9 Avril 1947, Grand Socco, Tangier

Barrada founded this independent cinema in an art deco building in the Casbah—previously home to the historic Cinema Rif—to showcase Morocco's rich filmmaking history and offer a social and cultural center for the community. Regular programming from the archive of Arabic and Maghreb films, and other archives, aims to "promote world cinema in Morocco and Moroccan cinema in the world."

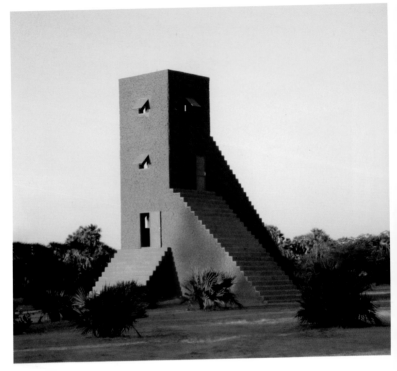

AFRICA — NIGER

NOT VITAL, HOUSE TO WATCH THE SUNSET, 2005

Aladab, near Agadez

A longtime fascination with the nomadic lifestyle of the Tuareg people led Vital to Niger in 1999. One of a group of structures by the artist in Agadez that includes a school, a mosque, and several houses, this tower is purpose-built for viewing the sunset over the desert, with staircases leading from each floor to follow the sun as it moves.

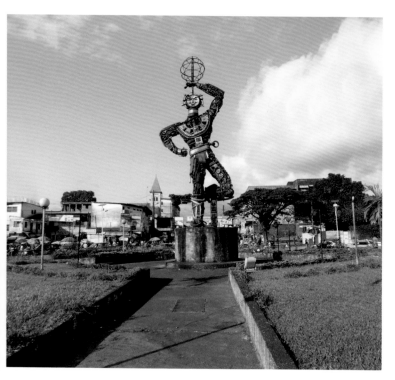

JOSEPH-FRANCIS SUMÉGNÉ, LA NOUVELLE LIBERTÉ [THE NEW FREEDOM], 1996

Rond-Point Deïdo, Douala

Commissioned by doual'art, a Cameroonian arts organization, this dancing figure with the radiant Sun King face was initially decried by elites but is now integrated into the urban fabric of Deïdo, one of Douala's oldest districts. The 32.8-foot (10 m) sculpture is typical of Sumegne's figurative style and recombinant method, which extracts value and function from consumer waste.

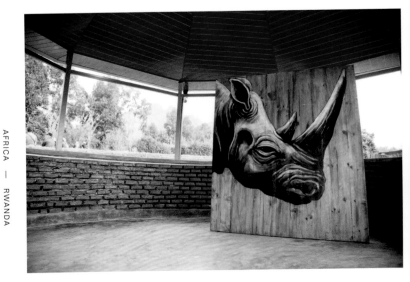

ROA, EASTERN AFRICAN BLACK RHINO, 2017

Volcanoes National Park Headquarters, Kinigi

The conservation-minded Belgian street artist ROA is known for his outsize depictions of animals on urban facades. The theme continued in his 2017 visit to Rwanda, resulting notably in a 49-foot (15 m) mural of an okapi in Kigali. ROA also visited the mountainous Musanze district, where he created a striking trio of panels that includes this rhino as well as a sunbird and a mountain gorilla.

L. BARTA, UNTITLED MOSAIC, 1956

National Gallery of Zimbabwe, 20 Julius Nyerere Way, Harare

The museum in Harare was a British colonial project of Rhodesia, erected in 1955. Its colorful mosaic facade over the entryway is believed to have been created by Cecilia McEwen, whose husband was the director (she signed the work "L. Barta" to avoid charges of nepotism). Since the revolution in 1981, the museum has stood as a leading venue for contemporary African art.

17°49'30.2"S 31°02'56.3"E

AFRICA — ZIMBABWE

AFRICA — SOUTH AFRICA

JEREMY ROSE, MANDELA CELL, 2014 A

Nirox Foundation Sculpture Park, R540 near R374, Krugersdorp

This concrete structure mirrors the dimensions of Nelson Mandela's cell on Robben Island, where he was incarcerated from 1964 to 1982. The park's 37 acres (0.15 sq km) of landscaped gardens, where Rose's sculpture sits, are themselves set within a vast nature reserve. All the park's sculptures, by artists including Richard Long, Caroline Bitterman, and Priyanka Choudahry, are products of residencies.

AFRICA — SOUTH AFRICA

WILLIAM KENTRIDGE WITH GERHARD MARX, FIRE WALKER, 2009

○

Foot of the Queen Elizabeth Bridge, Newtown, Johannesburg

This sculpture, standing 36 feet (11 m) high at the base of Queen Elizabeth Bridge, was commissioned by the city of Johannesburg to commemorate the 2010 FIFA World Cup. Kentridge and Marx took the opportunity to monumentalize a familiar figure within the city—the "fire walker," a female street vendor, shown here with a brazier of hot food balanced on her head.

26°11'57.9"S 28°02'16.5"E

AFRICA — SOUTH AFRICA

GERHARD MARX AND MAJA MARX, PAPER PIGEONS, 2009

Main Reef and Albertina Sisulu Roads, Ferreirasdorp, Johannesburg

Attracted by the discovery of gold, Chinese migrants began arriving in South Africa in the 1870s. A trio of painted steel pigeon sculptures, each measuring 9.8 feet (3 m) tall, commemorates their contributions to the city: the form of the pigeons is loosely based on Chinese paper-folding techniques. Perching rods invite real-life pigeons to rest on the sculptures.

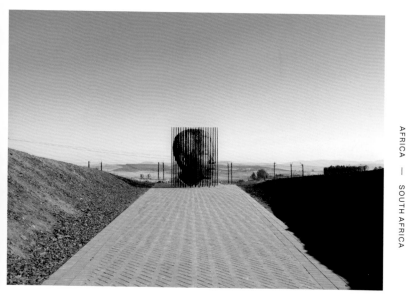

AFRICA — SOUTH AFRICA

MARCO CIANFANELLI, RELEASE, 2012

Nelson Mandela Capture Site, R103 near Howick

This public monument is located along the country road where Nelson Mandela was captured by authorities in 1962, during apartheid. It is composed of fifty laser-cut steel columns embedded in a landscaped approach created by Jeremy Rose. As viewers near the anamorphic sculpture, standing about 114.9 feet (35 m) tall, the vertical fragments cohere into a flat image of the revered political leader.

29°28'06.7"S 30°10'12.5"E 315

AFRICA — SOUTH AFRICA

ANDRIES BOTHA, WARWICK TRIANGLE ELEPHANTS, 2014

N3 near North Old Dutch Road, Warwick Junction, Durban

Botha's small herd of elephants gained unexpected notoriety in February 2010. A councillor from the African National Congress party complained that the sculptures too closely resembled the logo of the opposition Inkatha Freedom Party. The original elephants were destroyed, but following resolution of a legal dispute, a new set of four elephants was unveileved in 2015 in the originally planned location.

29°51'16.6"S 31°00'33.1"E

MICHELE MATHISON, ANGULAR MASS, 2018 ⊙

V&A Waterfront, Silo District, South Arm Road, Cape Town

During the construction of the Zeitz Museum of Contemporary Art Africa, located in a former grain silo, Mathison was invited to make a work using obsolete machinery from the site. His work displays five cast-iron flywheels that had powered the original grain elevators. Although static, the orientation of these naturally weathered parts evokes perpetual motion.

BRETT MURRAY, AFRICA, 2000

St. George's Mall and Waterkant Street, Cape Town

This painted bronze sculpture features an outsize Nigerian ancestral figure used in rituals bedecked with Bart Simpson heads. The work offers a satirical comment on converging cultural paradigms in postapartheid South Africa. City officials initially vetoed its installation along a busy pedestrian walkway but later capitulated when the artist submitted expert testimonials by Nigerian intellectuals.

JACQUES COETZER, OPEN HOUSE, 2015

Dorp and Long Streets, Cape Town

In 2014, on the twentieth anniversary of democratic rule in South Africa, Coetzer won a state sculpture commission with his proposal to erect a freestanding facade with balconies easily accessible from the street. The work promotes free dialogue and social engagement, as declared by its "open" sign. Its form references nearby Victorian buildings, while its metal cladding gestures to a common building material in poor communities.

MIDDLE EAST

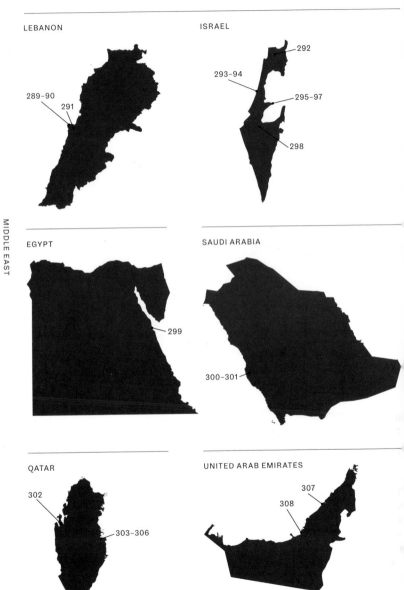

LEBANON

289–90
291

ISRAEL

292
293–94
295–97
298

EGYPT

299

SAUDI ARABIA

300–301

QATAR

302
303–306

UNITED ARAB EMIRATES

307
308

320

JEAN DUBUFFET, TOUR DENTELLIÈRE [TOWER OF LACE], 2001 (FROM A 1974 MODEL)

Bank Audi Palladium Building, Omar Daouk Street, Bab Idriss, Beirut

This sculpture was one of various possible designs for concealing a subway ventilation device in Brussels. Though never realized, the work found a home in Beirut, in the entrance hall of Bank Audi's head office. Hollow on the inside, and with an intricate painted pattern on the exterior, the 19.7-foot-tall (6 m) piece evokes both the sense of weightiness and delicacy of its title.

MIDDLE EAST — LEBANON

SALOUA RAOUDA CHOUCAIR, POEM-BENCH, 1969/1998

Amir Amin Square, Beirut Central District, Beirut

Choucair, a Lebanese abstract artist known for her obsession with geometry, created this bench from seventeen pieces of stone, which she interlocked like pieces of a puzzle into a half-moon shape. The company in charge of downtown Beirut's post–civil war reconstruction purchased the bench for Amir Amin Square and installed it as two pieces. It stands as both artwork and functional urban furniture.

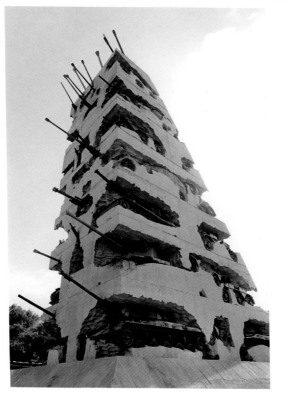

ARMAN, HOPE FOR PEACE, 1995

⭕

Near the Ministry of National Defense, Yarze

Arman's monumental sculpture commemorates the end of Lebanon's fifteen-year civil war and memorializes a lasting wish for peace. Using his characteristic style of accumulation—bringing together masses of similar objects—Arman created a concrete column into which about eighty military vehicles are embedded. As he explained at the piece's unveiling, the structure renders the vehicles "forever still and silent."

33°50'22.8"N 35°33'27.4"E

MIDDLE EAST — ISRAEL

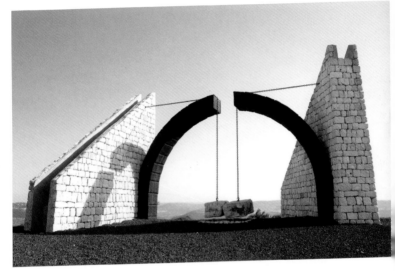

ILAN AVERBUCH, DIVIDED WORLD, 2000

Lavon Industrial Park, Shoham Street, Lavon

In Averbuch's monumental sculpture, the two halves of a divided stone arch appear to be frozen in space, just short of merging or collapsing. The piece embodies a delicate balance while framing views of the Galilean landscape below. The sculpture is found in Lavon Industrial Park, a project devoted to industrial innovation and fostering cultural experiences.

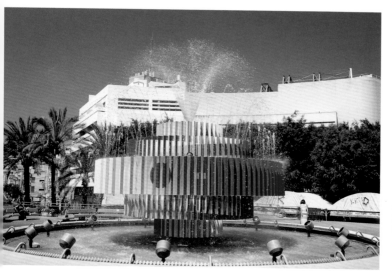

YAACOV AGAM, FIRE AND WATER FOUNTAIN, 1986

Dizengoff Square, Tel Aviv

Set in the newly renovated Dizengoff Square, this sculpture—by an Israeli artist internationally renowned for his contributions to kinetic art—is iconic of Tel Aviv and of Agam's art. The colorful geometrical shapes on the wheels' surfaces appear to shift as the sculpture rotates or as the viewer changes vantage point, while jets of fire and water create a spectacular display.

32°04'40.5"N 34°46'27.1"E

MIDDLE EAST — ISRAEL

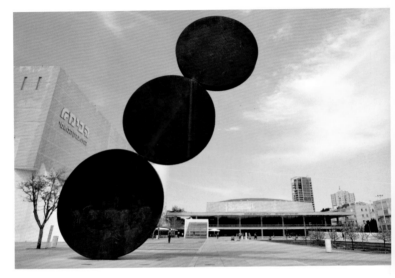

MENASHE KADISHMAN, UPRISE, 1967–74

Habima Square, Sderot Tarsat 2, Tel Aviv

The diagonal lean of this 50-foot-tall (15.2 m) Cor-Ten steel sculpture gives the impression that the three circles are defying gravity. The work's upward trajectory and inherent tension between balance and collapse allude to the inflation and general economic instability of Israel during the period in which Kadishman, a Tel Aviv native, made this work.

32°04'20.0"N 34°46'45.5"E

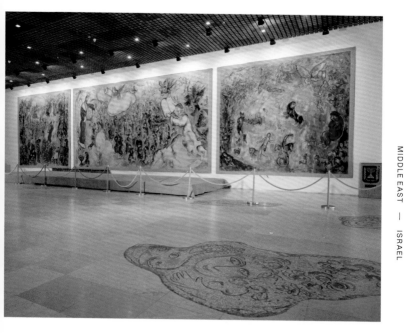

MARC CHAGALL, THE CHAGALL HALL TAPESTRIES, 1965–68

A

Chagall State Hall, Knesset, Jerusalem

Chagall created a triptych of vibrant tapestries for a foyer that hosts national ceremonies and events in the Parliament building. He first made three paintings, which depict biblical stories, topics in modern Jewish history, and imagery from the artist's childhood in Russia. Weavers then produced tapestry versions of the paintings, using over one hundred colors and shades of thread. Thirteen mosaics by Chagall also adorn the hall.

MIDDLE EAST — ISRAEL

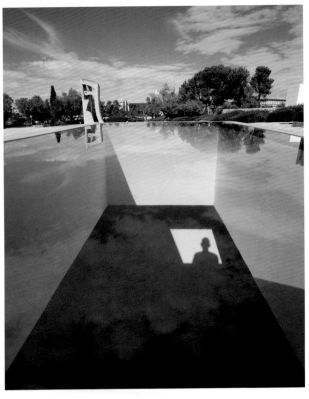

MICHA ULLMAN, EQUINOX, 2005–9

Billy Rose Art Garden, Israel Museum, Derech Ruppin 11, Jerusalem

A window in the ground reveals a subterranean chamber. The sun projects the viewer's shadow into the space, and twice yearly, during the spring and fall equinoxes, a "door" of sunlight to an unlit corridor appears. Ullman's installation is a part of the Isamu Noguchi–designed Billy Rose Art Garden, where an extensive collection of works by international artists is on display.

MIDDLE EAST — ISRAEL

NIKI DE SAINT PHALLE, GOLEM, 1972 ⊙

Rabinovich Park, Ya'akov Tahon and Chile Streets, Kiryat HaYovel,
Jerusalem

According to Hebrew folklore, a golem is an artificial being endowed with
life. De Saint Phalle, an artist known for her colorful, exuberant approach
to painting and monumental sculpture, created this playground slide in
the form of a golem, which is brought to life by the children who slide down
its three bright-red tongues.

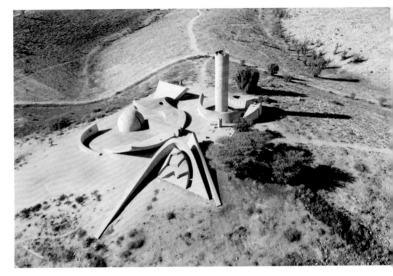

DANI KARAVAN, NEGEV MONUMENT, 1963–68

Ma'ale HaHativa Street, Ramot, Beersheba

To say the *Negev Monument* is made of concrete would not be entirely correct: Karavan also lists sunlight, trees, and wind as components of this environmental sculpture, which is designed to be climbed and explored. The piece honors Palmach Negev Brigade soldiers who died during the first Arab-Israeli war, in 1948; forms such as a gunfire-riddled watchtower represent wartime events.

31°15'59.4"N 34°49'14.9"E

MIDDLE EAST — EGYPT

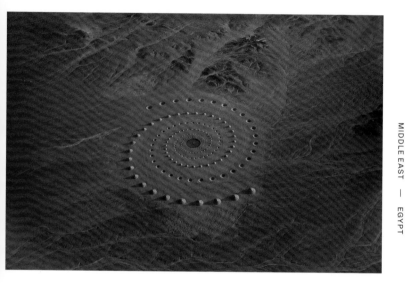

D.A.ST. ARTEAM, DESERT BREATH, 1997

Near El Gouna

Gazing at a vast desert landscape can feel like experiencing infinity. In this 25-acre (0.1 sq km) Land Art piece, interlocking spirals express that sensation. The artists formed the spirals with a series of convex and concave cones of sand. A pool of water that was originally at the center has evaporated, and the cones have been disintegrating, marking the passage of time.

27°22'54.59"N 33°37'48.46"E

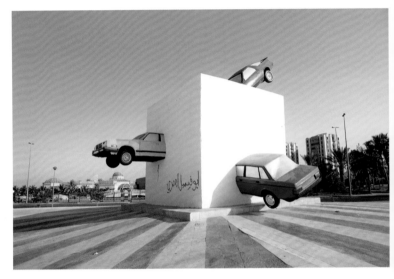

JULIO LAFUENTE, LANDMARK, 1986

Corniche Road, Ash Shati, Northern Corniche, Jeddah

In the 1970s, architect-sculptor Lafuente began participating in a project to create landmarks in the rapidly developing city of Jeddah. One result was this sculpture, which depicts five cars that have crashed headfirst into a cube of concrete. The unforgettable artwork serves as both a landmark and a safety warning.

JOAN MIRÓ, PROJECT FOR A MONUMENT, 1981

Jeddah Sculpture Museum, Corniche Road, Al-Hamra'a, Jeddah

The commissioning of public artwork by major artists was part of an urban development plan in Jeddah in the 1970s and '80s. Those artworks, damaged from exposure to wind and salt, were restored in 2013 and are now displayed in an open-air museum dedicated to them. Among the works on view is this bronze by Miró, cast by the artist at age eighty-seven.

MIDDLE EAST — SAUDI ARABIA

MIDDLE EAST — QATAR

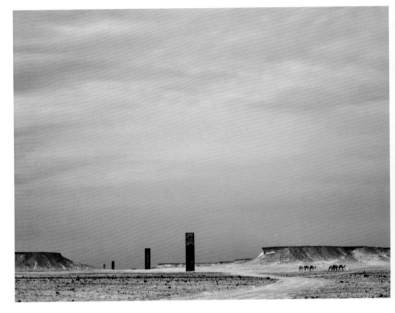

RICHARD SERRA, EAST-WEST/WEST-EAST, 2014 ⚫

Brouq Nature Reserve

These vast steel plates were erected in the remote Zekreet desert on the west coast of Qatar. Located in the Brouq Nature Reserve, the vast installation is Serra's largest public artwork. It occupies a 0.62 mile (1 km) corridor, with each monolithic plate carefully aligned with the surrounding plateaus and rising to more than 45.9 feet (14 m) tall.

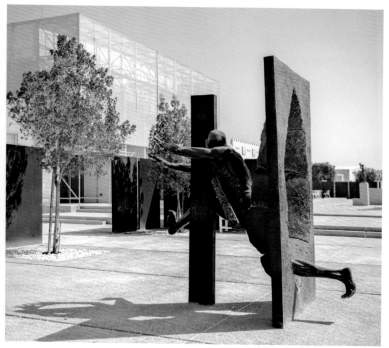

SAMI MOHAMMED, PENETRATION, 2010

Mathaf: Arab Museum of Modern Art, Education City, Doha

In this dynamic bronze sculpture, a muscular figure bursts through a solid wall. Mohammed, whose work deals with issues of oppression and suffering, designed the work as a call to perseverance in the face of hardships. By depicting an anonymous man's fight for freedom, the Kuwaiti artist speaks viscerally not to a specific context but to the human condition itself.

25°18'38.3"N 51°25'09.4"E

MIDDLE EAST — QATAR

SALOUA RAOUDA CHOUCAIR, BENCH, 1969–71

Museum of Islamic Art Park, Doha

Situated in the relaxing surroundings of the Museum of Islamic Art's growing sculpture park, this curved stone bench provides an opportunity to rest while looking across the bay to Richard Serra's *7* (2011), the tallest public sculpture in Qatar. Choucair's bench is formed from seventeen blocks of fine-grained limestone, fitted together like giant jigsaw pieces. The crisp, white stone contains many intriguing fossils, including various gastropods.

MIDDLE EAST — QATAR

SARAH LUCAS, PERCEVAL, 2006

Aspire Park, Doha

O

Situated in the largest park in Qatar, Lucas's first public artwork is a life-size Shire horse pulling a cart containing two oversized marrows. The artist is known for presenting everyday objects in new and unusual contexts. This bronze sculpture is no exception: it is an enlarged replica of a kitsch ceramic ornament popular in the 1940s and '50s in the United Kingdom.

URS FISCHER, UNTITLED (LAMP/BEAR), 2005-6

A

Hamad International Airport, Duty Free Plaza, Doha

Fischer's whimsically oversize sculpture of a teddy bear and a desk lamp offers a moment of curiosity and delight for travelers in Doha's Hamad International Airport. Interpretations vary from caustic to poetic—some think it presents a tart commentary on the gadgets and toys on sale in duty-free shops, while others believe it transforms childhood memories into a metaphor for traveling.

25°15'40.3"N 51°36'48.4"E

JAUME PLENSA, WORLD VOICES, 2009-10

Burj Khalifa Residential Lobby, 1 Sheikh Mohammed bin Rashid
Boulevard, Dubai

Burj Khalifa, the famous skyscraper, attracts people from around the globe.
In this lobby installation, which celebrates international communication, rods
rise like reeds from the bottoms of pools. Suspended from the rods are 196
cymbals, representing all the countries of the world. Falling droplets of water
hit the cymbals and create sounds of many timbres, symbolizing the diversity
of the world's voices.

25°11'49.5"N 55°16'26.3"E

GIUSEPPE PENONE, GERMINATION, 2017

Louvre Abu Dhabi, Saadiyat Cultural District, Abu Dhabi

A bronze tree with mirrors in its branches is the central element of Penone's installation at the Jean Nouvel–designed Louvre Abu Dhabi, reflecting the dance of light from the museum's spectacular roof. Other elements include a tiled wall containing patterns representing Sheikh Zayed's thumbprint and a vase made with clay from around the world. The work embodies Penone's interest in the relationship between humanity, nature, and art.

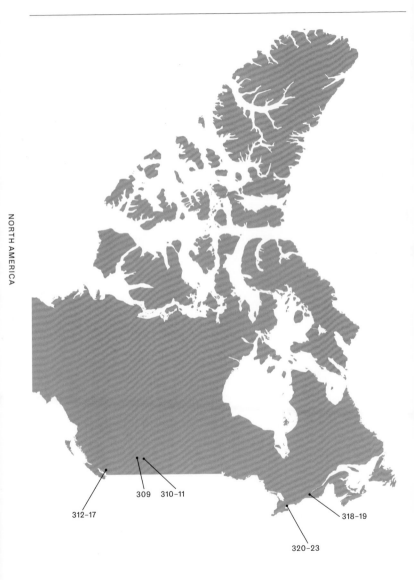

312-17

309 310-11

318-19

320-23

JANET CARDIFF, FOREST WALK, 1991

Walter Phillips Gallery, Banff Centre for Arts and Creativity,
107 Tunnel Mountain Drive, Banff, AB T1L 1H5

Through headphones, visitors are guided through the woods by the artist's spoken directions. Audio walks are a central component of Cardiff's practice, reflecting her interest in the way sound can affect perceptions of the physical world. Complete with sound effects, *Forest Walk* was her first audio walk, a rudimentary but charming prototype for all that followed.

JULIAN OPIE, PROMENADE, 2012 ⬤

Fourth Street SE and Dermot Baldwin Way SE, Calgary, AB T2G 0G1

On the edge of Calgary's East Village, six animated figures walk around a four-sided LED tower. Each faceless character, rendered in Opie's signature pared-down style, is based on a person known by the artist. Jeremy, Jennifer, Rod, Tina, Verity, and Kris all walk at different speeds in a perpetual flow of movement that echoes the passing pedestrians.

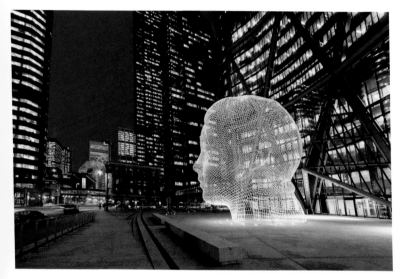

JAUME PLENSA, WONDERLAND, 2008–12 ⬤

The Bow, 500 Centre Street S, Calgary, AB T2G 0E3

This 39.4-foot-tall (12 m) sculpture of a head is based on a twelve-year-old Spanish girl named Anna and typifies Plensa's recurring interest in transparency. The stainless steel structure has two door-sized accesses to the interior, allowing visitors to explore the piece from the inside and see the city through its mesh-like surface.

51°02'51.7"N 114°03'43.5"W

NORTH AMERICA — CANADA

DOUGLAS COUPLAND, DIGITAL ORCA, 2009

Vancouver Convention Centre West Building, 1055 Canada Place,
Vancouver, BC V6C 0C3

Orcas are a familiar sight along Canada's west coast. Created from white-
and-black metal cubes, this pixelated representation of one looks as if it were
transported directly from the digital realm. Coupland's sculpture alludes
to the future of Coal Harbour's growing digital economy while also referencing
its history as a whaling station and a mining area.

DIANA THATER, LIGHT ART, 2005

Shaw Tower, 1067 West Cordova Street, Vancouver, BC V6C 3T5

This shaft of colored light is a prominent feature of Vancouver's nighttime skyline. Stretching 487 feet (148.4 m) from the bottom to the top of Shaw Tower, Thater's LED installation changes from green to blue to symbolize the transition from earth to sky. Clouds of artificial fog shroud the column's base, creating an ethereal atmosphere at street level.

49°17'18.9"N 123°07'04.8"W

LIAM GILLICK, LYING ON TOP OF A BUILDING... THE CLOUDS LOOKED NO NEARER THAN WHEN I WAS LYING ON THE STREET..., 2010

Fairmont Pacific Rim Hotel, 1038 Canada Place, Vancouver, BC V6C 0B9

Lines of text wrap around this forty-eight-story hotel and residential tower. The shiny steel letters were produced in Gillick's favored Helvetica Bold font. Legible from the street, the poetic text (also the work's title) suggests that the top of this luxury building is not a more privileged vantage point than the street below. The installation exemplifies the artist's interest in the intersection of high art and architectural design.

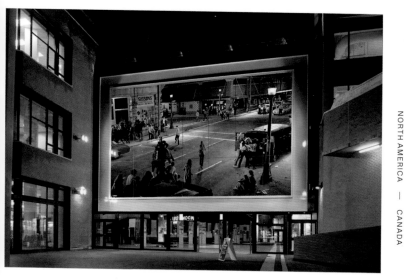

STAN DOUGLAS, ABBOTT & CORDOVA, 7 AUGUST 1971, 2009 ⊙

Woodward's Atrium, 128 West Cordova Street, Vancouver,
BC V6B 0G6

Douglas's first public artwork explores the history of the location where it
is displayed. Known for his assiduously staged tableaus, Douglas reimagined
the Gastown Riot, a 1971 standoff between hippies and Vancouver police.
An enormous photograph printed onto glass panels, it is a key feature
of the redevelopment of the site, which holds great cultural and historical
importance within the city.

49°16'57.2"N 123°06'27.4"W

NORTH AMERICA — CANADA

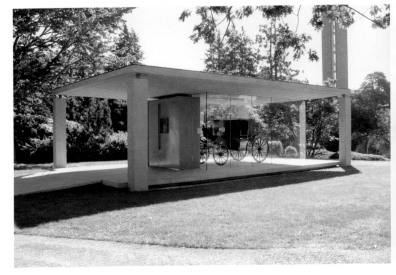

RODNEY GRAHAM, MILLENNIAL TIME MACHINE: A LANDAU CARRIAGE CONVERTED TO A MOBILE CAMERA OBSCURA, 2003

University of British Columbia, Main Mall and Memorial Road, Vancouver, BC V6T 1Z2

Graham once described this artwork as "a kind of time machine in which the spectators, looking forward, may see backwards." He created this effect by transforming a nineteenth-century carriage into a camera obscura; while sitting in the carriage, facing forward, viewers can see the camera's upside-down image of a sequoia tree that stands behind them.

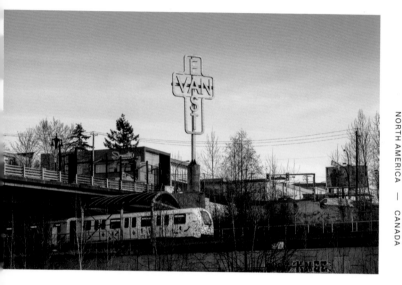

KEN LUM, MONUMENT FOR EAST VANCOUVER, 2010

Clark Drive and East Sixth Avenue, Vancouver, BC V5T 1E6

Born and raised in East Vancouver, Lum is familiar with the East Van cross, a graffiti symbol expressing community pride in this working-class side of the city. *Monument for East Vancouver* gives the underground icon a higher profile. Facing west, glowing with LEDs at night, Lum's 57-foot-high (17.4 m) cross reminds the city of its ongoing economic divide.

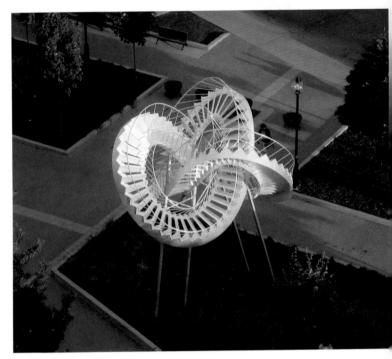

MICHEL DE BROIN, REVOLUTIONS, 2003

Near Papineau station, 1425 rue Cartier, Montreal, QC H2K 4C8

De Broin converted a prominent feature in Montreal's urban landscape—
a winding staircase—into an unrideable roller coaster, bestowing a circular,
impossible narrative on an architectural element normally associated with
functionality. The shape of the piece also refers to the lemniscate (the symbol
of infinity) and offers a poetic interpretation of the philosophical saying
"What goes up, must come down."

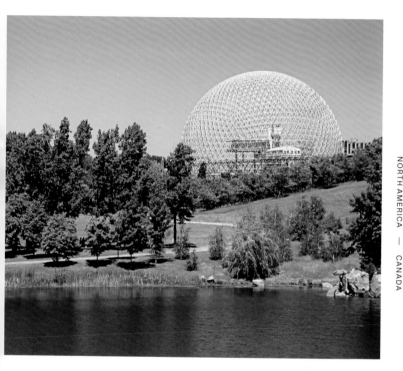

BUCKMINSTER FULLER, BIOSPHERE, 1967

Parc Jean-Drapeau, 1 circuit Gilles-Villeneuve, Montreal, QC H3C 1A9

This innovative freestanding structure was designed to host the US pavilion at the Expo 67 world's fair in Montreal. Based on the principle of "doing more with less," Fuller's geodesic domes offer a maximum amount of interior space in relation to exterior surface area. Since 1995 the dome has housed an environmental museum in Parc Jean-Drapeau, where fifteen public sculptures are on display, many of which were also created for Expo 67.

45°30'50.8"N 73°31'53.4"W

NORTH AMERICA — CANADA

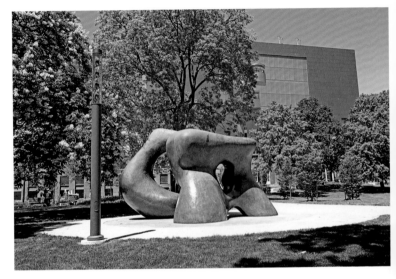

HENRY MOORE, LARGE TWO FORMS, 1969　　　　　　　　　　　　　●

Grange Park, 26 Grange Road W, Toronto, ON M5T 1C3

Moore's 8.8 ton (8 t) bronze was installed outside the Art Gallery of Ontario
in 1974, the same year the museum opened the Henry Moore Sculpture Centre.
Today the center boasts one of the most extensive collections of his work.
The sculpture is now located in a nearby park, where it can be enjoyed in
a recently revitalized green space.

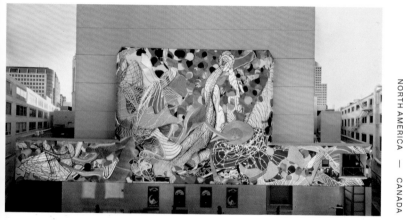

FRANK STELLA, MURAL, PRINCESS OF WALES THEATRE, 1994 ⬤

Princess of Wales Theatre, 300 King Street W, Toronto, ON M5V 1J2

Stella's works at the Princess of Wales Theatre in Toronto make up one of the largest mural commissions of the twentieth century. Passersby can enjoy the mural on the building's north-facing facade. Those with tickets to the theater can view Stella's laser-printed murals that adorn the lobbies and the sixty sections of bas-reliefs that cover the fronts of the balcony, dress circle, and ends of the aisles.

43°38'49.0"N 79°23'20.7"W

NORTH AMERICA — CANADA

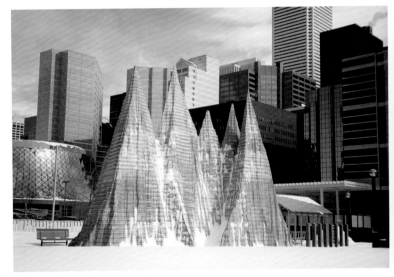

ANISH KAPOOR, MOUNTAIN, 1995

Simcoe Park, 240 Front Street W, Toronto, ON M5V 3K2

This metallic mountain range is made of 171 layers of water-jet-cut aluminum. It rises majestically above viewers, who are invited to slip between its craggy peaks, finding a contemplative space within the urban environment. One of Kapoor's first public sculptures, it marked a shift toward the ambitious, mirrored forms for which he later became renowned.

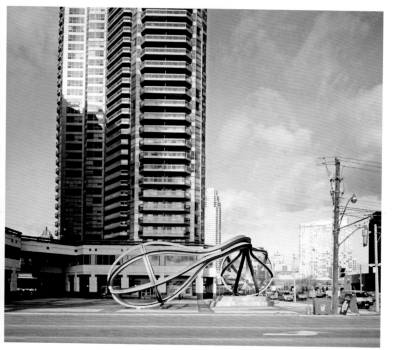

NORTH AMERICA — CANADA

RICHARD DEACON, BETWEEN THE EYES, 1990

Yonge Street and Queens Quay, Toronto, ON M5E 1R4

●

The sinuous forms of this steel sculpture coalesce into two bulbs. One appears deflated, sitting directly on the ground and facing Lake Ontario; the other, which looks fuller and faces north toward the city, is supported by a granite plinth. The monumental work invites consideration, but also play: Deacon intended it to be interacted with, walked through, and sat on.

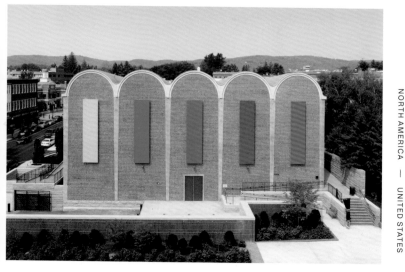

ELLSWORTH KELLY, DARTMOUTH PANELS, 2012

Spaulding Auditorium, Hopkins Center for the Arts,
Dartmouth College, 12 Lebanon Street, Hanover, NH 03755

Composed of five aluminum panels, each rendered in a single color, this
work reflects Kelly's long-standing interest in vibrant color and pure form—
and the intersection of these elements with the surrounding environment.
The rectilinear shapes play off the rounded roofline and reference the color
spectrum, the building blocks of visual experience.

43°42'04.4"N 72°17'15.3"W

SOL LEWITT, BARS OF COLOR WITHIN SQUARES (MIT), 2007

Green Center for Physics, Massachusetts Institute of Technology,
77 Massachusetts Avenue, Cambridge, MA 02139

LeWitt designed this vibrant artwork of bold, geometric patterns to cover
the entire floor of a U-shaped atrium at MIT's Green Center for Physics.
Covering nearly 5,500 square feet (511 sq m), the fifteen large squares are
each made of pieces of glass suspended in colored epoxy resins, which
yielded the luminous colors.

42°21'34.6"N 71°05'26.8"W

NORTH AMERICA — UNITED STATES

SOL LEWITT, WALL DRAWING #1259: LOOPY DOOPY (SPRINGFIELD), 2008

⭕

US Federal Courthouse, 300 State Street, Springfield, MA 01105

This 300-foot-long (91.4 m) mural is based on a pencil drawing made by LeWitt. The striking black-and-white design, like all the artist's wall drawings, was executed by assistants following detailed instructions. Installed on a curved wall outside the third-floor courtrooms of Springfield's federal courthouse, the piece can be seen from the street through the building's glass exterior.

42°06'16.8"N 72°34'58.6"W

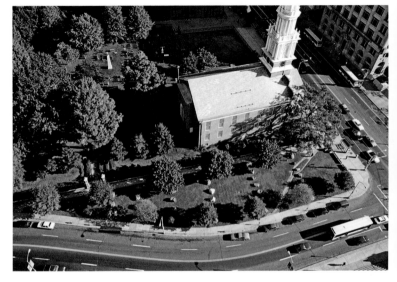

CARL ANDRE, STONE FIELD SCULPTURE, 1977 ⬤

Gold and Main Streets, Hartford, CT 06103

In this minimalist artwork, thirty-six glacial boulders are arranged in eight
rows of descending lengths, covering a triangular field. Andre used boulders
from the area, ranging in weight from 1,000 pounds (454 kg) to 11 tons
(10 t). He reportedly drew from a range of inspirations, from Stonehenge to
tombstones, and the installation prompts reflection on the enduring nature
of stone and the ephemerality of life.

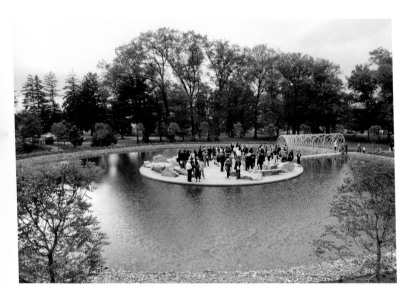

OLAFUR ELIASSON, THE PARLIAMENT OF REALITY, 2006–9 ⬤

Bard College, 60 Manor Avenue, near Richard B. Fisher Center for the
Performing Arts, Annandale-on-Hudson, NY 12504

This installation, made of a tree-ringed pond and a round island with
boulders for seating, offers a gathering space on Bard College's campus for
the open exchange of ideas. The Danish-Icelandic Eliasson was inspired
by Iceland's parliament, one of the oldest national legislatures in the world.
Patterns inscribed on the stone's surface recall nautical charts and symbolize
the navigation of ideas.

ROBERT IRWIN, GARDEN DESIGN, DIA:BEACON, RIGGIO GALLERIES, 2003

Dia:Beacon, 3 Beekman Street, Beacon, NY 12508

Irwin collaborated with the architecture firm OpenOffice to design Dia:Beacon's master plan, which tightly integrates building, functionality, and landscape. The parking lot doubles as an orchard; hornbeams frame the museum's entrance. The west garden, with rows of cherry trees, provides a spot to relax after exploring the museum's collection, which focuses on art from the 1960s and '70s (including works by Irwin).

41°30'02.9"N 73°58'59.7"W

DAVID SMITH, THE SITTING PRINTER, 1954–55

Storm King Art Center, 1 Museum Road, New Windsor, NY 12553

Located amid breathtaking scenery, Storm King houses an impressive collection of site-specific artworks by more than seventy artists. Even the park's grounds were sculpted with a curatorial vision in mind. A significant number of Smith's works can be seen here, including *The Sitting Printer*, an early sculpture assembled from cast-bronze components such as an old stool and a printer's type box.

HENRI MATISSE, THE ROSE WINDOW, 1956
(ADDITIONAL WINDOWS BY MARC CHAGALL)

Union Church of Pocantico Hills, 555 Bedford Road,
Pocantico Hills, NY 10591

When John D. Rockefeller Jr.'s first wife, Abby, died in 1948, their son Nelson
commissioned Henri Matisse to design a rose window for Union Church
in her honor. After Rockefeller's death in 1960, their children selected Marc
Chagall to create a window in his honor at the opposite end of the church.
He also designed eight additional windows for the church.

41°05'44.6"N 73°49'57.2"W

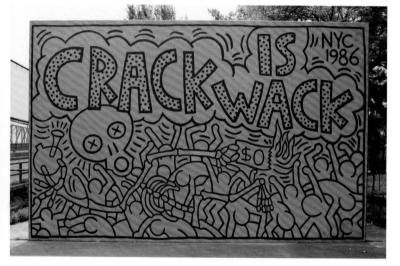

NORTH AMERICA — UNITED STATES

KEITH HARING, CRACK IS WACK, 1986

Crack Is Wack Playground, between East 127th Street, Second Avenue, and Harlem River Drive, New York, NY 10035

After a studio assistant became addicted to crack, Haring illicitly painted this doubled-sided mural in a location highly visible from a nearby highway. He was arrested and the mural was vandalized and painted over. Ultimately, Haring was fined only $100 and was given permission to repaint it. The piece became a potent symbol of the war on drugs.

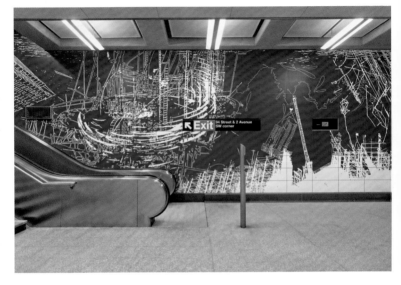

SARAH SZE, BLUEPRINT FOR A LANDSCAPE, 2017

96th Street station at Second Avenue, New York, NY 10128

This immersive installation decorates the interior of a New York subway station. Sze's dynamic blue-and-white designs, printed onto thousands of porcelain tiles, incorporate diverse influences: from Russian Constructivism and Italian Futurism to Japanese printmaking. A swirling patchwork of images, including billowing papers and bustling construction sites, surrounds viewers, evoking a powerful sense of movement in space.

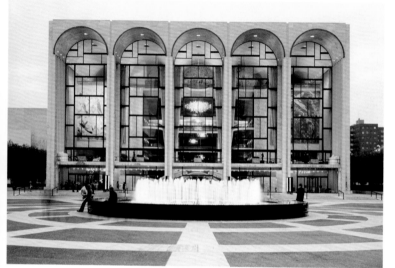

MARC CHAGALL, THE TRIUMPH OF MUSIC, 1966; THE SOURCES OF MUSIC, 1966

Metropolitan Opera House, 30 Lincoln Center Plaza,
New York, NY 10023

The Metropolitan Opera commissioned these two Chagall paintings for the opening of Lincoln Center, in 1966; they hang in the lobby but are visible from the plaza outside. The imagery, which includes ballet dancers, floating musicians, and buildings from the city's skyline, embraces the range of performing arts presented at Lincoln Center, in a style deeply affected by Russian folklore and Chagall's Hasidic roots.

40°46'21.6"N 73°59'02.6"W

ALICE AYCOCK, EAST RIVER ROUNDABOUT, 1995/2014 ⬤

John Finley Walk at East Sixtieth Street, New York, NY 10022

The weightlessness of Fred Astaire's dancing inspired this structure on the East River waterfront, a twisting aluminum helix attached to the skeletal steel roof of a former waste-transfer station. Aycock's striking design transformed the derelict site into an inviting public plaza that contrasts with the dynamic urban environment surrounding it.

<div style="float:right">NORTH AMERICA — UNITED STATES</div>

**LOUISE NEVELSON, THE CHAPEL OF THE GOOD
SHEPHERD, 1977**

Saint Peter's Church, 619 Lexington Avenue, New York, NY 10022

This tranquil chapel, which is used for prayer and meditation, offers a place
to escape the frenetic pace of New York City life. Nevelson designed all
the sculptures and furnishings in its five-sided sanctuary, which sits in the
heart of Midtown Manhattan. Her sculptural environment includes six
wooden abstract sculptures, each representing a different Christian theme.

40°45'31.7"N 73°58'14.0"W

NORTH AMERICA — UNITED STATES

MICHAEL HEIZER, LEVITATED MASS, 1982

590 Madison Avenue, New York, NY 10022

In this sculptural fountain, an 11-ton (10 t) rock appears to float above running water inside a stainless steel basin. The cryptic code on its surface references its address. Heizer, a pioneer of Land Art, is known for large-scale stone works that appear weightless or seem to defy gravity altogether. A much larger piece of the same name is installed at LACMA in Los Angeles.

JIM DINE, LOOKING TOWARD THE AVENUE, 1989

Calyon Building, 1301 Sixth Avenue, New York, NY 10019

In the heart of Midtown Manhattan stand Dine's three bronze variations of the Venus de Milo, the ancient Greek sculpture that epitomizes feminine beauty and love. They provide a striking visual contrast to the landscape of corporate skyscrapers. The figures are oriented toward Midtown landmarks—the tallest looks toward the Museum of Modern Art and St. Patrick's Cathedral, and the other two face toward Rockefeller Center.

40°45'40.9"N 73°58'46.7"W

NORTH AMERICA — UNITED STATES

**SOL LEWITT, WALL DRAWING: BANDS OF LINES IN FOUR COLORS
AND FOUR DIRECTIONS, SEPARATED BY GRAY BANDS, 1985** ⬤

Pedestrian arcade between West Fifty-First and West Fifty-Second
Streets, AXA Equitable Center, 787 Seventh Avenue, New York, NY 10019

Rectangular sections of horizontal, vertical, and diagonal stripes
are interspersed across two sides and six stories of a covered midblock
passageway. LeWitt's wall drawing echoes the geometric grid and linearity
of the architecture of the surrounding Midtown Manhattan neighborhood.
This wall drawing is one of several works commissioned for the AXA
Equitable Center and was unveiled to the public in 1986.

NORTH AMERICA — UNITED STATES

MAX NEUHAUS, TIMES SQUARE, 1977

Pedestrian island, Broadway between West Forty-Fifth and West
Forty-Sixth Streets, New York, NY 10036

Neuhaus's sound installation is hidden underneath one of New York City's
busiest areas. Invisible to passersby, the work produces a continuous
electronic drone that emanates from a subway grate. The sound's deliberate
regularity is audible over many of the city's ambient noises. Neuhaus has
permanent sound installations in several European venues but only one
other in the United States, at Dia:Beacon.

40°45'30.2"N 73°59'07.7"W

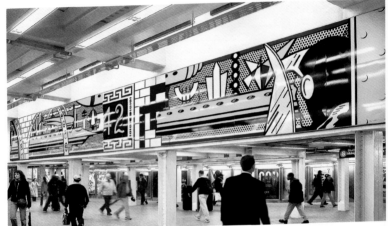

ROY LICHTENSTEIN, TIMES SQUARE MURAL, 1990 (FABRICATED 1994, INSTALLED 2002)

Times Square station, Times Square, New York, NY 10018

Lichtenstein's mural of porcelain, enamel, and steel in the Times Square subway station includes imagery informed by the popular language of comic books. References to New York City monuments and the subway itself are embedded in the design, including the number 42 that indicates the subway stop (Forty-Second Street), drawn in the style of the original ceramic tiles.

40°45'15.9"N 73°59'12.3"W

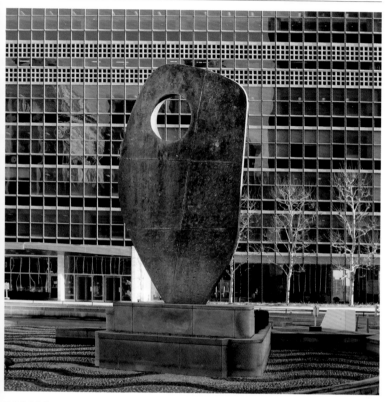

NORTH AMERICA — UNITED STATES

BARBARA HEPWORTH, SINGLE FORM, 1961–64

United Nations Headquarters, 405 East Forty-Second Street,
New York, NY 10017

At United Nations Plaza, this serenely simple bronze sculpture sits within
a round pool that echoes the artwork's circular void. Dag Hammarskjöld,
a former UN secretary-general and Hepworth's friend, owned a wood carving
of the piece. After Hammarskjöld died in a plane crash in 1961, this 21-foot-
high (6.4 m) sculpture was commissioned as a memorial to him.

NORTH AMERICA — UNITED STATES

JOSEPH BEUYS, 7000 OAKS, 1982

⬤

West Twenty-Second Street between Tenth and Eleventh Avenues,
New York, NY 10011

A series of twenty-five trees of varying species, each paired with a basalt
column, is installed along a section of West Twenty-Second Street. The
installation is an extension of an eco-conscious project by Beuys that
originated in Kassel, Germany, in 1982, when seven thousand tree-and-basalt
pairings were planted throughout city. In the context of New York, the part-
living/part-stone monuments reference urban renewal.

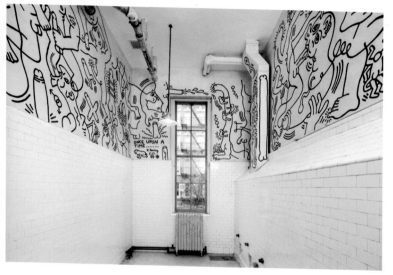

KEITH HARING, ONCE UPON A TIME…, 1989

The Center, 208 West Thirteenth Street, New York, NY 10011

This provocative mural, executed in Haring's signature style, was created for a men's bathroom at New York's Lesbian, Gay, Bisexual & Transgender Community Center (The Center). Erotic black line drawings cover the white tiles with an orgy of cartoon penises and contorting bodies, celebrating carefree sexual encounters and gay rights. It was Haring's last major mural before his death from AIDS-related complications.

40°44'17.3"N 74°00'03.7"W

NORTH AMERICA — UNITED STATES

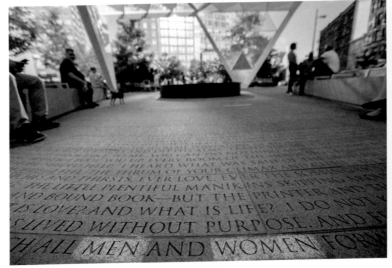

JENNY HOLZER, YOU HAVE GIVEN ME LOVE, 2016 ⬤

New York City AIDS Memorial, 200–218 West Twelfth Street,
New York, NY 10011

The site of this memorial is steeped in somber history: one of the country's
earliest AIDS hospital wards was across the street. In the memorial's concrete
pavers, Holzer engraved the words of New Yorker Walt Whitman's poem "Song
of Myself," selected for its message of hope and transcendence. Overhead
is an airy metal canopy by the memorial's architect, Studio ai Architects.

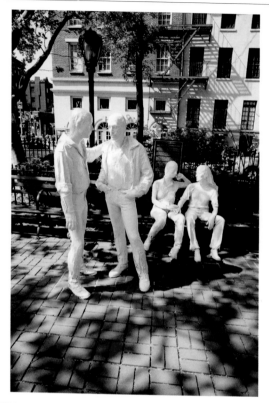

GEORGE SEGAL, GAY LIBERATION, 1980

Christopher Park, between Christopher, Grove, and West Fourth Streets, New York, NY 10014

A male couple stands chatting while two women engaged in intimate conversation sit on a nearby bench. Cast in Segal's signature style, this bronze tableau commemorates the 1969 Stonewall riots that occurred nearby in Greenwich Village, widely considered as a milestone in the modern movement for gay rights. Segal's realist sculpture promotes peaceful acceptance.

NORTH AMERICA — UNITED STATES

NORTH AMERICA — UNITED STATES

PABLO PICASSO, SYLVETTE, 1968 (AFTER A 1954 ORIGINAL)

○

Silver Towers, 100–110 Bleecker Street, New York, NY 10012

This colossal 60-ton (54.4 t) sculpture is based on a small metal bust of Sylvette David (now Lydia Corbett), a young woman from Vallauris, who in 1954 modeled for Picasso. The artist's assistant, Carl Nesjar, fabricated this concrete bust. *Sylvette* is the only outdoor work by Picasso in New York City.

40°43'37.5"N 73°59'54.6"W

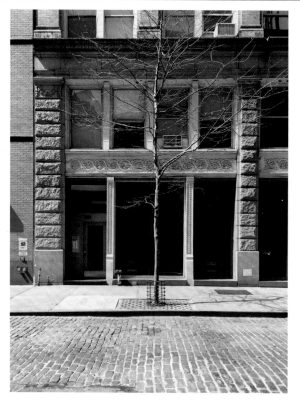

WALTER DE MARIA, THE NEW YORK EARTH ROOM, 1977

141 Wooster Street, New York, NY 10012

Visitors are surrounded by the smell of damp soil when climbing the stairs to the loft that houses De Maria's domesticated earthwork, made from 140 tons (127 t) of dark, pungent earth held behind a piece of Plexiglas. The soil—the same earth that was placed here in 1977—is watered and raked regularly.

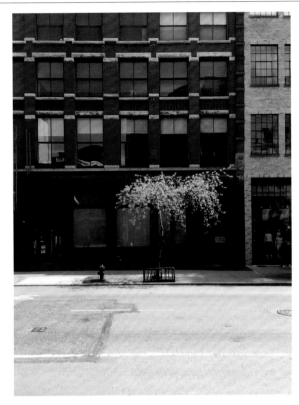

WALTER DE MARIA, THE BROKEN KILOMETER, 1979

393 West Broadway, New York, NY 10012

Five hundred solid brass rods extend in five parallel rows across the ground floor of a SoHo building. While the rods appear evenly spaced, the distance between them increases in increments of 0.2 inches (0.5 cm)—suggesting the infinite but using repetitive, finite units. The companion piece, *Vertical Earth Kilometer*, in Kassel, Germany, was made by driving a similar rod into the ground.

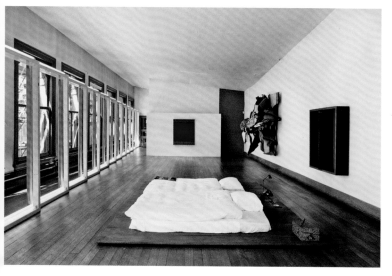

NORTH AMERICA — UNITED STATES

JUDD FOUNDATION, 101 SPRING STREET

A

101 Spring Street, New York, NY 10012

In 1968 this cast-iron building, built in 1870, became Donald Judd's home, studio, and exhibition space. Judd retained many of the original architectural elements throughout the five stories. 101 Spring Street is where Judd first developed the concept of permanent installation, driven by his belief that the placement of a work of art was as critical to its understanding as the work itself.

40°43'24.5"N 73°59'58.0"W

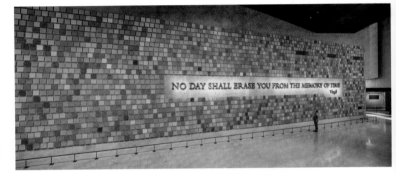

NO DAY SHALL ERASE YOU FROM THE MEMORY OF TIME
Virgil

SPENCER FINCH, TRYING TO REMEMBER THE COLOR OF THE SKY ON THAT SEPTEMBER MORNING, 2014

●

National September 11 Memorial & Museum, 180 Greenwich Street,
New York, NY 10007

The sky was a beautiful blue on the morning of the 9/11 attacks on the World
Trade Center. Finch's mosaic—a commission for the National September
11 Memorial & Museum—includes 2,983 watercolor squares, one for each
victim of the 2001 and 1993 attacks, in varied hues of blue. A Virgil quote
underscores that the victims will not be forgotten.

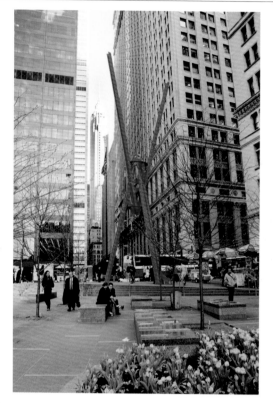

MARK DI SUVERO, JOIE DE VIVRE, 1997

Zuccotti Park, Cedar Street and Broadway, New York, NY 10006

NORTH AMERICA — UNITED STATES

A beacon of bright diagonal lines at the southeast corner of Zuccotti Park, di Suvero's sculpture originally stood at the entrance to the Holland Tunnel and was relocated to this site in 2006. Its I-beams reference the ubiquitous construction activity of the urban landscape, while its open lines and seeming weightlessness provide an antidote to the surrounding architecture.

40°42'32.2"N 74°00'38.8"W

NORTH AMERICA — UNITED STATES

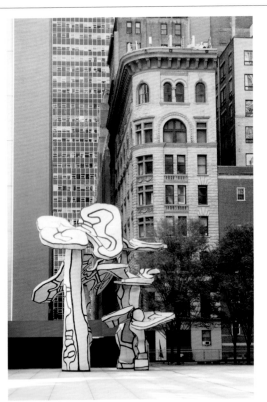

**JEAN DUBUFFET, GROUPE DE QUATRE ARBRES
[GROUP OF FOUR TREES], 1971–72**

28 Liberty Street, New York, NY 10005

A block and a half from the New York Stock Exchange, in New York City's
canyon of narrow streets and tall buildings, the black-and-white artificiality
of Dubuffet's trees humorously interacts with the real trees that line the plaza.
The sculpture is part of a body of work that includes graphically styled 3-D
paintings the artist called *Peintures Monumentées* (Monumental Paintings).

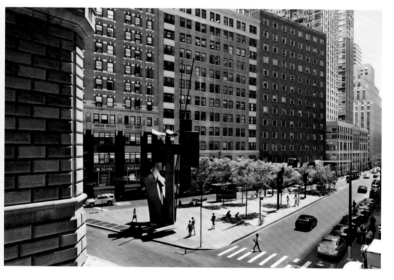

NORTH AMERICA — UNITED STATES

LOUISE NEVELSON, SHADOWS AND FLAGS, 1978

Louise Nevelson Plaza, between William Street, Liberty Street, and Maiden Lane, New York, NY 10038

Seven black steel sculptures by Nevelson dominate this plaza, including one colossal piece that reaches 40 feet (12.2 m) high. The smaller works float on tall stems, recalling the flags referenced in their title. Nevelson's original design for the site also included Callery pear trees and specially made benches. But new plantings and contemporary glass seating have replaced those.

40°42'27.3"N 74°00'28.7"W

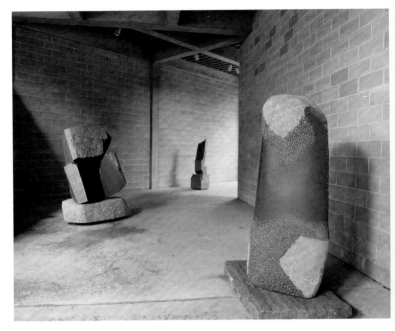

ISAMU NOGUCHI, THE NOGUCHI MUSEUM, OPENED 1985 ●

9–01 Thirty-Third Road, Long Island City, NY 11106

Noguchi designed this museum for the permanent display of his modernist sculptures. Representative examples from the Japanese-American artist's six-decade career are exhibited across two floors of the former 1920s industrial building and outside in a tranquil sculpture garden, also designed by the artist. The museum is itself considered to be one of Noguchi's greatest accomplishments.

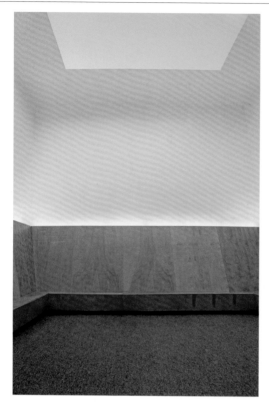

JAMES TURRELL, MEETING, 1986

MoMA PS1, 22–25 Jackson Avenue, Long Island City, NY 11101

A large rectangular aperture was cut into the ceiling of this whitewalled room at MoMA PS1. Benches invite visitors to sit and contemplate the open sky above. Subtle artificial lights in the room cast an orange glow, accentuating the color of the sky, especially during sunset. Turrell calls these signature works *Skyspaces*, of which this is an early example.

NORTH AMERICA — UNITED STATES

BILL BRAND, MASSTRANSISCOPE, 1980/2008 O

DeKalb Avenue station, DeKalb and Flatbush Avenues,
Brooklyn, NY 11217

This piece's simple, colorful animations bring moments of whimsy and wonder
to subway riders on the B and Q lines heading from Brooklyn into Manhattan.
Brand's 228 hand-painted panels turned the abandoned Myrtle Avenue station
into a form of zoetrope, a nineteenth-century device for creating animations
by spinning images. In *Masstransiscope*, the images stay still; the train's
motion creates the animations.

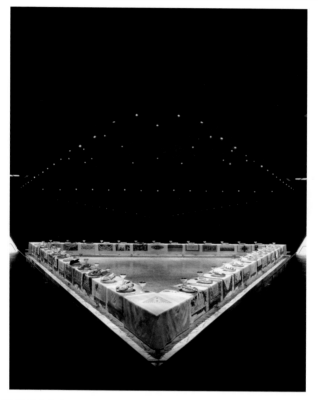

NORTH AMERICA — UNITED STATES

JUDY CHICAGO, THE DINNER PARTY, 1979

Brooklyn Museum, 200 Eastern Parkway, Brooklyn, NY 11238

This feminist art installation celebrates the role of women in the history of Western civilization. Thirty-nine remarkable historical and mythical women have places at the banquet table, shaped as an equilateral triangle to symbolize equality and femininity. The painted plates and embroidered runners are decorated to represent each woman and her accomplishments; 999 more women are honored on vertical panels and on the floor.

40°40'16.7"N 73°57'49.4"W

NORTH AMERICA — UNITED STATES

SOPHIE CALLE, HERE LIE THE SECRETS OF THE VISITORS OF GREEN-WOOD CEMETERY, 2017–42 ●

Green-Wood Cemetery, 500 Twenty-Fifth Street, Brooklyn, NY 11232

This marble obelisk, nestled in Brooklyn's Green-Wood Cemetery, provides an opportunity for visitors to disclose their darkest secrets, which can be deposited through a small slit in its base. Calle has pledged to periodically exhume the contents, destroying the confessions in ceremonial burnings. The twenty-five-year project, which explores the artist's fascination with human vulnerability, will remain in place until 2042.

ODILI DONALD ODITA, KALEIDOSCOPE, 2011–12

20th Avenue station at Eighty-Sixth Street, Brooklyn, NY 11214

At Brooklyn's Twentieth Avenue subway station on the D line, the array of colors in Odita's artwork evokes the vibrancy and diversity of its Bensonhurst neighborhood. Odita designed forty laminated-glass panels that are installed throughout the station platforms. The diagonal swathes and zigzags of color—characteristic of Odita's work—visually convey the neighborhood's energy.

THE DAN FLAVIN ART INSTITUTE, 1983

23 Corwith Avenue, Bridgehampton, NY 11932

A two-story 1908 fire station, which was later converted to a Baptist church, now contains highlights of nearly two decades (1963–81) of Flavin's famed fluorescent tube sculptures, curated and installed by the artist. The light of the individual works draws viewers toward corners and through corridors, creating an immersive experience of changing light.

POLLOCK–KRASNER HOUSE AND STUDY CENTER, OPENED 1988 ●

830 Springs-Fireplace Road, East Hampton, NY 11937

This former home and studio of artists and partners Jackson Pollock and
Lee Krasner lets visitors see their personal and artistic environments frozen
in time—the furnishings and artifacts appear as they did when Krasner died,
in 1984. In the barn that was Pollock's studio, the floor is covered in spattered
paint, as though it were a painting itself.

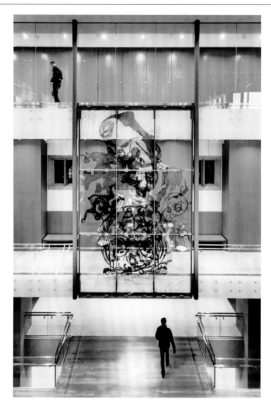

SHAHZIA SIKANDER, QUINTUPLET-EFFECT, 2016

Julis Romo Rabinowitz Building, Princeton University,
20 Washington Road, Princeton, NJ 08540

Instead of canvas, this painting employs nine large panels of stacked
glass. Inspired by Princeton University's illustrated copy of the *Shahnama*,
an ancient history of Iran, Sikander created her own complex interpretation
of the epic narrative. Princeton's historic campus houses a rich collection of
modern art, including works by Picasso, Louise Nevelson, George Rickey,
Ai Weiwei, and Alexander Calder.

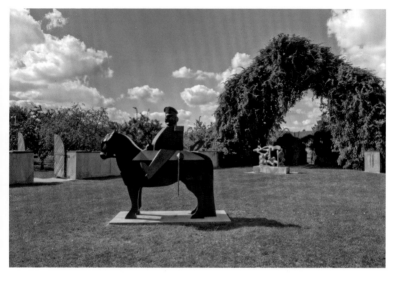

MARISOL, GENERAL BRONZE, 1997

A

Grounds for Sculpture, 80 Sculptors Way, Hamilton, NJ 08619

NORTH AMERICA — UNITED STATES

Marisol's sculpture, based on the Venezuelan dictator General Juan Gómez, satirizes the convention of honoring political figures with public statues by creating what she calls an antimonument. It is displayed at Grounds for Sculpture, a contemporary sculpture park in New Jersey, which contains nearly three hundred works by American and international artists, including several site-specific commissions.

MARCEL DUCHAMP, ÉTANT DONNÉS: 1° LA CHUTE D'EAU, 2° LE GAZ D'ÉCLAIRAGE... [GIVEN: 1. THE WATERFALL, 2. THE ILLUMINATING GAS...], 1946–66

Philadelphia Museum of Art, 2600 Benjamin Franklin Parkway, Philadelphia, PA 19130

At the Philadelphia Museum of Art, viewers can peer through peepholes in a door to see Duchamp's last major artwork, which Jasper Johns once called "the strangest work of art in any museum." The assemblage of objects, sculpture, and photos is at once bucolic and disturbing. Two ladies in Duchamp's life served as models for the life-size figure of a woman.

<div style="writing-mode: vertical">NORTH AMERICA — UNITED STATES</div>

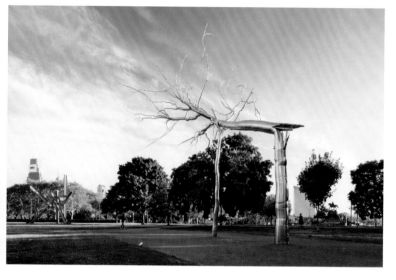

ROXY PAINE, SYMBIOSIS, 2011 ⭕

Iroquois Park, North Twenty-Fourth Street and Pennsylvania Avenue,
Philadelphia, PA 19130

These gnarled, metallic trees are hand fabricated from industrial steel pipes.
Blurring the distinction between natural and artificial, the spindly sculpture
simultaneously evokes industrial pipelines and arboreal structures. By
showing a small dead tree supporting a larger, damaged one, Paine suggests
an ecological tension between organic and man-made forms, a theme
consistently explored in his work.

NAM JUNE PAIK, VIDEO ARBOR, 1990 ●

One Franklin Town Apartments, 1 Franklin Town Boulevard,
Philadelphia, PA 19103

Eighty-four color-video monitors mounted outside a Philadelphia apartment
block display a dazzling array of images and colors. Turned on at night,
the screens show local scenes intermingled with writhing geometric shapes.
Paik also planted wisteria vines in order to create a harmony between nature
and technology.

NORTH AMERICA — UNITED STATES

KEITH HARING, UNTITLED (FIGURE BALANCING ON DOG), 1989 ⭕

Kutztown Park, 440 East Main Street, Kutztown, PA 19530

This exuberant red sculpture depicts a person with flailing arms riding on the back of a howling dog. The lively composition, rendered in Haring's trademark cartoon style, with simple, bold lines, was donated to his hometown in 1992. Reflecting the central role of dance and movement in his work, the sculpture captures the atmosphere of a wild children's playground.

NORTH AMERICA — UNITED STATES

SCOTT BURTON, CHAIRS FOR SIX, 1985

BNY Mellon Center, Grant Street and Fifth Avenue,
Pittsburgh, PA 15219

Burton often infused his sculpture with functional and social dimensions,
as epitomized in this public art piece. The six granite chairs are arranged
facing one another to encourage people—friends or strangers—to sit and
converse. Burton once called himself a "lunch artist" because he has created
a variety of chair sculptures that workers on lunch breaks put to good use.

NORTH AMERICA

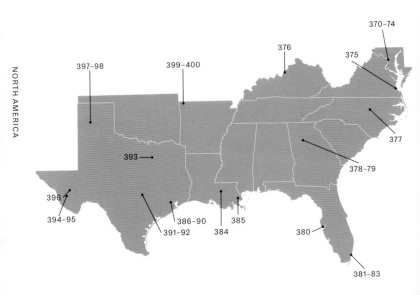

370–74

376

375

397–98

399–400

393

396

394–95

386–90

391–92

384

385

377

378–79

380

381–83

ALEXANDER CALDER, MOUNTAINS AND CLOUDS, 1976/1986

Hart Senate Office Building, 120 Constitution Avenue NE, Washington, DC 20002

Mountains and Clouds is Calder's last artwork and his only piece that combines a separate mobile and "stabile" (static sculpture). The soaring piece is painted flat black to contrast with the white marble walls of the Hart Senate Office Building's nine-story atrium, for which it was commissioned. After a safety analysis in 2016, the mobile was removed for refabrication.

LUCAS SAMARAS, CHAIR TRANSFORMATION NUMBER 20B, 1996

National Gallery of Art Sculpture Garden, Seventh Street and Constitution Avenue NW, Washington, DC 20408

This abstract sculpture suggests a precarious tower of stacked chairs. From some viewpoints it appears to stand upright; from others it seems to lean back or topple forward. Displayed in the National Gallery of Art's spacious, landscaped sculpture garden, Samaras's vertiginous structure is joined by sixteen other major works, by Louise Bourgeois, Roy Lichtenstein, and Tony Smith, among others.

38°53'28.3"N 77°01'22.6"W

BEVERLY PEPPER, EX CATHEDRA, 1967

Hirshhorn Museum and Sculpture Garden, Independence Avenue
SW and Seventh Street SW, Washington, DC 20560

The highly seductive, polished surface of this large geometric sculpture
reflects everything surrounding it. Pepper's bold visual statement is one
of more than sixty artworks, from the 1880s to the present day, displayed
in the Sculpture Garden and Plaza at the Hirshhorn Museum. Works by
Auguste Rodin and Hans Arp are featured alongside pieces by Jimmie Durham,
Yayoi Kusama, and many other artists.

38°53'20.8"N 77°01'24.6"W

JOEL SHAPIRO, LOSS AND REGENERATION, 1993

United States Holocaust Memorial Museum, 100 Raoul Wallenberg
Place SW, Washington, DC 20024

Shapiro's installation at the United States Holocaust Memorial Museum
includes an upturned houselike form that represents the subversion of
familial safety and security. Nearby, his black abstract tree points to potential
renewal. Permanent artworks by Sol LeWitt, Richard Serra, and Ellsworth
Kelly accompany Shapiro's contribution; together they address the lasting
impact of the Holocaust and underscore the museum's memorial function.

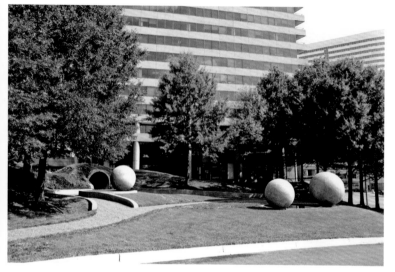

NANCY HOLT, DARK STAR PARK, 1979–84

Dark Star Park, 1655 North Fort Myer Drive, Arlington, VA 22209

The large spheres in this urban park represent fallen, extinguished stars. Metal impressions on the ground have been carefully placed, and each year, on August 1, at 9:30 a.m., the spheres' shadows align perfectly with the inset plates. The date commemorates William Henry Ross's acquisition, in 1860, of the land that would become Rosslyn, the neighborhood in Arlington where the piece resides.

38°53'36.6"N 77°04'17.3"W

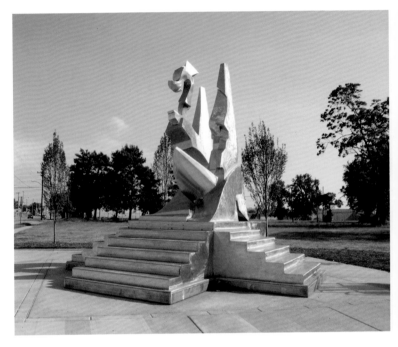

RICHARD HUNT, BUILD A DREAM, 2011

Thirty-First Street and Jefferson Avenue, Newport News, VA 23607

This sculpture injects a dose of optimism and vitality to the Newport News neighborhood where it is installed. As its title suggests, Hunt's sculpture is about building aspiration and the hope that his bold, stainless steel forms will inspire the community to be ambitious, dreaming for themselves an even bigger, better future. Hunt is known for his public artworks, which often speak to local themes or histories.

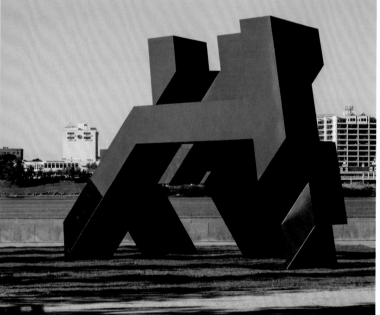

TONY SMITH, GRACEHOPER, 1962

Overlook at Louisville Waterfront Park, Louisville, KY 40202

This monumental black steel sculpture is formed from huge interlocking geometric sections. Its title is taken from James Joyce's novel *Finnegans Wake* (1939), in which the Gracehoper is an insect representing progress and change. Although this sculpture has a buglike appearance, for Smith it is a catalyst of the imagination, sparking associations that vary depending on the viewer.

38°15'36.8"N 85°44'55.1"W

BARBARA KRUGER AND SMITH-MILLER + HAWKINSON ARCHITECTS, PICTURE THIS, 1996

Ann and Jim Goodnight Museum Park, North Carolina Museum of Art,
2110 Blue Ridge Road, Raleigh, NC 27607

Kruger, a provocative social commentator, is known for her use of text. In this collaboration with Smith-Miller + Hawkinson Architects, 80-foot-tall (24.4 m) letterforms spell out the phrase "picture this," evoking the creative act itself. Many of the letters are decorated with quotations by cultural figures and statements pertaining to North Carolina's history.

NORTH AMERICA — UNITED STATES

ISAMU NOGUCHI, PLAYSCAPES, 1975–76

Piedmont Park, Twelfth Street Gate, Atlanta, GA 30309

The colorful equipment in this urban playground blurs the distinction between art and play. Designed for Piedmont Park, Noguchi's *Playscapes* are intended to get children moving, thinking, and exploring the world by encouraging creative play. The artist believed that great art should be available to all, as a part of the lived experience outside traditional galleries.

ROY LICHTENSTEIN, HOUSE III, 1997 (FABRICATED 2002)

High Museum of Art, 1280 Peachtree Street NE, Atlanta, GA 30309

Designed as an optical illusion, this playful sculpture reflects Lichtenstein's interest in exploring perspective. At first sight, the aluminum structure seems strangely proportioned; the recognizable form of a house is visible only from a certain angle. The sculpture, which was one of the artist's last, was inspired by his large-scale paintings of domestic interiors produced during the 1990s.

33°47'23.2"N 84°23'07.3"W

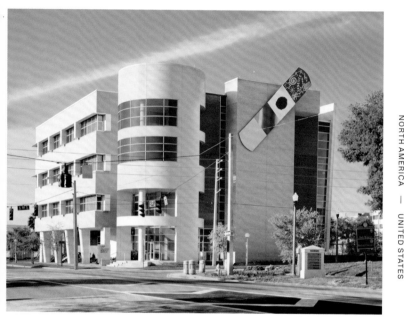

JAMES ROSENQUIST, IT HEALS UP: FOR ALL CHILDREN'S HOSPITAL, 2002

Children's Research Institute at the Johns Hopkins All Children's Hospital, University of South Florida, 601 Fourth Street S, St. Petersburg, FL 33701

Rosenquist's sculpture for this children's hospital takes the form of an enormous adhesive bandage. The artist wanted to create an optimistic work that celebrated the endurance of the human body and the expertise of the facility's staff. Functioning like a sign, it communicates to children that this is a place of help and healing.

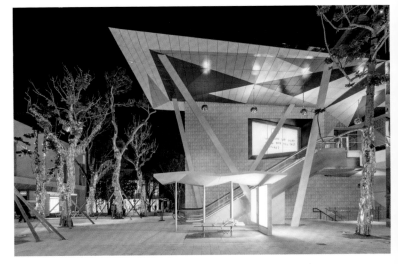

URS FISCHER, BUS STOP, 2017

Paradise Plaza, 151 Northeast Forty-First Street, Miami, FL 33137

In the middle of a shopping plaza in Miami's Design District, Fischer sprawled a skeleton on the bench of a bus stop designed to look like those found throughout the city. The skeleton's deathly stillness is counterbalanced by the movement of the water trickling onto its forehead and pooling on the ground below—intended to represent life.

25°48'51.3"N 80°11'32.7"W

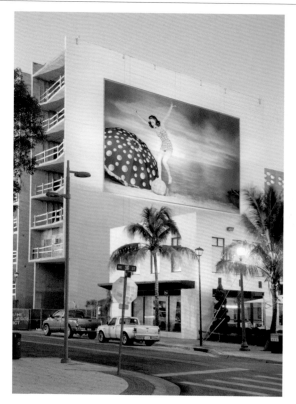

JOHN BALDESSARI, FUN (PART 2), 2003/2014

City View Garage, 3800 Northeast First Avenue, Miami, FL 33137

●

This perforated-metal mural and its companion, *Fun (Part 1)* (2003/2014), which appears on another side of the same building, depict scenes of carefree recreation. The retro quality of the scenes—the woman in *Part 2* dons an old-fashioned bathing suit and hairstyle—contrasts with the contemporary architecture of the building in a playful nod to Miami's real and imagined history and present.

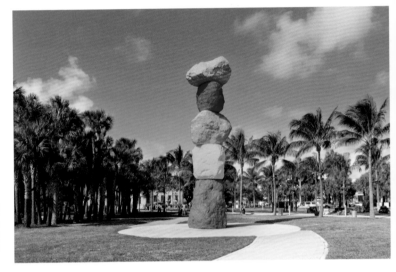

UGO RONDINONE, MIAMI MOUNTAIN, 2016 ⭕

Collins Park, Twenty-First Street and Collins Avenue,
Miami Beach, FL 33140

Rising 42 feet (12.8 m) into the air, this colorful column was made by stacking
five megalithic boulders. While Rondinone was inspired by the geological rock
formations of the North American Badlands, his fluorescent paint is thoroughly
modern. Installed in Collins Park, the sculpture launched the Bass Museum's
ten-year program to acquire contemporary public works for its permanent
collection.

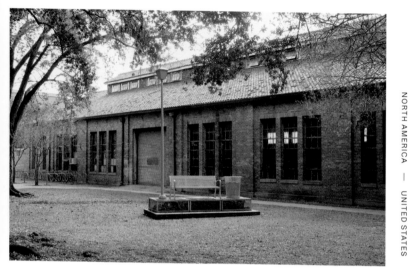

NARI WARD, MSSSSPP RUNOFF, 2014

LSU Sculpture Park, College of Art & Design, Louisiana State University, 102 Design Building, Baton Rouge, LA 70803

Ward created a sculptural replica of the types of benches, trash cans, and lampposts that typically decorate the banks of the Mississippi River in Baton Rouge, using found objects collected at the Louisiana Machinery Caterpillar "graveyard." Painted yellow in reference to LSU's trademark gold, the bench welcomes viewers to sit and contemplate their surroundings without fearing the river's strong waters.

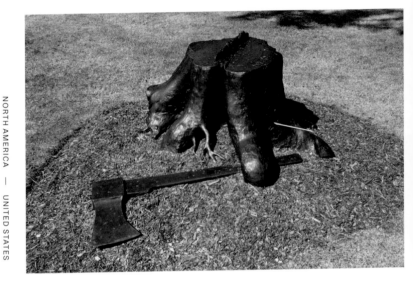

RENÉ MAGRITTE, THE LABORS OF ALEXANDER, 1967

Sydney and Walda Besthoff Sculpture Garden, New Orleans Museum
of Art, 1 Collins Diboll Circle, City Park, New Orleans, LA 70124

In this surreal sculpture, an ax is trapped beneath the root of a recently felled
tree. Based on Magritte's 1950 painting, it presents a paradox typical of his
work. The bronze is displayed in the New Orleans Museum of Art's beautifully
landscaped sculpture garden, which contains more than sixty works by Robert
Indiana, Louise Bourgeois, Barbara Hepworth, and other artists.

29°59'10.5"N 90°05'35.1"W

MEL CHIN, THE SEVEN WONDERS, 1998 ⬤

Sesquicentennial Park, 400 Texas Avenue, Houston, TX 77002

The Houston-born Chin had lots of help creating this artwork in Houston's Sesquicentennial Park. Local children born in 1986 (the city's 150th anniversary year) contributed 1,050 illustrations depicting Houston's history of agriculture, energy, manufacturing, medicine, philanthropy, technology, and transportation. The illustrations were laser cut into the 70-foot-tall (21.3 m) stainless steel pillars, which light up like lanterns at light.

29°45'50.3"N 95°21'57.7"W

FRANK STELLA, EUPHONIA, 1997

A

Moores Opera House, University of Houston, 120 School of Music Building,
Houston, TX 77004

This colorful collage of painted and silkscreened imagery covers the vaulted
ceiling of the Moores Opera House lobby at the University of Houston.
Three more exuberant works with writhing abstract forms can be seen on
the mezzanine level, while another celebration of shape and color is found
inside the auditorium itself.

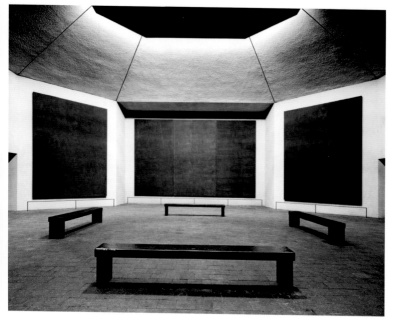

MARK ROTHKO, ROTHKO CHAPEL, 1971

Rothko Chapel, 3900 Yupon Street, Houston, TX 77006

Rothko collaborated with architects Philip Johnson and Howard Barnstone to create a dedicated space for his paintings. Fourteen canvases, made especially for the chapel, are displayed on its eight interior walls, creating an intimate yet engulfing effect. The chapel is a spiritual center that uses modern art's universal language of abstraction to speak to all faiths.

29°44'15.4"N 95°23'46.3"W

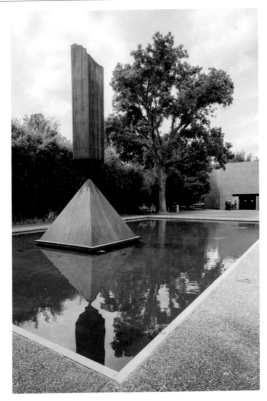

BARNETT NEWMAN, BROKEN OBELISK, 1971

Rothko Chapel, 3900 Yupon Street, Houston, TX 77006

In this well-known sculpture, two Egyptian forms—the obelisk and the pyramid—improbably meet at their points. One of an edition of four, this is Newman's only obelisk sited within a reflecting pool. John and Dominique de Menil founded the adjacent Rothko Chapel and dedicated both the chapel and Newman's sculpture to Martin Luther King Jr.

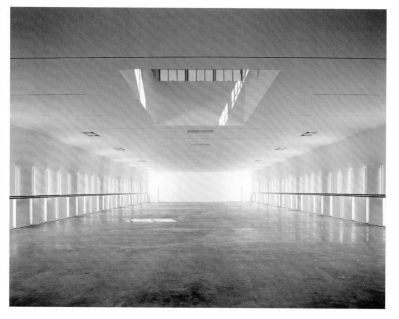

DAN FLAVIN, UNTITLED, 1996

●

Richmond Hall, 1500 Richmond Avenue, Houston, TX 77006

In his commissioned installation at Richmond Hall, Flavin combined ready-made fluorescent tubes with the warehouse architecture of a former grocery store to create a stunning play of color and light. Taking its shapes and scale directly from the building, the work draws attention to the architectural frame and also activates the structure's interior and exterior spaces.

NORTH AMERICA — UNITED STATES

SUPERFLEX, LOST MONEY, 2009

Betty and Edward Marcus Sculpture Garden at Laguna Gloria,
The Contemporary Austin, 3809 West Thirty-Fifth Street,
Austin, TX 78703

Nickels, dimes, and quarters lie scattered across the patio and terrace at
Laguna Gloria, forming a shimmering carpet around the ornamental fountain.
But the coins are useless; speaking to the 2008 financial crash, they are all
stuck to the ground and cannot be spent. Superflex's installation is presented
alongside a growing collection of contemporary artworks set amid this urban
site's woodlands, meadows, and gardens.

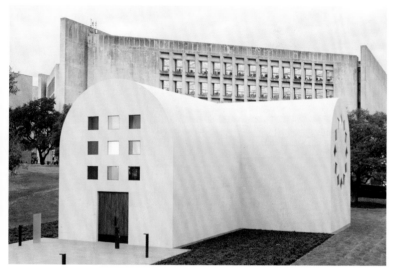

ELLSWORTH KELLY, AUSTIN, 2015

Blanton Museum of Art, 200 East Martin Luther King Jr. Boulevard, Austin, TX 78701

Resembling both a stone igloo and Romanesque church, Kelly's serene chapel is his last and most monumental work. The simple, double-barrel-vaulted building with colored-glass windows was conceived in 1986 but not realized until 2015. Inside are fourteen black-and-white marble panels that refer to the Stations of the Cross. Kelly envisioned the chapel as a site for joy and contemplation.

WILLEM DE KOONING, SEATED WOMAN, 1969/1980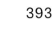

Nasher Sculpture Center, 2001 Flora Street, Dallas, TX 75201

This large sculpture is based on a small clay version that de Kooning made while vacationing in Europe. Enlarged at the suggestion of Henry Moore, it retains the artist's lively, gestural style. Displayed on the grounds of the Nasher Sculpture Center, it is among the 300 modern masterpieces in the Raymond and Patsy Nasher Collection.

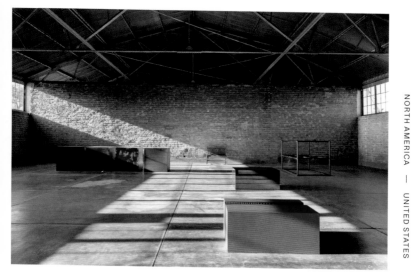

JUDD FOUNDATION, LA MANSANA DE CHINATI/THE BLOCK

A

Judd Foundation, 104 South Highland Avenue, Marfa, TX 79843

Donald Judd first encountered the desert landscape of west Texas in 1946 and would return to the region in the early 1970s. He moved there in 1973 and continued to develop his concept of permanent installation across eight properties and three ranches. The buildings that he purchased and transformed at the Block preserve Judd's installations of his own art and furniture.

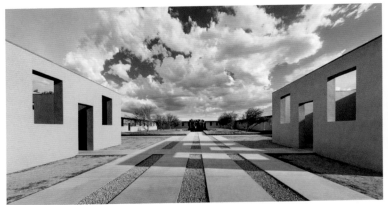

ROBERT IRWIN, UNTITLED (DAWN TO DUSK), 2016 ●

Chinati Foundation, 1 Cavalry Row, Marfa, TX 79843

Founded by Donald Judd on the site of a former military camp, the Chinati Foundation displays permanent site-specific works by a select group of artists, including Dan Flavin and John Chamberlain. Irwin transformed an abandoned hospital and an adjacent courtyard into a total work of art, combining indoor elements and an outdoor garden to create an experience of light and space that masterfully fuses art, architecture, and nature.

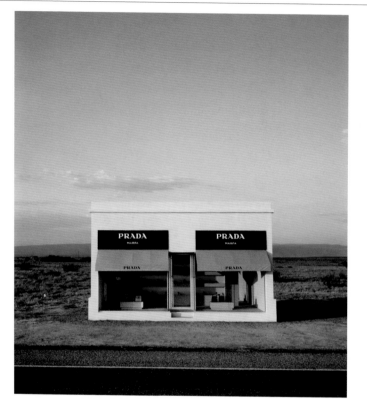

ELMGREEN & DRAGSET, PRADA MARFA, 2005

US Route 90 near Valentine, TX 79854

A Prada boutique is a surreal sight in this barren Texas landscape. Upon closer inspection, it is not a store but a hermetic sculpture that forever displays the company's fall 2005 collection of shoes and handbags. Typical of the artists, who are known for their meticulous yet fictional recreations of objects or places, the piece speaks to the inherent absurdity of fetishizing a brand.

30°36'12.4"N 104°31'06.6"W

ANDREW LEICESTER, FLOATING MESA, 1980

Near Tascosa Road and FM 2381, Amarillo, TX 79012

Taking advantage of the desert's proclivity for atmospheric trompe l'oeil, Leicester's environmental artwork seems to cut through the top of a flat butte, making it appear as if a horizontal slice of earth and rock is floating in the air. The piece is made of a simple length of painted steel hoarding, running horizontally near and parallel to the top of the bluff.

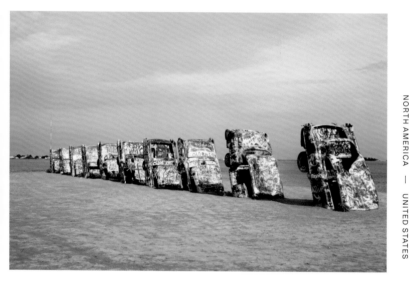

ANT FARM (CHIP LORD, HUDSON MARQUEZ, AND DOUG MICHELS), CADILLAC RANCH, 1974

Interstate 40 Frontage Road, near Arnot Road, Amarillo, TX 79124

Ten Cadillacs, like absurd monuments, rise out of the sand at the same angle as the Great Pyramid of Giza. These classic cars feature different forms of tail fin and represent various evolutions of the Cadillac, making the installation a sly satire of the glorification of consumerism and technological advancement.

NORTH AMERICA — UNITED STATES

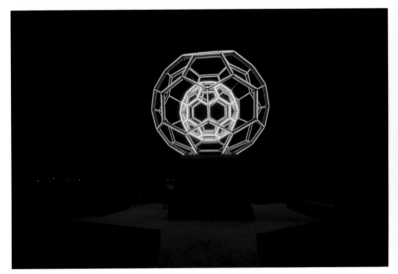

LEO VILLAREAL, BUCKYBALL, 2012 ●

Crystal Bridges Museum of American Art, 600 Museum Way,
Bentonville, AR 72712

This towering sculpture is based on the fullerene carbon molecule, named
after Buckminster Fuller. Illuminated by 4,500 LEDs, the piece is animated
by custom software. Villareal's mesmerizing colored-light show is featured
on the sculpture trail that links Crystal Bridge's 120-acre (0.49 sq km)
park to downtown Bentonville. Works by Keith Haring, James Turrell, Roxy
Paine, and Celeste Roberge are also on display.

DAAN ROOSEGAARDE, FLOW 5.0, 2007–13

21c Museum Hotel, 200 Northeast A Street, Bentonville, AR 72712

Roosegaarde's site-specific installation is a black wall made up of hundreds
of fans that together generate a breeze in response to movement.
The geometric patterns formed by the fans also shift and at times depict one
of three letters, *A*, *E*, or *R*, to refer to *air*. The piece heightens the viewer's
awareness of their impact on the space around them.

UNITED STATES—MIDWEST

420

417–18

416

415

419

404–10

411

421–22

401

402 403

412-13

414

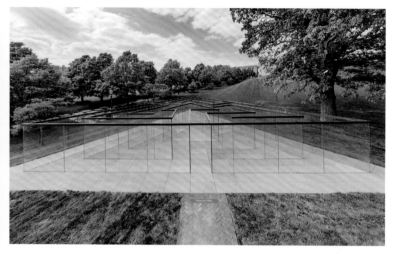

NORTH AMERICA — UNITED STATES

ROBERT MORRIS, GLASS LABYRINTH, 2013

Donald J. Hall Sculpture Park, Nelson-Atkins Museum of Art,
4525 Oak Street, Kansas City, MO 64111

Unlike traditional labyrinths, constructed of dense hedges or other opaque materials, Morris's is made from 1-inch-thick (2.5 cm) glass. The experience of moving through the transparent structure is disorienting, but it is impossible to get lost. The sculpture was commissioned to mark the twenty-fifth anniversary of the Donald J. Hall Sculpture Park.

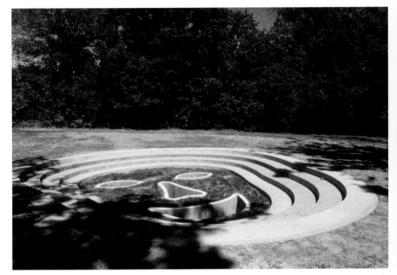

VITO ACCONCI, FACE OF THE EARTH #3, 1988

Laumeier Sculpture Park, 12580 Rott Road, St. Louis, MO 63127

The features of this primitive-looking face are sunk in the ground, inviting viewers to step into its eyes, nose, and mouth. It is one of sixty artworks installed at Laumeier Sculpture Park, one of the oldest dedicated sculpture parks in the United States. The 105-acre (0.42 sq km) site also includes works by Donald Judd, Beverly Pepper, Anthony Caro, and Jessica Stockholder.

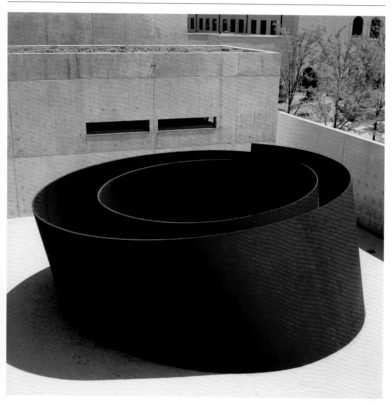

RICHARD SERRA, JOE, 1999

Pulitzer Arts Foundation, 3716 Washington Boulevard,
St. Louis, MO 63108

Forged from five plates of steel, this monumental sculpture stands in
the Pulitzer Arts Foundation's courtyard. It is one of the museum's three
permanent artworks, with Ellsworth Kelly's *Blue Black* (2000) and Scott
Burton's *Rock Settee* (1988–90), and is named after cofounder Joseph
Pulitzer. Its vast leaning sides, which can be explored inside and out, create
a disorienting and dizzying experience.

38°38'24.4"N 90°14'05.5"W

ANISH KAPOOR, CLOUD GATE, 2004

Millennium Park, 201 East Randolph Street, Chicago, IL 60601

Kapoor's first public artwork in the United States, "the Bean," as it was dubbed during its installation, has a polished surface that creates fantastic optical effects. Visitors can appreciate reflections of the famous skyline of Chicago's nearby Loop and walk through the piece's central aperture to gaze up at the concave underside, which offers additional distorted views.

PABLO PICASSO, UNTITLED, 1967

Daley Plaza, 50 West Washington Street, Chicago, IL 60602

The true identity of this monumental sculpture remains ambiguous. To some it is a woman; to others, a mandrill or perhaps an Egyptian deity. Picasso, who shed no light on the matter, insisted only that it was a gift to Chicago. It ushered in a new era of civic and urban planning, advancing notions of sculpture in the public realm.

41°53'01.0"N 87°37'47.9"W

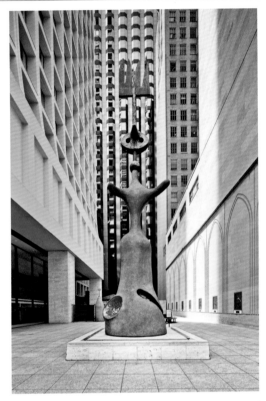

JOAN MIRÓ, MOON, SUN AND ONE STAR (MISS CHICAGO), 1981 ○

Cook County Administration Building, 69 West Washington Street, Chicago, IL 60602

Known colloquially as Miss Chicago, Miró's celestially inspired figure is a celebration of material and form. The curvaceous sculpture, which combines concrete, bronze, steel, and ceramic, soars above pedestrians in Brunswick Plaza. Commissioned in 1969, the sculpture was not realized until 1981, after the city's mayor secured the necessary funding.

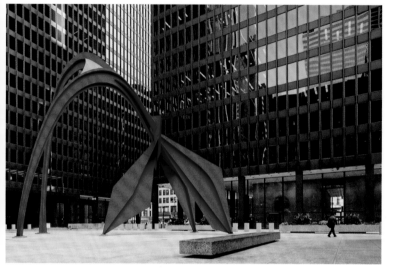

ALEXANDER CALDER, FLAMINGO, 1973 ⬤

Federal Plaza, West Adams and South Dearborn Streets,
Chicago, IL 60610

Calder's 53-foot-tall (16 m) abstract sculpture uses elegant arcs of steel to
create an impression of buoyancy. Its curves and brilliant red color—known
as Calder red—cause the work to stand out in dramatic contrast against
the black steel and glass of the Ludwig Mies van der Rohe–designed building
behind it.

NORTH AMERICA — UNITED STATES

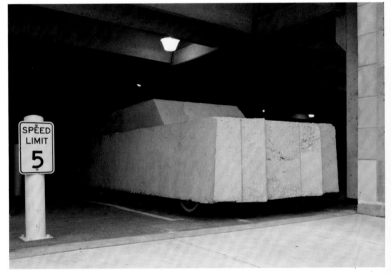

NORTH AMERICA — UNITED STATES

WOLF VOSTELL, CONCRETE TRAFFIC, 1970 ⭕

University of Chicago, Campus North Parking Garage,
5525 South Ellis Avenue, Chicago, IL 60637

In January 1970, a group of Chicago artisans poured 16 tons (14.5 t) of concrete
over a 1957 Cadillac DeVille to create this sculpture. Vostell conceived
the work as an "instant happening"—a play on the term *happening*, coined
by Allan Kaprow to describe performances or events as art. Vostell's
performative and humorous act memorializes a vehicle as a sculptural object.

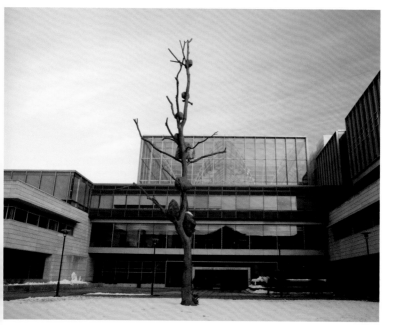

GIUSEPPE PENONE, IDEAS OF STONE (IDEE DI PIETRA), 2004–7

⬤

Charles M. Harper Center, Booth School of Business, University of
Chicago, 5807 South Woodlawn Avenue, Chicago, IL 60637

One of the largest of Penone's countless sculpted trees, this piece originally
stood in a small town in the artist's native Italy, but since 2010 it has graced
the campus of the Booth School of Business. The tree—which at first glance
appears real but is actually made of steel and bronze—holds granite boulders
collected by Penone from a river near his home.

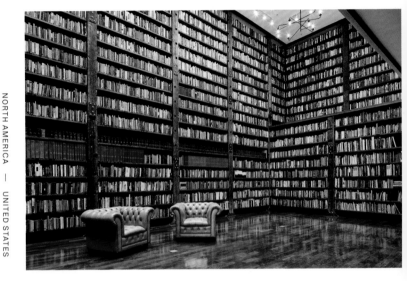

THEASTER GATES, STONY ISLAND ARTS BANK, 2012–PRESENT

Stony Island Arts Bank, 6760 South Stony Island Avenue, Chicago, IL 60649

For the price of one dollar, Gates purchased an abandoned bank building in the South Side of Chicago and took responsibility for its restoration. He transformed it into a public library and cultural center, renovating certain areas and reclaiming and reusing some of the old building parts. According to the artist, this project fills an economic and cultural need of the community.

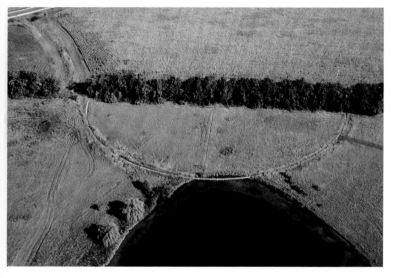

NORTH AMERICA — UNITED STATES

MARTIN PURYEAR, BODARK ARC, 1982 ●

Nathan Manilow Sculpture Park, Governors State University,
1 University Parkway, University Park, IL 60484

Among the twenty-nine sculptures at Nathan Manilow Sculpture Park—
one of the most-celebrated outdoor art venues in the Midwest—is a major
contribution by Puryear. Using wood, asphalt, cast bronze, and planted
Osage orange trees, the artist created an environmental work in the shape
of a bow along the edge of the pond. Visitors can walk through the space
of the work to explore its subtleties.

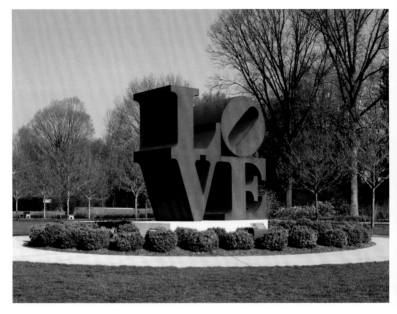

ROBERT INDIANA, LOVE, 1970 ●

Indianapolis Museum of Art, 4000 Michigan Road, Indianapolis,
IN 46208

Indiana's *Love* artworks depict both the word and the emotion: the letters
huddle together convivially. The Indianapolis Museum of Art features Indiana's
first *Love* sculpture, which is 12 feet (3.7 m) high. It is made of Cor-Ten steel,
which gains a patina over time. Other versions of the work appear in various
international locations and in multiple languages, including Hebrew and Italian.

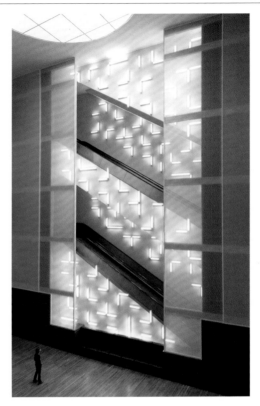

ROBERT IRWIN, LIGHT AND SPACE III, 2008

Indianapolis Museum of Art, 4000 Michigan Road, Indianapolis,
IN 46208

For its 125th anniversary, the Indianapolis Museum of Art commissioned this
installation for the great hall that leads to the galleries. An array of fluorescent
light bulbs lines the walls surrounding the escalators, framed by scrims on
the left and right. The combination of the scrims and glowing lights transforms
an otherwise-ordinary escalator space into something extraordinary.

NORTH AMERICA — UNITED STATES

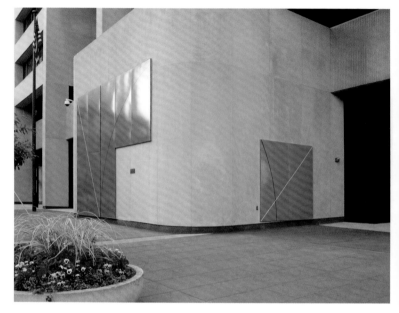

**ROBERT MANGOLD, CORRELATION: TWO WHITE LINE
DIAGONALS AND TWO ARCS WITH A 16 FOOT RADIUS, 1978**

John W. Bricker Federal Building, 200 North High Street,
Columbus, OH 43215

Made of steel and porcelain enamel, Mangold's minimalist artwork was
commissioned as part of the General Services Administration's Art in
Architecture Program. The simple geometric forms enliven the architecture
of the rather austere federal building—for example, the two thin black arcs
subtly gesture toward the curve at the corner of the wall.

MIKE KELLEY, MOBILE HOMESTEAD, 2010 ○

Museum of Contemporary Art Detroit, 4454 Woodward Avenue,
Detroit, MI 48201

Kelley envisioned this full-scale replica of his childhood home in the Detroit
suburb of Westland as a community gallery. It is permanently installed at the
Museum of Contemporary Art Detroit, but since the white clapboard front
section is detachable, it can be loaded onto a truck and driven through local
neighborhoods to offer and host public services, such as book lending and
food distribution.

NORTH AMERICA — UNITED STATES

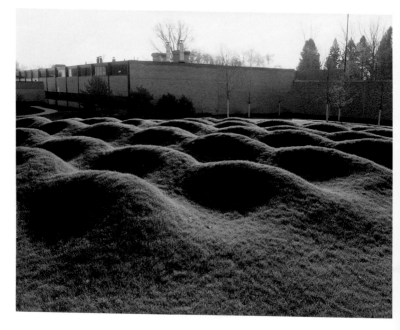

MAYA LIN, WAVE FIELD, 1995

Francois-Xavier Bagnoud Building, University of Michigan, 1320 Beal
Avenue, Ann Arbor, MI 48109

The natural rippling patterns of water inspired the undulating surface of
this verdant lawn, made from just soil and grass. Preceded by a detailed
study of fluid dynamics at the university, Lin's installation appears to change
depending on the movement of the sun. This is Lin's first of three wave
pieces: one in Miami and another at Storm King Art Center in New York.

NORTH AMERICA — UNITED STATES

DAVID NASH, SABRE LARCH HILL, 2013–PRESENT

Frederik Meijer Gardens and Sculpture Park, 1000 East Beltline
Avenue NE, Grand Rapids, MI 49525

After planting several dozen larch seedlings in the Japanese Garden at this
sculpture park, Nash left a set of detailed instructions to the horticultural
staff, explaining how the trees should be pruned and manipulated. The living
artwork, which will slowly evolve over time, is one of nearly 300 works at the
158-acre (0.64 sq km) site, which includes speciality gardens, a conservatory,
and a gallery.

ALEXANDER CALDER, LA GRANDE VITESSE, 1969 ⦿

Calder Plaza, 300 Monroe Avenue NW, Grand Rapids, MI 49503

The swooping curves of this enormous red sculpture are designed to suggest movement. In the 1960s, Calder produced a number of similar structures, which are known as "stabiles," in contrast to his famous mobiles. The sculpture became so popular that it is featured in Grand Rapids's official logo. Situated nearby is Mark di Suvero's towering tire swing *Motu Viget* (1977).

MARK DI SUVERO, THE CALLING, 1981–82 ⬤

O'Donnell Park, 910 East Michigan Street, Milwaukee, WI 53202

Located in front of the Milwaukee Art Museum near the Lake Michigan waterfront, this 40-foot-high (12.2 m) painted steel sculpture evokes a rising sun in form and color. The piece has been the subject of local public debate, including opinions on whether it complements or obstructs the Santiago Calatrava–designed 2001 addition to the museum, but it continues to stand in its original location.

43°02'20.9"N 87°53'57.9"W 457

PIERRE HUYGHE, WIND CHIME (AFTER "DREAM"), 1997/2009

Minneapolis Sculpture Garden, Walker Art Center, 725 Vineland Place, Minneapolis, MN 55403

Forty-seven wind chimes hanging from trees are tuned to notes from John Cage's piano composition "Dream" (1948). Inspired by Cage's devotion to chance, Huyghe invites the wind to complete the piece. *Wind Chime* is part of the Minneapolis Sculpture Garden and is displayed alongside artworks such as Claes Oldenburg and Coosje van Bruggen's famous *Spoonbridge and Cherry* (1985–88) and Theaster Gates's first permanent outdoor work.

UGO RONDINONE, MOONRISE. EAST. JANUARY, 2005 (FRONT); MOONRISE. EAST. AUGUST, 2005 (BACK)

John and Mary Pappajohn Sculpture Park, Des Moines Art Center, 1330 Grand Avenue, Des Moines, IA 50309

These two 8-foot-high (2.4 m) busts come from a larger series of twelve sculptures. Inspired by the moon and named for the months of the year, the works reflect Rondinone's interest in giving tangible form to the passing of time. They are part of a 4.4-acre (17,806 sq m) sculpture park that features works by twenty-two major artists, including Gary Hume, Barry Flanagan, and Yoshitomo Nara.

MARY MISS, GREENWOOD POND: DOUBLE SITE, 1989–96

Greenwood/Ashworth Park, 4500 Grand Avenue,
Des Moines, IA 50312

Artworks often draw your gaze to them, but this piece is about finding new
views of nature. The artist created lookouts, a pavilion, a multilevel walkway,
and paths at varying heights to give visitors shifting perspectives on
a landscape near the Des Moines Art Center. Visitors can even step below
ground level to contemplate a pond's surface at eye level.

UNITED STATES—WEST

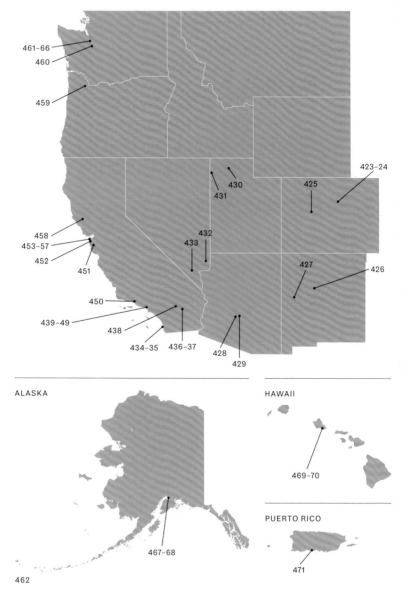

NORTH AMERICA

461–66
460
459

423–24
430
431
425

458
453–57
452
451
432
433

427
426

450
439–49
438
434–35
436–37
428
429

ALASKA

467–68

462

HAWAII

469–70

PUERTO RICO

471

JOEL SHAPIRO, FOR JENNIFER, 2007–11

Bannock Street and West Thirteenth Avenue, Denver, CO 80204

This dazzling blue sculpture towers over viewers. Straddling abstraction and figuration, the 32.8-foot-tall (10 m) structure typifies Shapiro's work. Its metal bars are both an exploration of form and color in space and a portrait of a woman dancing, specifically Jennifer Moulton, the planning director, who envisioned the Civic Center Cultural Complex where the sculpture stands.

ED RUSCHA, PORTION OF THE DENVER LIBRARY MURAL, 1994–95

Denver Central Library, Schlessman Hall, 10 West Fourteenth Avenue Parkway, Denver, CO 80204

This 390-foot-long (118.9 m) panoramic mural stretches around the atrium of Denver's Central Library, depicting the history of the region. The seventy-panel mural includes explanatory anamorphic text, and it also features voiceprints (visual representations of sound) of buffalo snorts and the trill of a lark bunting, the state bird, among other sounds.

HERBERT BAYER, GRASS MOUND, 1955

○

Aspen Meadows, 845 Meadows Road, Aspen, CO 81611

Commissioned by the Aspen Institute, Bayer designed the organization's resort grounds and conference center. A highlight is his *Grass Mound*, a 40-foot-wide (12.2 m) depression in the earth containing a rock and a mound and framed by an earthen rim. The piece reflects Bayer's fascination with the natural dynamism of the earth and is widely considered to be the first contemporary environmental artwork.

39°12'02.7"N 106°49'44.3"W

BRUCE NAUMAN, THE CENTER OF THE UNIVERSE, 1988 ⚫

University of New Mexico, Yale Boulevard NE near Mitchell Hall,
Albuquerque, NM 87106

This piece by Nauman seems to sculpt space and human perception.
Consisting of three interconnected tunnels, it offers views from its center
toward each of the four cardinal directions, the sky, and the ground beneath
(via a metal grate)—or as a plaque describes it: "the center of the universe."

WALTER DE MARIA, THE LIGHTNING FIELD, 1977 A

Near Quemado, Catron County, NM

On a high desert plain De Maria had four hundred stainless steel poles installed, spaced about 220 feet (67 m) apart in sixteen rows that together form a grid measuring 1 × 0.62 miles (1.6 × 1 km). The poles are lightning rods, and during storms, lightning bolts strike the terrain not far from the viewers' cabin—a sublime and fearsome phenomenon to behold.

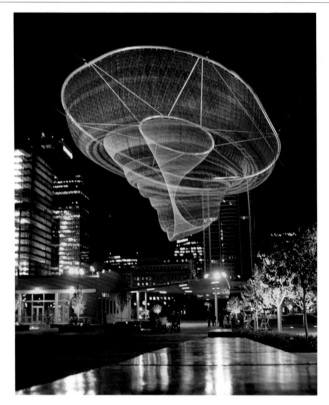

JANET ECHELMAN, HER SECRET IS PATIENCE, 2009

Civic Space Park, 424 North Central Avenue, Phoenix, AZ 85004

Phoenix is one of many cities where this Echelman's sculptures shimmy in the wind. For this piece, Echelman drew inspiration from local natural forms— monsoon cloud formations, fossils, flora—and from Ralph Waldo Emerson, whose quote about nature doubles as the work's title. The polyester net is illuminated with colors that change seasonally: cool hues in the summer heat, warm ones in winter.

33°27'11.6"N 112°04'27.8"W

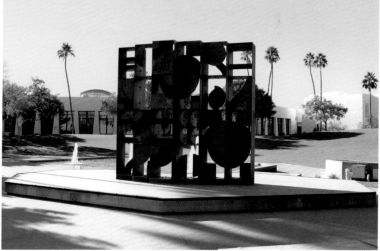

NORTH AMERICA — UNITED STATES

**LOUISE NEVELSON, ATMOSPHERE AND ENVIRONMENT
XVIII (WINDOWS TO THE WEST), 1973** ○

Scottsdale Civic Center Mall, North Seventy-Fifth Street
near East Main Street, Scottsdale, AZ 85251

This wall-like sculpture at Scottsdale's Civic Center Mall consists of six
columns of hollow rectangular cubes filled with geometric shapes. Made
of Cor-Ten steel, the structure depends on the shifting play of light and
shadow to give depth to its weathered surfaces. Belonging to Nevelson's
Atmosphere and Environment series, this was her first large-scale work in
the American Southwest.

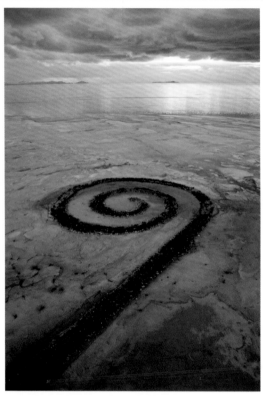

ROBERT SMITHSON, SPIRAL JETTY, 1970

Northeastern shore of the Great Salt Lake, near Corinne, Box Elder
County, UT 84307

To create this work of Land Art, Smithson bulldozed material from the nearby
shore into the Great Salt Lake, creating a monumental nontraditional sculpture
that could exist outside the system of galleries and museums. The scale
and remote location of *Spiral Jetty* allow visitors to reconnect with nature's
vastness. When not submerged underwater, the spiral can be walked on.

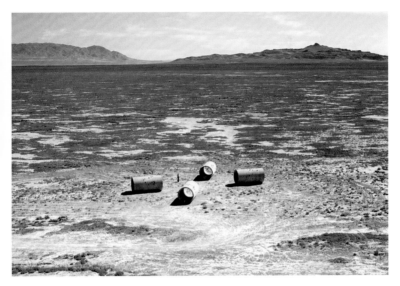

NANCY HOLT, SUN TUNNELS, 1973–76 ○

Great Basin Desert, Box Elder County, UT

Holt's concrete cylinders offer a frame of reference in a region where the vast openness is awesome and disorienting. The tunnels align with the sunrises and sunsets during the summer and winter solstices. Holt also drilled holes in the shapes of constellations into each tunnel so that when sunlight travels though the holes, it casts an image of the star-inspired arrangements on the tunnels' inner surface.

MICHAEL HEIZER, DOUBLE NEGATIVE, 1969

Mormon Mesa, near Overton, NV

Heizer, an innovator of Land Art, carved 240,000 tons (218,000 t) of earth from this site to create a monumental, straight void that is 50 feet (15 m) deep and 1,500 feet (457 m) long. The piece was inspired in part by the artist's childhood experiences accompanying his father, anthropologist Robert Heizer, on archaeological excavations at pre-Columbian and Egyptian sites.

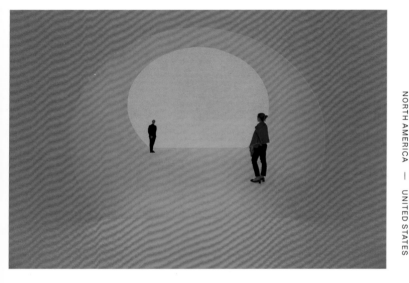

JAMES TURRELL, AKHOB, 2013

Louis Vuitton, the Shops at Crystals, CityCenter, 3720 South Las Vegas Boulevard, Las Vegas, NV 89109

Inside *Akhob*, viewers are totally immersed in color. The walk-through chambers feature vivid and intense hues that subtly shift during twenty-four-minute cycles. The installation belongs to Turrell's *Ganzfeld* series, titled after the German word describing the phenomenon of losing depth perception. It is located on the top floor of Louis Vuitton's Las Vegas store, the brand's largest in North America.

NORTH AMERICA — UNITED STATES

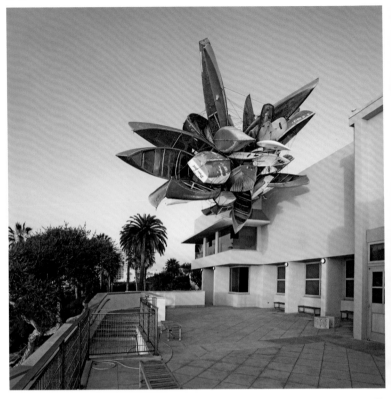

NANCY RUBINS, PLEASURE POINT, 2006

Museum of Contemporary Art San Diego, 700 Prospect Street,
La Jolla, CA 92037

A dynamic assemblage of rowboats, canoes, and surfboards is attached to
the museum's roof. Cantilevered above viewers' heads, the vessels are held
in place solely by wires. Rubins, who is known for transforming discarded
consumer goods into elaborate sculptural compositions, was drawn to
the simple structure of boats for the role they have played in the growth
of civilization.

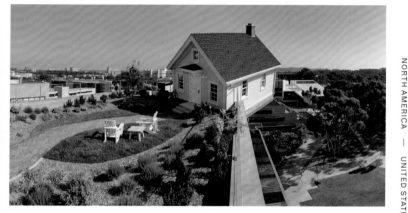

NORTH AMERICA — UNITED STATES

DO HO SUH, FALLEN STAR, 2012 ●

Stuart Collection, University of California San Diego, 9500 Gilman Drive, La Jolla, CA 92093

A small cottage appears to teeter precariously on the corner of a faculty building at the University of California San Diego. The house, complete with a garden, is safe to enter, though some visitors report dizziness or vertigo. Addressing notions of cultural displacement, Suh's work is one of many site-specific sculptures in the renowned Stuart Collection, which also features work by Kiki Smith, John Baldessari, Barbara Kruger, and other artists.

NORTH AMERICA — UNITED STATES

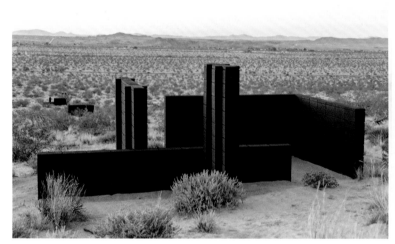

ANDREA ZITTEL, PLANAR PAVILIONS AT A-Z WEST, 2017 ⭘

Near Neptune Avenue and Twentynine Palms Highway,
Joshua Tree, CA 92252

Scattered across an area of about 11 acres (44,714 sq m), the ten pavilions that
make up this artwork exist at the intersection of sculpture and architecture.
Each pavilion consists of vertical planes that function as walls—framing the
surrounding landscape and providing physical and psychological shelter. As
the desert becomes increasingly developed, the pavilions appear as ruins,
or structures still in a state of construction.

NORTH AMERICA — UNITED STATES

NOAH PURIFOY, EVERYTHING AND THE KITCHEN SINK, 1996

Noah Purifoy Desert Art Museum of Assemblage Art, 63030 Blair Lane,
Joshua Tree, CA 92252

"The Environment," as it is commonly known, is a total work of art that
fulfills Purifoy's lifelong mission to explore the human experience and the
communicative power of art—principles informed by his participation in
the Black Arts Movement. Purifoy was devoted to the project from 1994 until
his death, in 2004. The environment of found-object sculptures suggests
the potential freedom in self-expression.

RACHEL WHITEREAD, SHACK II, 2016

○

Near Geronimo and Cottontail Roads, Yucca Valley, CA 92284

This sculpture, located near Joshua Tree in California's Mojave Desert, at first appears to be an old shack. It is, in fact, a solid-concrete cast of the interior of an abandoned cabin. It belongs to Whiteread's *Shy Sculptures* series, in which each piece is a full-scale architectural structure cast from the inside of a rustic building and placed inconspicuously in an outdoor location.

CAROL BOVE, IO, 2014 ⭕

Beverly Gardens Park, North Beverly Drive and Park Way,
Beverly Hills, CA 90210

This glossy white sculpture of looping tubular steel is part of Bove's *Glyphs*
series. (Glyphs are characters or symbolic figures in a system of writing.)
The work was commissioned by the City of Beverly Hills, which has an
ambitious public art program. Other sculptures by notable artists, including
Jonathan Borofsky and William Kentridge, are installed throughout the city.

NORTH AMERICA — UNITED STATES

NORTH AMERICA — UNITED STATES

CHARLES RAY, BOY WITH FROG, 2009

Getty Center, 1200 Getty Center Drive, Los Angeles, CA 90049

A nude boy grasping a bullfrog stands inquisitively on the Getty's steps. At 8 feet (2.4 m) tall, the classically inspired, white-fiberglass sculpture towers over visitors. An impressive collection of outdoor sculptures includes works by Mark di Suvero, Martin Puryear, Alberto Giacometti, and René Magritte. Also available for viewing is Robert Irwin's elaborate Central Garden (1997), designed specifically for the site.

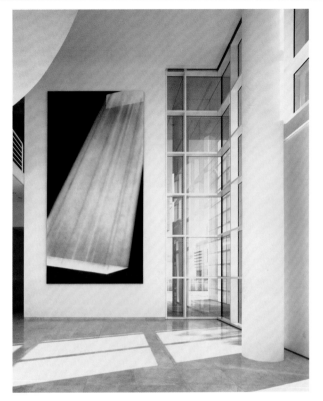

ED RUSCHA, PICTURE WITHOUT WORDS, 1997 ●

Harold M. Williams Auditorium, Getty Center, 1200 Getty Center
Drive, Los Angeles, CA 90049

Ruscha's canvas is one of many works displayed inside the Getty's sprawling
hilltop complex in the Santa Monica Mountains. Five pavilions house the
permanent collection. This specially commissioned painting is a portrait of the
light that shines through the window of the auditorium where it is permanently
installed, but it also evokes the monolithic, sun-drenched museum.

PAE WHITE, "W"IND THING (FALLEN STARS), 2010

W Hollywood, 6250 Hollywood Boulevard, Los Angeles, CA 90028

White's assortment of laser-cut forms coated with metallic colors hangs and shimmers in the breeze. Nature and the beauty of everyday phenomena are recurring themes in the artist's work. In this sculpture, her suspended columns of ornate steel disks animate the space between two buildings with subtle movement determined by the force of the wind.

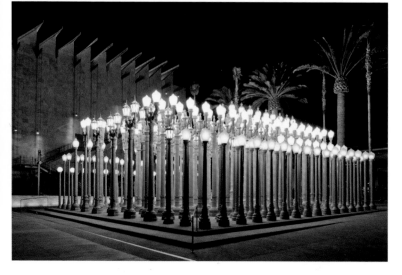

CHRIS BURDEN, URBAN LIGHT, 2008

Los Angeles County Museum of Art, 5905 Wilshire Boulevard,
Los Angeles, CA 90036

Burden is best known for disturbing, dangerous performance art, but this art
installation evokes awe and serenity. He collected 202 vintage cast-iron street
lamps, painted them gray, and placed them in a grid in front of the Los Angeles
County Museum of Art. In this array, they resemble classical columns, and
their blaze of light serves as a welcoming beacon.

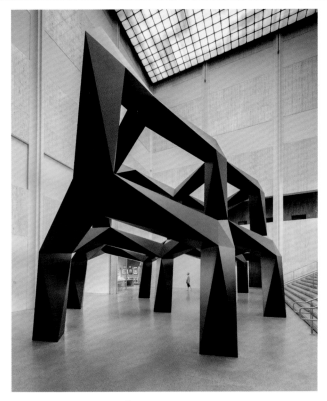

TONY SMITH, SMOKE, 1967/2005 ●

Los Angeles County Museum of Art, 5905 Wilshire Boulevard,
Los Angeles, CA 90036

Filling the museum's atrium, this huge skeletal sculpture is one of Smith's
largest. Its form—black hexagons and tetrahedrons—reflects the artist's
interest in patterns and geometry. Conceived during the 1960s, the sculpture
was first made from wood. This aluminum version was fabricated after Smith's
death and is the only large-scale work that he designed for interior display.

NORTH AMERICA — UNITED STATES

YAYOI KUSAMA, INFINITY MIRRORED ROOM—THE SOULS OF MILLIONS OF LIGHT YEARS AWAY, 2013

A

The Broad, 221 South Grand Avenue, Los Angeles, CA 90012

The walls of this dazzling room are mirrored. Over one hundred colored LED lights hang from the ceiling, giving the impression of infinite, endless space. Kusama has been creating these introspective rooms since the 1960s as places for perceiving, listening, and feeling. Visitors may enter individually and remain in the space for 45 seconds, a brief yet intimate viewing experience.

NORTH AMERICA — UNITED STATES

ROBERT RAUSCHENBERG, FARGO PODIUM, 1982

Citigroup Center, 444 South Flower Street, Los Angeles, CA 90071

This downtown office building contains a series of site-specific sculptures that vitalize its plazas and frame views of the surrounding city. Sitting across from an indoor waterfall, Rauschenberg's *Fargo Podium* is a benchlike platform decorated with an elaborate mixed-media collage of maps, newspaper images, and photographs. Also at the Citigroup Center are sizable sculptures by Michael Heizer, Bruce Nauman, and Mark di Suvero.

34°03'05.8"N 118°15'18.5"W

JENNY HOLZER, BLACKLIST, 1999

O

USC Fisher Museum of Art, University of Southern California,
823 West Exposition Boulevard, Los Angeles, CA 90089

During the Cold War, government paranoia over communist beliefs led to
the blacklisting of many Americans. These stone benches engraved with
quotations reference the Hollywood Ten, a group of filmmakers imprisoned
when they refused to testify before the House Un-American Activities
Committee in 1947. Celebrated for her text-based work, Holzer created this
installation as a memorial to free speech and civil liberties.

34°01'06.9"N 118°17'15.3"W

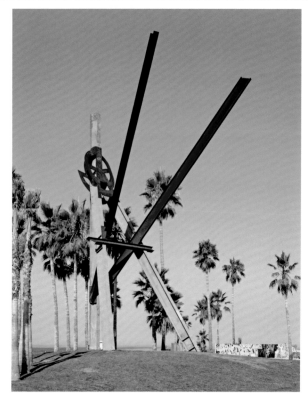

MARK DI SUVERO, DECLARATION, 1999–2001

Venice Beach Boardwalk at Windward Avenue,
Los Angeles, CA 90291

Dramatically exceeding the height of the palm trees that separate it from the waterfront, di Suvero's monumental sculpture stands as a bold graphic form against the sky, declaring its place and its status as public art. Since the 1960s, di Suvero has created large-scale Erector Set–like sculptures that use industrial materials to suggest the weightlessness of abstract paintings.

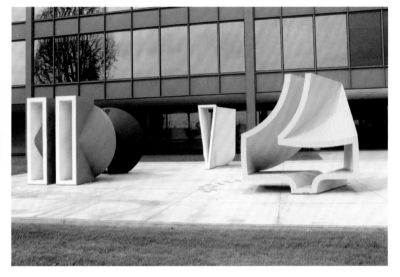

**GEORGE SUGARMAN, YELLOW TO WHITE TO BLUE
TO BLACK, 1967** ⬤

701 South Aviation Boulevard, El Segundo, CA 90245

Sugarman is celebrated for his large-scale pedestal-free sculptures painted
with vivid colors. These large yellow, white, blue, and black steel forms
constitute the artist's first outdoor artwork and provide a striking counterpoint
to the gray steel and glass architecture of the 1960s Craig Ellwood–designed
office building.

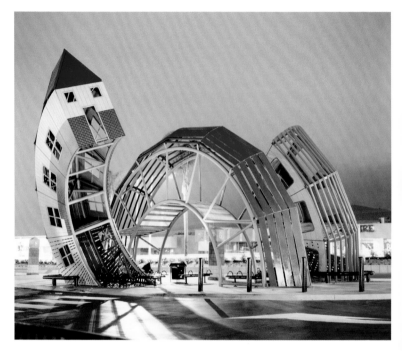

DENNIS OPPENHEIM, BUS HOME, 2002

○

Pacific View Mall Transit Center, 3330 Telegraph Avenue,
Ventura, CA 93003

Neither a bus nor a home, this installation, which doubles as a bus station,
showcases the artist's characteristic humor. Its parallel tubes, slats, and
painted panels suggest a journey, with the end of a city bus morphing into
the shape of a cartoonlike house and echoing the movement of passengers
traveling from the city to home.

JOSEF ALBERS, STANFORD WALL, 1980　　　　○

Stanford University, Palm Drive and Roth Way, Stanford, CA 94305

On one side of Albers's freestanding wall are black rods inlaid between white bricks. On the other, steel rods form geometric patterns across a surface of black granite. The commanding sculpture was the last major project by the pioneering abstract artist, who is celebrated for his explorations of geometry and color. It was completed posthumously, four years after his death.

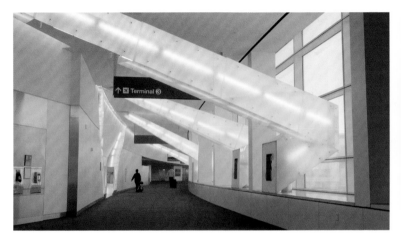

VITO ACCONCI, LIGHT BEAMS FOR THE SKY OF A TRANSFER CORRIDOR, 2001

San Francisco International Airport, International Terminal, Level 2, San Francisco, CA 94128

Acconci's sculptural yet functional installation helps brighten and enliven travelers' treks in this airport corridor (in a presecurity area of San Francisco International Airport). From a light strip in the ceiling, acrylic beams lined with fluorescent lights exuberantly careen down the walls or diagonally toward outside-facing windows before landing, intentionally, on working public telephones.

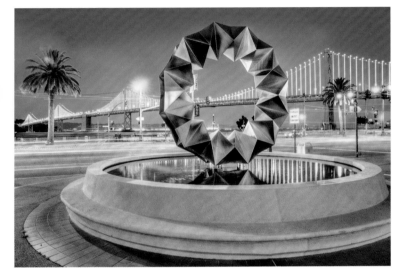

RUTH ASAWA, AURORA, 1986 ⭕

Bayside Plaza, 188 The Embarcadero, San Francisco, CA 94105

Asawa once commented that "an artist is an ordinary person who can take ordinary things and make them special." A paper-fold design formed the basis for this stainless steel sculpture-fountain, which frames views of the Bay Bridge. Other public works by Asawa, a California native, can be found throughout the city.

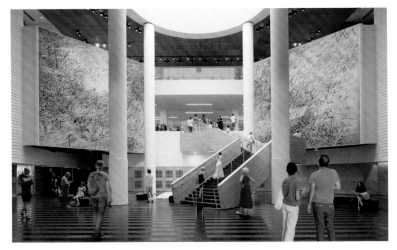

JULIE MEHRETU, HOWL, EON (I, II), 2017

San Francisco Museum of Modern Art, 151 Third Street,
San Francisco, CA 94103

These immense abstract paintings, the largest and most ambitious of Mehretu's career, dwarf visitors at the San Francisco Museum of Modern Art. Installed above the museum's central staircase, the two epic canvases are covered with tangled webs of gestural marks referencing the majestic landscapes of the American West and its history of colonialism and violent conflict.

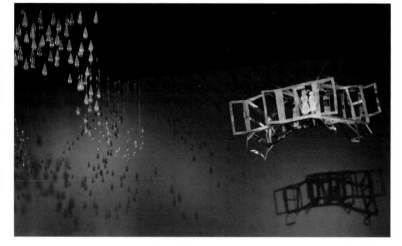

KIKI SMITH, NEAR, 2005

De Young Museum, Golden Gate Park, 50 Hagiwara Tea Garden Drive,
San Francisco, CA 94118

Two girls stand in an aluminum cardboard flying machine that is suspended
near a fog of glass teardrops. A seventeenth-century portrait inspired Smith's
installation, which is one of the museum's four site-specific commissions.
Gerhard Richter, James Turrell, and Andy Goldsworthy also created pieces
for the new museum building, which replaced the 1895 original after an
earthquake destroyed it in 1989.

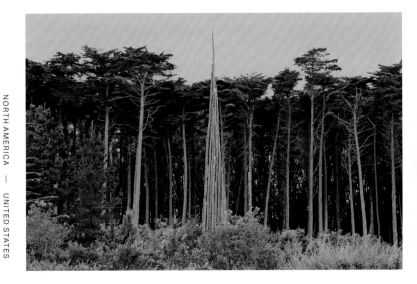

ANDY GOLDSWORTHY, SPIRE, 2008 ●

The Presidio, Bay Area Ridge Trail, San Francisco, CA 94129

Thirty-seven cypress logs were gathered together to form a single spiraling trunk. Standing over 90 feet (27.4 m) tall and overlooking San Francisco Bay, *Spire* is the first of four sculptures Goldsworthy created for the Presidio from 2008 to 2014. The 1,500-acre (6.1 sq km) park features woodland walks and scenic views. Goldsworthy's works can be explored along a three-mile hiking trail.

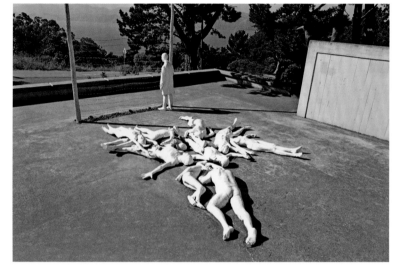

GEORGE SEGAL, THE HOLOCAUST, 1982

○

Lincoln Park, near Legion of Honor, 100 Thirty-Fourth Avenue,
San Francisco, CA 94129

This poignant memorial draws from press photographs taken in 1945 at the
liberation of the Nazi concentration camp in Buchenwald, Germany. Segal's
bronze tableau makes powerful use of his particular brand of realism,
incorporating a variety of religious symbolism with the figures of the dead.
A Holocaust survivor modeled for the figure of the lone standing man.

NORTH AMERICA — UNITED STATES

ANN HAMILTON, TOWER · OLIVER RANCH, 2007

A

Oliver Ranch, 22205 River Road, Geyserville, CA 95441

This picturesque 100-acre (0.4 sq km) property is home to eighteen site-specific installations, including works by Bruce Nauman, Richard Serra, and Martin Puryear. Hamilton designed this unique acoustic environment to host dance, poetry, theater, and music performances. Events are regularly held in the space, which is defined by two twisting staircases: one for the audience, the other for performers.

CHRIS JOHANSON AND JOHANNA JACKSON, CHERRY SPROUT PRODUCE, 2009

⬤

722 North Sumner Street, Portland, OR 97217

This mural by husband-and-wife artists Johanson and Jackson folds in multiple vantage points and moments in time, creating a dynamic depiction of farming and nature. The scene depicts local greens—apropos for a mural that runs along the side of a market that offers a wide selection of local produce. The painting's bold, colorful style is characterisitc of the duo's collaborative works.

NORTH AMERICA — UNITED STATES

ROBERT MORRIS, JOHNSON PIT #30, 1979

21610 Thirty-Seventh Place S, SeaTac, WA 98198

This project is Morris's response to a site in need of environmental remediation. His design reimagined a disused gravel pit as an amphitheater, planted with resilient rye grass. According to Morris, this was "the first instance of the hiring of an artist to produce art billed as land reclamation." The pit has become a popular park in what is now a residential neighborhood.

NORTH AMERICA — UNITED STATES

TONY OURSLER, BRAINCAST, 2004

Seattle Central Library, 1000 Fourth Avenue, Seattle, WA 98104

This piece by Oursler can be seen by riding the escalator at Seattle's Central Library. Embedded into the walls between levels three and five, the video installation reflects on the way that information is transmitted in society. Images of faces are projected onto three Plexiglas-covered oval white frames. An ambiguous spoken soundtrack adds to the work's enigmatic quality.

NORTH AMERICA — UNITED STATES

ALEXANDER LIBERMAN, OLYMPIC ILIAD, 1984

Seattle Center, west of the Space Needle, Broad Street,
Seattle, WA 98109

On the lawn near Seattle's famed Space Needle stands Liberman's monumental
red sculpture, approximately 45-feet-tall (13.7 m) and with archlike spaces
that visitors can walk through. Liberman created the piece by cutting steel
cylinders at various angles and lengths, resulting in shapes that earned
the piece its nickname, "Pasta Tube."

LOUISE BOURGEOIS, EYE BENCHES III, 1996–97

●

Olympic Sculpture Park, 2901 Western Avenue, Seattle, WA 98121

The eco-friendly 9-acre (36,422 sq m) Olympic Sculpture Park is named for its views of the Olympic Mountains. The Z-shaped path guides visitors to twenty-one works from the mid-twentieth century to the present—by Tony Smith, Louise Nevelson, George Rickey, and other artists. Bourgeois's *Eye Benches* provide surrealism-inspired seating to those needing rest.

MICHAEL HEIZER, ADJACENT, AGAINST, UPON, 1976

⭘

Myrtle Edwards Park, 3130 Alaskan Way, Seattle, WA 98121

Visitors to the shore of Elliott Bay in Myrtle Edwards Park will discover Heizer's piece, three massive natural blocks of granite that rest nearby, against, or atop three concrete plinths (hence the title). The plinths have five, four, and three sides. The simpler the plinth, the closer the accompanying piece of granite sits to it.

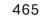

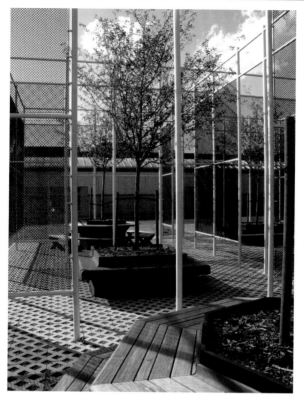

ROBERT IRWIN, 9 SPACES 9 TREES, 1983/2007

University of Washington, George Washington Lane Northeast near
Odegaard Undergraduate Library, Seattle, WA 98195

Nature's color palette is "beyond anything any painter has ever considered,"
Irwin once remarked. This installation heightens the visitor's awareness
of that beauty. Purple-coated fencing encloses nine outdoor rooms, each
featuring a Winter King hawthorn tree. The appearance of the tree shifts
seasonally; it grows white flowers, orange-red berries, and leaves of green
that later turn gold or scarlet.

47°39'23.2"N 122°18'39.9"W

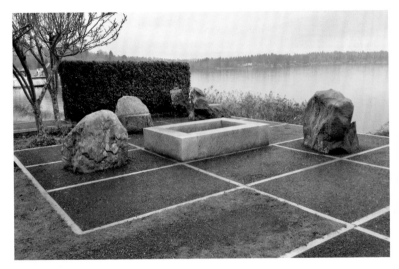

SCOTT BURTON, VIEWPOINT, 1981

National Oceanic and Atmospheric Administration Western Regional
Center, 7600 Sand Point Way NE, Seattle, WA 98115

Overlooking Lake Washington, Burton created a space resembling
a terraced garden, with chairs created from boulders. As he often did with
his furniture-sculptures, Burton left some of the boulders' edges rough—
a reminder of the material's original state. Located on the National Oceanic
and Atmospheric Administration campus, *Viewpoint* is one of various pieces
in the NOAA Art Walk.

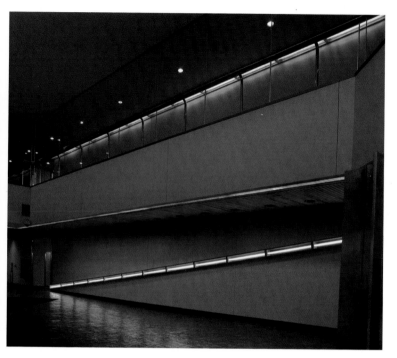

DAN FLAVIN, UNTITLED, 1980

●

James M. Fitzgerald US Courthouse and Federal Building, 222 West
Seventh Avenue, Anchorage, AK 99513

Fluorescent light fixtures are usually blandly utilitarian, but in Flavin's hands,
they become materials of minimalist art. Across this government building's
lobby wall, he used fifteen green lights to form a 60-foot (18.3 m) diagonal
stripe of green; in the mezzanine, twelve rose-colored lights create a similar
line across the ceiling.

ANTONY GORMLEY, HABITAT (ANCHORAGE), 2010 ⬤

C Street and West Sixth Avenue, Anchorage, AK 99501

This sculpture of a seated figure, made of stainless steel boxes, is as large as a house. Its components were inspired by the city grid and explore the many scales of the human habitat: one's body, residence, and city. A similar work perched at the Beaumont Hotel in London functions as an abode; its interior is the bedroom of one of the hotel suites.

ISAMU NOGUCHI, SKY GATE, 1976–77 ⭕

Honolulu Municipal Building Civic Center, 650 South King Street,
Honolulu, HI 96813

The three jutting cylinders of this sculpture support an undulating black ring.
Its design is informed by the passage of the sun, which twice yearly shines
directly overhead, during the phenomenon known as Lahaina Noon. On May 26
and July 15, Noguchi's tripod casts a shadow of a perfect circle on the ground;
on the other 363 days, the shadow is twisted.

GEORGE RICKEY, TWO OPEN TRIANGLES UP GYRATORY, 1982 ●

Honolulu Museum of Art Spalding House, 2411 Makiki Heights Drive,
Honolulu, HI 96822

These large steel triangles move gracefully in the air, directed by the wind.
The metal forms pivot on special ball-bearing joints developed by Rickey,
who engineered the work to prevent any contact between the moving parts.
Installed in the gardens of the Honolulu Museum of Art, the kinetic sculpture
produces endless combinations of balletic gyrations.

ROY LICHTENSTEIN, BRUSHSTROKES IN FLIGHT, 1984/2010

Museo de Arte de Ponce, 2325 Boulevard Luis A. Ferré Aguayo,
Ponce, Puerto Rico 00717

This sculpture is part of Lichtenstein's *Brushstrokes* series, which satirizes the gestural painting of abstract expressionism. The series began in the 1960s with paintings and prints, and in the 1980s the artist began to include sculptures, such as this 25-foot-high (7.6 m) painted-aluminum piece. *Brushstrokes in Flight* is prominently displayed at the Museo de Arte de Ponce's main entrance.

18°00'13.5"N 66°37'01.9"W

MEXICO AND CUBA

MEXICO

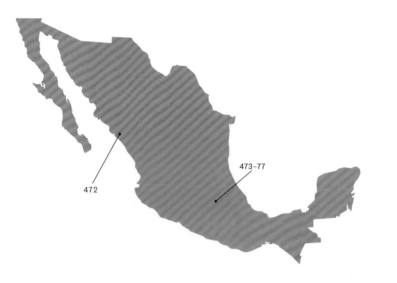

472

473–77

CUBA

478

479

NORTH AMERICA — MEXICO

FRANCIS ALŸS, GAME OVER, 2010–11

●

Jardín Botánico Culiacán, Avenida de las Américas 2131,
Col. Burócrata, Culiacán

This botanical garden features more than twenty site-specific contemporary
artworks exploring issues relating to society and nature. Alÿs created *Game
Over* by crashing a Volkswagen sedan into a parota tree. Biological activity
has taken place within the wrecked car, creating symbiosis between nature
and technology. Gabriel Orozco, Teresa Margolles, and others also created
works for the garden.

MATHIAS GOERITZ AND LUIS BARRAGÁN, CINCO TORRES [FIVE TOWERS], 1958 ⚫

Ciudad Satélite, Naucalpan de Juárez

Located on a main highway, these five prism-shaped towers welcome people to the district of Ciudad Satélite just north of Mexico City. The concrete structures came to symbolize a new type of urban sculpture in Mexico that broke with tradition. Embodying the modern utopian spirit of the late 1950s, the sculpture has since become a distinctive landmark.

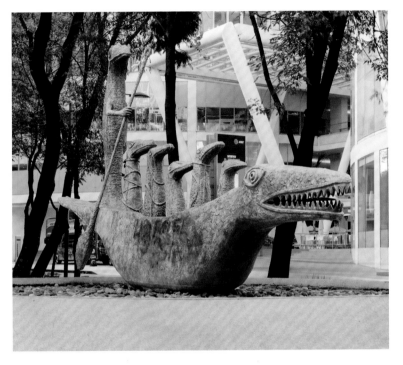

NORTH AMERICA — MEXICO

LEONORA CARRINGTON, COCODRILO [CROCODILE], 2000 ⬤

Paseo de la Reforma and Havre, Juárez, Mexico City

A band of reptilian sailors ride in a crocodile-shaped gondola. The 26-foot-long (8 m) bronze sculpture was inspired by Lewis Carroll's *Alice's Adventures in Wonderland* (1865), which describes how the creature's welcoming smile lures fish into its jaws. Carroll's fantasy novel greatly appealed to Carrington, whose surrealist sculptures drew inspiration from the animal world, mythology, and magic.

NORTH AMERICA — MEXICO

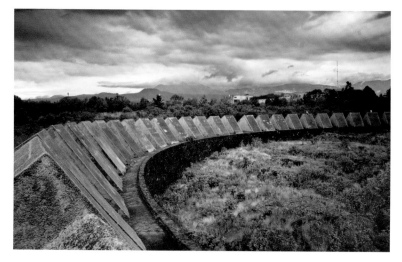

MATHIAS GOERITZ, FEDERICO SILVA, SEBASTIÁN, HELEN ESCOBEDO, MANUEL FELGUÉREZ, AND HERSÚA, ESPACIO ESCULTÓRICO [SCULPTURAL SPACE], 1979

Centro Cultural Universitario, UNAM, Ciudad Universitaria, Mexico City

Six sculptors designed this public area of the university campus. Their collaboration resulted in a circular, craterlike space made of volcanic lava, with sixty-four 13-foot-tall (4 m) polyhedral monuments towering over it; the space is renowned and beloved for the panoramic views it offers from within. Sculptures by the individual artists are installed nearby as part of a walk leading up to the circle.

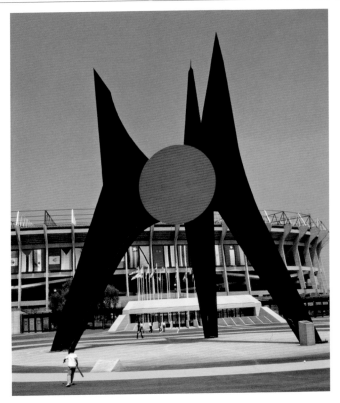

ALEXANDER CALDER, EL SOL ROJO, 1968

Estadio Azteca, Calzada de Tlalpan 3465, Sta. Úrsula Coapa,
Coyoacán, Mexico City

As a young man working on a ship, Calder once saw a spectacular sight:
a fiery sunrise beginning on one side of the horizon while the moon still
glowed on the other. Not surprisingly spheres and discs are recurring
motifs in his artwork. His largest sculpture is this one, which stands over
80 feet (24.3 m) tall, at Estadio Azteca (Aztec Stadium).

19°18'08.3"N 99°08'51.3"W

NORTH AMERICA — MEXICO

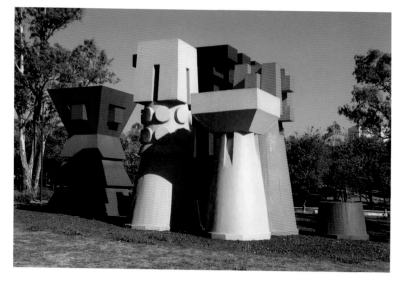

JOOP BELJON, TERTULIA DE LOS GIGANTES [GATHERING OF THE GIANTS], 1968

Anillo Periférico and Viaducto Tlalpan, Mexico City

For the 1968 Summer Olympics in Mexico City, twenty-two abstract sculptures were commissioned to be displayed along a ten-mile route that has since become a major highway. The modernist works, by Ángela Gurría, Willi Gutmann, Kiyoshi Takahashi, and others, celebrate the Olympic values of international friendship and cooperation. Beljon's colorful towers, inspired by Mesoamerican architecture, were neglected for years but are now fully restored.

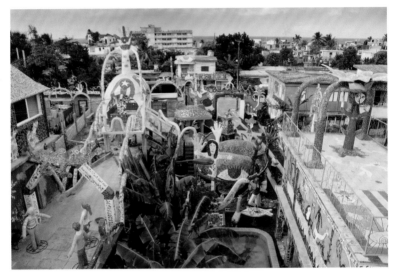

JOSÉ RODRÍGUEZ FUSTER, FUSTERLANDIA, 2000–PRESENT

Jaimanitas, Havana

Seeking to add visual intrigue and excitement to his home, Cuban artist Fuster covered its surfaces with ceramic tiles and colored paint. The project grew and now extends for blocks in the surrounding neighborhood. Vibrant mosaics adorn courtyards, roofs, doorways, and more, while painted quotations from Cuban literary icons and a variety of sculptures provide additional layers to explore in this art-filled community.

MELVIN EDWARDS, POINT OF MEMORY, 2010–13

Parque de la Beneficiencia, Santiago de Cuba

At 18 feet (5.5 m) tall, this is the largest of Edwards's sculptures to date, consisting of a solid pillar joined with a column of chains, a composition that symbolizes both the shackles of slavery and the freedom from them. The piece is installed near a colonial building where slaves were brought during the sixteenth century, heightening the symbolic significance of the work.

SOUTH AMERICA

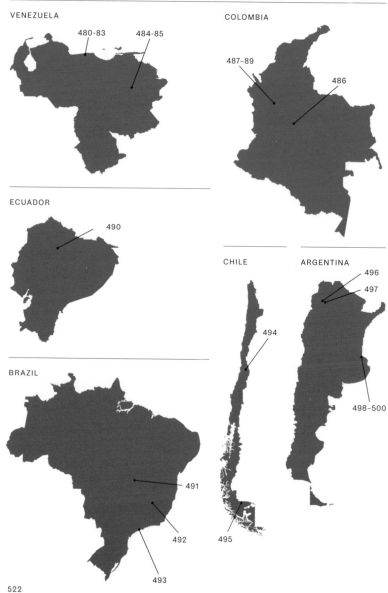

VENEZUELA

480-83 484-85

COLOMBIA

487-89 486

ECUADOR

490

CHILE

494

495

ARGENTINA

496
497

498-500

BRAZIL

491

492

493

GEGO, CUADRILÁTEROS [QUADRILATERALS], 1983

La Hoyada station, Avenida Sur 5, Caracas

Gego's installation at La Hoyada Caracas metro station continues one of her most significant series, *Reticuláreas*, which are installations of interconnected nets that fill exhibition spaces and reveal her interest in line and space. *Cuadriláteros*, an installation of aluminum tubes fitted into the ceiling to create a construction of geometrical lines, is, likewise, integrated into an architectural space.

SOUTH AMERICA — VENEZUELA

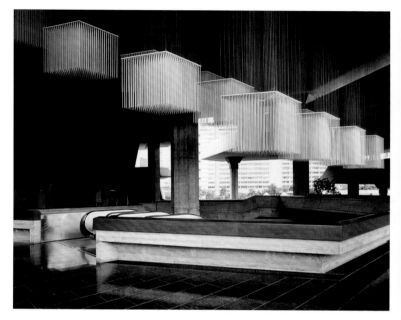

JESÚS RAFAEL SOTO, CUBOS VIRTUALES BLANCOS SOBRE PROYECCIÓN AMARILLA [WHITE VIRTUAL CUBES OVER YELLOW PROJECTION], 1982

●

Complejo Cultural Teatro Teresa Carreño, Av. Paseo Colón, Caracas

Yellow and white rods suspended over the foyer of the Sala Ribas constitute this piece, one of several by Soto in this cultural complex. The yellow layer occupies a single plane; the white areas hover below it. The viewer's relative position alters their perception of the piece: when traveling on the escalators directly below, the rods appear to dematerialize into thin air.

10°29'55.9"N 66°53'54.6"W

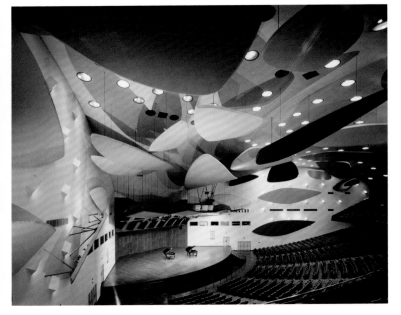

SOUTH AMERICA — VENEZUELA

ALEXANDER CALDER, ACOUSTIC CEILING, 1954

Aula Magna, Universidad Central de Venezuela, Ciudad Universitaria, Caracas

The large, irregular ovoid panels splayed across the ceiling and walls of the Aula Magna, an auditorium with a capacity of nearly three thousand, resemble individual elements of Calder's mobiles. But unlike his kinetic works, they seem to be frozen in space. They act as acoustic panels—their shapes, material, and precise angle and position were all chosen to best serve the theater's acoustics.

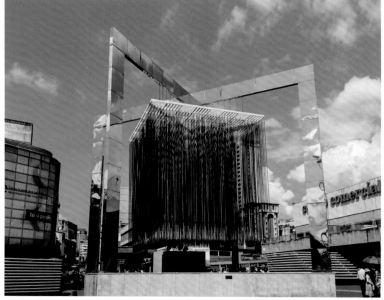

JESÚS RAFAEL SOTO, CUBO VIRTUAL AZUL Y NEGRO [BLUE AND BLACK VIRTUAL CUBE] AND PROGRESIÓN AMARILLA [YELLOW PROGRESSION], 1983

○

Chacaíto station, Avenida Principal del Bosque, Caracas

Soto created this work, which is made up of two parts, for Caracas's Chacaíto station. The two pieces are strategically placed to cover the air duct space and meet in the middle to form a single unit. *Cubo virtual azul y negro*, hanging outside the station, appears suspended in the air, and *Progresión amarilla*, on the mezzanine level below, reaches upward toward the hanging cube.

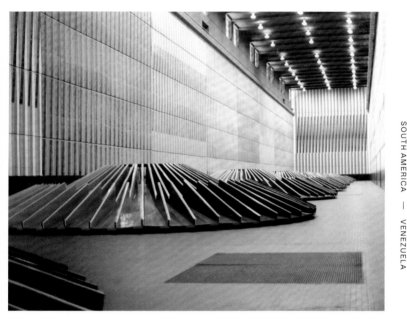

CARLOS CRUZ-DIEZ, AMBIENTACIÓN CROMÁTICA [CHROMATIC ENVIRONMENT], 1977–86

⬤

Simón Bolívar Hydroelectric Plant, Guri Dam, Bolívar

Located in a rain forest, the Simón Bolívar Hydroelectric Plant generates more than half of Venezuela's electricity. Chromatic environments by Cruz-Diez adorn both of the engine rooms and include geometric murals and painted metal sculptures that resemble turbines, which bring the colors of the rain forest into the industrial space. These works enliven and humanize the space.

SOUTH AMERICA — VENEZUELA

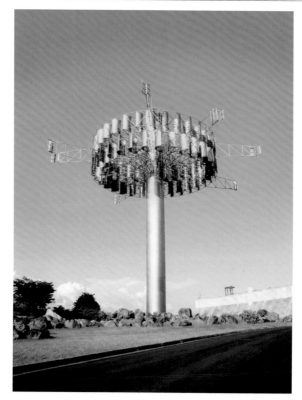

ALEJANDRO OTERO, TORRE SOLAR [SOLAR TOWER], 1986

Via Torre Solar, Simón Bolívar Hydroelectric Plant, Guri Dam, Bolívar

This outdoor sculpture of concrete and steel consists of a 164-foot-tall (50 m) column with a structure on top that resembles two stacked Ferris wheels on a horizontal axis. Otero's largest work ever, the sculpture also recalls a turbine engine, referencing the enormous generators housed in the hydroelectric plant's engine rooms.

BEATRIZ GONZÁLEZ, AURAS ANÓNIMAS [ANONYMOUS AURAS], 2007–9

Cementerio Central de Bogotá, Carrera 20 No. 24–80, Bogotá

The neoclassical tombs at one of Colombia's oldest cemeteries provided the inspiration for this provocative installation. González placed nearly nine thousand silk-screened silhouettes in the empty tomb niches. Her black-and-white images, which show figures carrying dead bodies, were adapted from press photographs after a paramilitary attack on a cocaine plantation. The artist considers her work a memorial to anonymous victims.

SOUTH AMERICA — COLOMBIA

LUIS FERNANDO PELÁEZ, BOSQUE URBANO [URBAN FOREST], 2005

Plaza de Cisneros, Medellín

Three hundred stone and metal posts of varying heights make up this monumental sculpture that transforms the plaza into a work of art and a popular destination. Reflectors embedded into the posts illuminate the site at night, while the posts offer shade during the day—supplemented by large swaths of bamboo that the artist planted.

SOUTH AMERICA — COLOMBIA

FERNANDO BOTERO, PÁJARO DE LA PAZ [BIRD OF PEACE], 2000 (LEFT); PÁJARO [BIRD], 1994 (CENTER); TORSO MASCULINO [MALE TORSO], 1994 (RIGHT)

Parque San Antonio, Medellín

In 1995 a terrorist bomb exploded from inside Botero's *Pájaro* sculpture at Parque San Antonio, killing twenty-three people and wounding more than one hundred. Botero decided to leave the sculpture's remains as a symbol of the horror of violence. In 2000 he donated another sculpture, *Pájaro de la Paz*, in homage to peace in the aftermath of that event.

SOUTH AMERICA — COLOMBIA

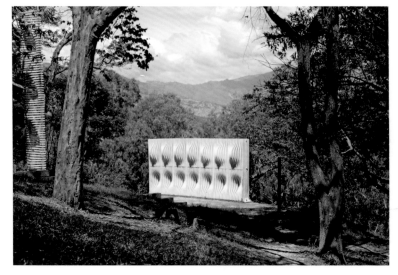

JULIO LE PARC, VOLUME VERTICALE, 1983 ●

Nutibara Hill Sculpture Park, Cerro Nutibara, Calle 30A No. 55–64, Medellín

Nestled in the woods of Nutibara Hill Sculpture Park is Le Parc's two-part installation—a tall slatted tower and an undulating wall. Variations in the surfaces of the white fiberglass and aluminum structures create the illusion of rhythmic movement. Other site-specific sculptures by Colombian and international artists are showcased at the park, where each work is positioned according to the natural contours of the hill.

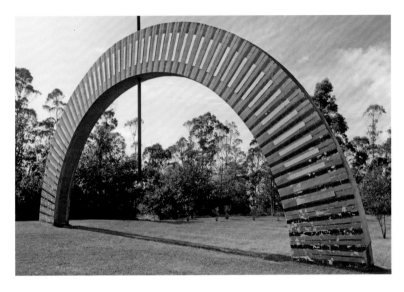

CARLOS CRUZ-DIEZ, ARCO DE INDUCCIÓN CROMÁTICA [CHROMATIC INDUCTION ARC], 1997

●

Parque Metropolitano Guangüiltagua, Quito

This enormous concrete arch uses patterns of colored tiles to suggest movement. An exploration into perception and color phenomena, Cruz-Diez's site-specific sculpture is one of more than a dozen large-scale works by Ecuadorian and international artists that are dotted across Parque Metropolitano Guangüiltagua's wooded landscape. At 1,376 acres (1.5 sq km), the vast mountaintop site is the largest urban green space in South America.

SOUTH AMERICA — BRAZIL

BRUNO GIORGI, THE WARRIORS, 1959 ○

Praça dos Três Poderes, Brasília

Surrounded by government buildings, this 26.2-foot-tall (8 m) bronze depicting two warriors stands as the centerpiece of Brasília's Three Powers Plaza. Lúcio Costa and Oscar Niemeyer developed the city of Brasília in the mid-1950s. Their vision included siting several public sculptures, including Giorgi's, which is an homage to the many workers who built the city.

SOUTH AMERICA — BRAZIL

CILDO MEIRELES, INMENSA [IMMENSE], 1982–2002 ●

Instituto de Arte Contemporânea e Jardim Botânico Inhotim,
Rua B 20, Brumadinho

With this colossal abstract sculpture, Meireles subverts the language
of minimalism. Suggesting domestic furniture, its formal arrangement of
geometric elements invites multiple interpretations. More than seventy
site-specific artworks are displayed across Inhotim's 5,000 acres (70 sq km),
including works by Tunga, Lygia Pape, and Hélio Oiticica.

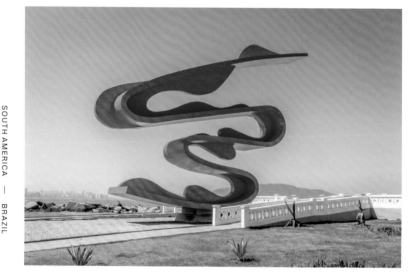

TOMIE OHTAKE, UNTITLED, 2008

Parque Municipal Roberto Mário Santini, José Menino Beach, Santos

Resembling a huge billowing red ribbon, this monumental steel sculpture celebrates São Paulo's Japanese community. Erected to mark the centenary of the first Japanese immigrants to Brazil, the 49-foot-high (15 m) structure is a popular coastal landmark. Its bright-red color recalls Japan's flag, while its serpentine form suggests a heroic dragon, a popular symbol in the nation's mythology.

23°58'19.7"S 46°20'59.8"W

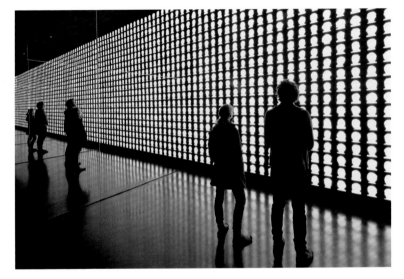

ALFREDO JAAR, THE GEOMETRY OF CONSCIENCE, 2010 ●

Museo de la Memoria y los Derechos Humanos, Matucana 501, Santiago

Viewers of Jaar's light installation descend into darkness to witness artificial light shining from behind a grid of innumerable silhouettes of heads—those of present-day Chileans and of victims under the dictatorship of Augusto Pinochet. As viewers exit the installation, they retain the impressions of light, which underscores the intangibility of memory and questions the redemptive connotation of light.

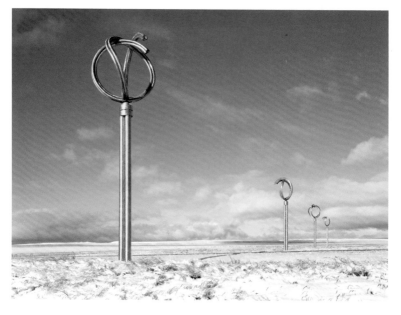

ALEJANDRA RUDDOFF, HOMAGE TO THE WIND, 2000 ⭘

Ruta 9 between Punta Arenas and Puerto Natales, near Villa
Tehuelche, Magallanes Region

This remote sculpture intersects the Southern Pan-American Highway in the
pampas of southern Chile. The work, with its four steel poles that support
twisted, whirling forms, references both the swirling routes of the winds
that circle the globe and the vast network of highways traversed by human
travelers. A plaque explains the work to curious motorists.

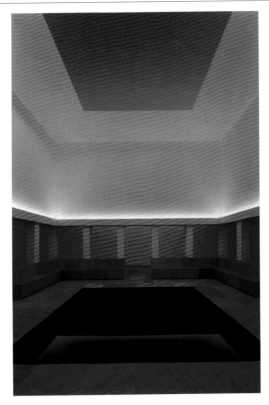

JAMES TURRELL, UNSEEN BLUE, 2002

James Turrell Museum, Colomé Winery and Estate, Ruta Provincial 53 km 20, Molinos, Province of Salta

The James Turrell Museum, the first dedicated to the artist's pioneering light works, houses installations and sculptures spanning five decades. Installed across nine purpose-built rooms, the collection includes *Unseen Blue*, a large version of the artist's mesmerizing skyspaces. Sitting on white benches, viewers can observe the sky's shifting colors through a large aperture in the roof, as natural and artificial light mingle to create a hypnotic effect.

SOUTH AMERICA — ARGENTINA

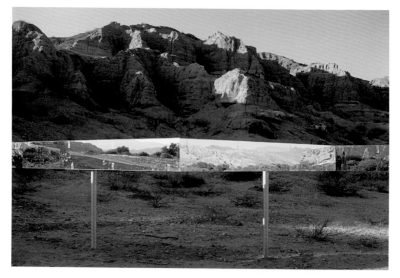

SERGIO AVELLO, MIRAGE, 2006

Ruta Nacional 40, Palo Pintado, Valles Calchaquíes, Province of Salta

This corrugated sculpture has the appearance of a road sign, but its surface is made entirely from mirrors. Like many of Avello's works, it interacts with its environment, reflecting the rugged, rural surroundings. Like a mirage, the mirror tricks and disorients the eye. Viewers, who also see their own reflections, are challenged to consider their relationship to the natural environment.

GRUPO DE ARTE CALLEJERO, MEMORY SIGNS, 1999–2010 ●

Parque de la Memoria, Av. Costanera Norte Rafael Obligado 6745,
Buenos Aires

Parque de la Memoria is a site of remembrance for those who disappeared
or were killed by the Argentinian state from 1969 to 1983. Among the various
artworks is this piece by an artist collective known for its interest in human
rights issues. Borrowing from the iconography of road signs, these signs
describe the history of state terrorism in Argentina and elsewhere.

SOUTH AMERICA — ARGENTINA

NUSHI MUNTAABSKI AND CRISTINA SCHIAVI, HOMENAGEM [TRIBUTE], 2011

Museo de Arte Latinoamericano de Buenos Aires, Av. Figueroa
Alcorta 3415, Buenos Aires

Located next to the Museo de Arte Latinoamericano de Buenos Aires, this
piece pays homage to a well-loved landscape design by Roberto Burle Marx,
which used to exist nearby. Marx's design had featured a prominent spiral,
which Muntaabski and Schiavi echo in one of the mosaics (which also serve
as seating). *Homenagem*'s color palette also reflects Marx's aesthetic.

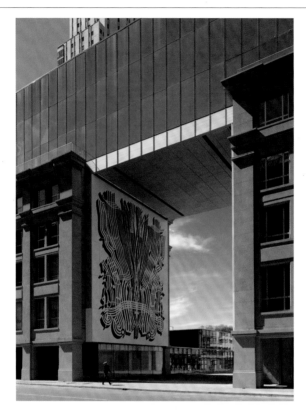

PABLO SIQUIER, MURALS FOR THE MOLINOS BUILDING, 2008

Los Molinos Building, Juana Manso and Azucena Villaflor, Puerto Madero, Buenos Aires

Local artist Siquier created two murals for the Molinos Building using aluminum mounted on steel. The dense geometries—rendered in straight lines in one and curvy lines in the other—are typical of the artist, whose works are abstract but often evoke the forms of architecture and cities. The two panels face one another across a passageway, offering an immersive experience for visitors passing through.

AUSTRALASIA

AUSTRALIA

1 aussiebushwalking.com/qld/sunshine-
 coast/strangler-cairn
3 lakeballard.com
 T +61 8 9024 2072
5 grosvenorplacesydney.com.au
 T +61 2 9256 3900
6 istaybyjennyholzer.com
8 nga.gov.au/sculpturegarden
 T +61 2 6240 6411
9 aph.gov.au/Visit_Parliament/Art/Top_5_
 Treasures/Forecourt_Mosaic
 T +61 2 6277 7111
10 mona.net.au
 T +61 3 6277 9900

NEW ZEALAND

11 gibbsfarm.org.nz
12 connellsbay.co.nz/the-sculpture-park
 T +64 9 372 8957
14 christchurchartgallery.org.nz
 T +64 3 941 7300

ASIA

BANGLADESH

21 samdani.com.bd/srihatta/
 T +8802 8878784 7

PHILIPPINES

22 bellasartesprojects.org/special-projects-vital

MALAYSIA

23 rimbundahan.org
24 ilhamgallery.com

SINGAPORE

27 milleniawalk.com
 T +65 6883 1122
28 marinabaysands.com/museum.html
 T +65 6688 8888
31 publicarttrust.sg/Public-Art/Wind-Arbor

INDONESIA

33 wotbatu.id
 T +62 22 825 244 80

CHINA

35 sifangartmuseum.org/en
 T +86 25 5860 9999

SOUTH KOREA

39 olympicpark.co.kr/jsp/english
 T +82 2 410 1114
40 english.visitkorea.or.kr:1001/enu/SI/SI_
 EN_3_1_1.jsp?cid=826948&nearBy=site&
 T +82 55 225 7034

JAPAN

41 towadaartcenter.com/en
42 oku-noto.jp/en
43 hikarinoyakata.com/eng
 T +81 25 761 1090
44 kanazawa21.jp/en
 T +81 76 220 2800
45 matsumoto-artmuse.jp/en
 T +81 263 39 7400
46 moonflower-sagaya.com/en
 T +81 3 6263 2525
48 hakone-oam.or.jp
 T +81 460 82 1161
49 expo70-park.jp/languages/english
 T +81 6 6877 7387
50 benesse-artsite.jp/en
51 benesse-artsite.jp/en/art/lee-ufan.html
 T +81 87 892 3754
52 benesse-artsite.jp/en/art/teshima-
 artmuseum.html
 T +81 879 68 3555
54 open-air-museum.org/en
 T +81 995 74 5945

EUROPE

NORWAY

55 skulpturlandskap.no/artwork/uten-tittel-
 dan-graham
56 skulpturstopp.no/en/dovre
57 skulpturstopp.no/en/gran
58 kistefos.museum.no
 T +47 61 31 03 83
59 skulpturstopp.no/en/skedsmo
61 akerbrygge.no
 T +47 23 11 54 60
63 ekebergparken.com/en
 T +47 21 42 19 19

SWEDEN

64	umedalenskulptur.org
	T +46 90 144990
65	modernamuseet.se/stockholm/en
	T +46 8 5202 3500
66	kph.kumla.com/index.htm
67	wanaskonst.se/en-us
	T +46 44 660 71

DENMARK

71	en.aros.dk
	T +45 8730 6600
73	en.louisiana.dk/louisiana-collection
	T +45 49 19 07 19

ICELAND

75	visitseydisfjordur.com/project/ tvisongur-sound-sculpture
76	artangel.org.uk/project/library-of-water
78	imaginepeacetower.com

SCOTLAND

80	fruitmarket.co.uk/scotsman-steps
81	nationalgalleries.org
	T +44 131 624 6200
82	jupiterartland.org
	T +44 1506 889900
83	littlesparta.org.uk
	T +44 7826 495677

ENGLAND

85	gateshead.gov.uk/Leisure%20and%20 Culture/attractions/Angel/Map.aspx
88	harewood.org
	T +44 113 218 1010
89	www.leeds.gov.uk/museumsandgalleries/ leedsartgallery
	T +44 113 378 5350
90	ysp.org.uk/openair/seizure
	T +44 1924 832631
94	houghtonhall.com
	T +44 1485 528569
95	ikon-gallery.org
	T +44 121 248 0708
97	thehiveworcester.org
	T +44 1905 822866
99	jesus.cam.ac.uk/college/events/ permanent-collection
100	living-architecture.co.uk/the-houses/ a-house-for-essex/overview
101	henry-moore.org/visit/henry-moore- studios-gardens
	T +44 1279 843 333
103	arcelormittalorbit.com
	T +44 333 8008 099
104	longplayer.org

106	rmg.co.uk/national-maritime-museum
	T +44 20 8858 4422
107	whitechapelgallery.org
	T +44 20 7522 7888
108	broadgate.co.uk/art
109	stpauls.co.uk
	T +44 207 246 8350
114	stmartin-in-the-fields.org
	T +44 20 7766 1100
117	serpentinegalleries.org
	T +44 20 7402 6075
118	southwark.gov.uk/parks-and-open-spaces/ parks/dulwich-park
122	hollow.org.uk
123	11thequay.co.uk/
	T +44 1271 868090
124	folkestoneartworks.co.uk
125	folkestoneartworks.co.uk
126	folkestoneartworks.co.uk
127	sculpture.org.uk
	T +44 1243 538 449
128	tate.org.uk/visit/tate-st-ives/barbara- hepworth-museum-and-sculpture-garden
	T +44 173 679 6226

NETHERLANDS

130	brokencircle.nl
	T +31 591 62 30 37
131	landartflevoland.nl/en/permanent- installations/robert-morris- observatorium-1977
133	rijksmuseum.nl/en
	T +31 20 6747 000
134	landartflevoland.nl/en/permanent-installations/ marinus-boezem-de-groene-kathedraal
135	kroondomeinhetloo.nl
	T +31 55 527 55 22
136	krollermuller.nl/en
	T +31 318 591 241
140	boijmans.nl/en
	T +31 10 44 19 400

BELGIUM

142	middelheimmuseum.be/en
	T +32 3 288 33 60
144	smak.be/en
	T +32 9 240 76 01
147	monarchie.be/en
	T +32 2 551 20 20

LUXEMBOURG

148	eib.org/infocentre/contact/offices/ue/ luxembourg.htm
	T +352 43 791

VISITOR INFORMATION

FRANCE

150	musee-lam.fr/gb
	T +33 3 20 19 68 68
151	cathedrale-metz.fr
	T +33 3 87 75 54 61
152	axe-majeur.fr
153	ladefense.fr/en/oeuvres-d-art
154	fondationlouisvuitton.fr/en
	T +33 1 40 69 96 00
157	domaine-palais-royal.fr/en
160	unesco.org/new/en/unesco/about-us
	/where-we-are/visit-us
	T +33 1 4568 1000
163	dubuffetfondation.com
	T +33 1 47 34 12 63
164	lecyclop.com
	T +33 1 64 98 95 18
166	T +33 4 50 90 80 01
167	refugedart.fr
168	chapellematisse.com
	T +33 4 93 58 03 26
169	fondation-maeght.com/en
	T +33 4 93 32 81 63
170	antibesjuanlespins.com/en/art-et-culture
	/picasso-museum
	T +33 4 92 90 54 28
171	en.musees-nationaux-alpesmaritimes.fr
	/picasso
	T +33 4 93 64 71 83
172	domainedumuy.com/en
	/galerie/contact/0/
	presentation-de-la-galerie
	T +33 6 77 04 75 92
173	chateau-la-coste.com/en
	T +33 4 42 61 92 90

SPAIN

176	cgac.xunta.gal/en
	T +34 981 546 619
177	guggenheim-bilbao.eus/en
	T +34 944 35 90 00
181	salvador-dali.org/en/museums/dali-
	theatre-museum-in-figueres
	T +34 972 677 500
186	madrid.es/museoairelibre
187	artangel.org.uk/project/tres-aguas
188	fundacionnmac.org/en/visit
	T +34 956 455 134
189	underwatermuseumlanzarote.com/en
	T +34 928 518 668

PORTUGAL

| 192 | serralves.pt/en |
| | T +351 226 156 500 |

GERMANY

194	hamburg.de/sehenswuerdigkeiten/4611904
	/balkenhol-figuren
196	kw-berlin.de/en/visit/#cafe-bravo
	T +49 30 2345 7777
198	bundestag.de/en/visittheBundestag/art
	T +49 30 227 0
201	rauminszenierungen.gartenlandschaftowl.
	de/informationen.jsp?id=10
202	skulptur-projekte-archiv.de/en-us
203	skulptur-projekte-archiv.de/en-us
204	skulptur-projekte-archiv.de/en-us
207	grassimuseum.de/en
	T +49 341 2229 100
208	diaart.org/visit/visit/walter-de-maria-the-
	vertical-earth-kilometer-kassel-germany
209	skulpturenpark-waldfrieden.de/en/info
	T +49 202 4789 8120
210	kunsthalle-duesseldorf.de
211	koelner-dom.de/home.html?&L=1
	T +49 221 1794 0555
213	arpmuseum.org/en
	T +49 2228 94250
215	mfk-frankfurt.de/en
221	T +49 89 23990
222	evkirche-hoeri.de
	T +49 7735 2074

AUSTRIA

228	salzburgfoundation.at/walk-of-modern-art
	/ideen-ziele/
229	politische-landschaft.at/en/kunst
	/florian-huettner

SWITZERLAND

230	fondationbeyeler.ch/en
	T +41 61 645 97 00
232	schaulager.org/en
	T +41 61 335 32 32
237	enea.ch/baummuseum/?lang=en
	T +41 55 225 55 55
238	kunstmuseum-so.ch
	T +41 32 624 40 00
239	atelier-amden.ch
243	gyre.ch
	T +41 21 338 00 01
244	montetamaro.ch/en
	T +41 91 946 23 03

ITALY

246	fondoambiente.it/luoghi/villa-e-collezione-
	panza/visita
	T +39 0332 283960
247	fondazionezegna.org/en/all-aperto
	T +39 015 7591463

248 hangarbicocca.org/en/anselm-kiefer
T +39 02 66 11 15 73
249 mudima.net
T +39 02 2940 9633
251 fondazioneprada.org/project/louise-
bourgeois/?lang=en
T +39 02 5666 2611
252 fondazioneprada.org/project/chiesa-rossa
253 collezionemaramotti.org
T +39 0522 382484
254 goricoll.it/index.php?chlang=en
T +39 0573 479907
256 chiantisculpturepark.it
T +39 0577 357151
257 ilgiardinodeitarocchi.it/en
T +39 0564 895122

ESTONIA
265 lauluvaljak.ee/en/visiting-park

LITHUANIA
266 europosparkas.lt
T +370 5 2377 077

TURKEY
275 art.ykykultur.com.tr
T +90 212 252 47 00

AFRICA

MOROCCO
276 cinemathequedetanger.com/en
T +212 5 22 39 93 46 83

RWANDA
279 volcanoesnationalpark.org
T +250 788 558 880

ZIMBABWE
280 nationalgallery.co.zw
T +263 4 704 666

SOUTH AFRICA
281 niroxarts.com
T +27 82 854 6963
284 thecapturesite.co.za

MIDDLE EAST

LEBANON
289 bankaudi.com.lb/about-the-bank
/about-us/headoffice
T +961 1 994000

ISRAEL
295 knesset.gov.il/tour/eng/evisit.htm
T +972 2 675 3337
296 imj.org.il/en
T +972 2 670 8811

EGYPT
299 danaestratou.com/web/portfolio-item
/desert-breath

QATAR
303 mathaf.org.qa/en
T +974 4402 8855
306 dohahamadairport.com/relax/art-
exhibitions/lamp-bear
T +974 4010 6666

UNITED ARAB EMIRATES
308 louvreabudhabi.ae
T +971 600 56 55 66

NORTH AMERICA

CANADA
309 banffcentre.ca/walter-phillips-gallery
T +1 403 762 6281
319 parcjeandrapeau.com/en
T +1 514 872 6120

UNITED STATES
325 listart.mit.edu/public-art-map/bars-color-
within-squares-mit
326 mad.uscourts.gov
T +1 413 785 6800
328 fishercenter.bard.edu/visit
329 diaart.org/visit/visit/diabeacon-beacon-
united-states
T +1 845 440 0100
330 stormking.org
T +1 845 534 3115
331 hudsonvalley.org/historic-sites/union-
church-pocantico-hills
T +1 914 631 2069
332 nycgovparks.org/parks/crack-is-wack-
playground/monuments/1801
T +1 212 360 8143
336 saintpeters.org/the-arts-and-design/art-
collection/nevelson/
T +1 212 935 2200
340 diaart.org/visit/visit/max-neuhaus-times-
square
343 diaart.org/visit/visit/joseph-beuys-7000-oaks
T +1 212 989 5566
344 gaycenter.org
T +1 212 620 7310

INDEX OF NAMES

INDEX OF PLACES

INDEX OF PLACES

PICTURE CREDITS

Phaidon Press Limited
Regent's Wharf
All Saints Street
London N1 9PA

Phaidon Press Inc.
65 Bleecker Street
New York, NY 10012

phaidon.com

First published 2018
© 2018 Phaidon Press Limited

ISBN 978 0 7148 7646 7

A CIP catalog record for this book
is available from the British Library
and the Library of Congress.

Commissioning Editor: Rebecca Morrill
Project Editor: Bridget McCarthy
Editorial Assistant: Simon Hunegs
Picture Researcher: Nikos Kotsopoulos
Production Controller: Lisa Fiske
Designer: Hans Stofregen
Artworker: Ana Rita Teodoro

Texts by: Lisa Delgado, Ellen Mara De
Wachter, Eva McGovern-Basa, Raina Mehler,
Michele Robecchi, Sean O'Toole,
Roxanne Smith, Elisa Taber, David Trigg

Printed in China

Publisher's Acknowledgments:

Special thanks to Roberto Amigo; Geoffroy Bablon;
Sara Bader; Marc Bailes; Laura Barlow; Catherine
Belloy at Marian Goodman; Toma Berlanda; Bea
Bradley at White Cube; Katja Bremer; Caroline
Burghardt; Jan Church; Susan Clements; Sadie
Coles; Capucine Coninx; Tom Dingle; Andre Dunlop;
Fergus Egan; Jessica Focht; Raimi Gbadamosi;
Massimiliano Gioni; Arne Glimcher, Jon Mason,
and Lindsay McGuire at Pace Gallery; Kate
Greenberg; Rania Ho; Catalina Imizcoz; Tim Jones
at Christchurch Art Gallery Te Puna o Waiwhetu;
Rachel Kent; Crystal Kim; Yurina Ko; Cecelia
Leddy; Linda Lee; Sanaë Lemoine; Benji Liebmann
and Lloyd-Anthony Smith at Nirox Foundation;
Lesley Lokko; Alexandra Magnuson at Gagosian
Gallery; Matthew Marks Gallery; Virginia McLeod;
Gražina Michnevičiūtė; Mary Miller, Max Levai,
and Alexa Burzinski at Marlborough Gallery;
Katie Minchinton; Maxwell Mutanda; Liina Ojamu;
Alessandra Olivi at Tyburn Gallery, London; Emma
Phillips; Hala Schoukair; Nicolò Scialanga at
Fondazione Prada; Bisi Silva; Jerry Sohn; Emma
Sumner; Guy Tindale; Elena Ubeda Montero and
Gonzalo Romera Lobo; Giorgia von Albertini;
William Winning; Danielle Wu at Galerie Lelong;
and all the artists, photographers, galleries,
estates, and institutions who contributed time
and materials to this book.